FIGURE SCULPTURE IN WAX AND PLASTER

Tami: Bending Forward.
5½″ high; unique bronze.
Richard McDermott Miller.
Collection of Carol Crasson,
New York City.

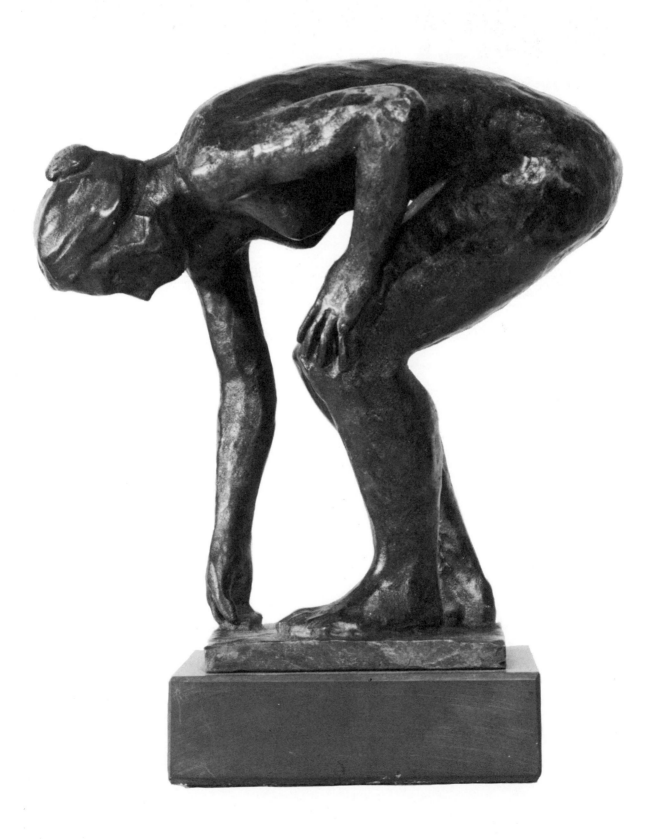

FIGURE SCULPTURE IN WAX AND PLASTER

BY RICHARD McDERMOTT MILLER/EDITED BY GLORIA BLEY MILLER

WATSON-GUPTILL PUBLICATIONS, NEW YORK

For Sue and Michelle

Foreword

Many themes, materials, and methods can be used in the making of sculpture. This book sets its focus on a single theme: the human figure; and concentrates on two versatile materials, wax and plaster. It begins with "conceptual tools" or ways to think about the figure. But thereafter, most of the emphasis is on the practice, rather than on the theory of sculpture.

This approach recognizes that—apart from the artist's need for personal expression—sculpture is a physical task involving the manipulation of materials. It is fundamental therefore, that the artist have an understanding of such materials and how to work with them. This is why the book will concentrate on the *working problems* of sculpture.

The purpose of this book is threefold: (1) to put the reader quickly in possession of the basic procedures he'll need to get started; (2) to answer questions about materials and tools and (3) to launch him into actual projects specifically designed to teach him sculptural skills.

All the material here is treated in sufficient depth to interest the professional, yet is spelled out clearly enough for the beginner. Thus the reader, whatever his background, can carry out the demonstration projects—as well as figures of his own—with a goodly measure of success and can in the process discover a satisfying form of personal expression.

RICHARD McDERMOTT MILLER
New York City

Only by doing sculpture does one become a sculptor. Only by involving ourselves in actual working problems can we begin to translate our insights and feelings into sculptural terms. And only through such development, can we begin to find in our work a form of personal expression which is uniquely our own.

Contents

Introduction

Everyone is aware that sculpture is an ancient art, going back to human beginnings. But the fact that, for millennia, early man could make clay images before he learned to make more utilitarian clay pots, boggles the imagination. Yet historian Lewis Mumford points out that clay sculptures still exist from a time many thousands of years before there is any evidence of clay being used to make pots. Although we tend to believe utility always came first, this reminds us how basic art—and especially the art of sculpture—is to the nature of man.

We aren't surprised, however, to recognize the *images* of even these earliest works. We invariably expect the visual art of any time and place— no matter how remote—to convey some meaning to us. We know art has this remarkable capacity to speak across the boundaries of history and geography. The sculptures of Greece, Egypt, and China communicate with us although we may not know a word of the language of these countries. This is because the ideas expressed in sculpture and painting do not depend on language. Rarely, if ever, can they be put precisely into words. Nevertheless, these are strong vehicles of human expression and—having nothing comparable to a verbal vocabulary—speak to us all the more directly.

Unlike painting, which deals with *illusions* of form and space, sculpture is *actual* form occupying actual space. A work of sculpture is tangible and solid. It changes with light, with distance and with how it is viewed. It can be touched, felt and sometimes even held, as well as just being looked at. Thus sculpture establishes its meaning, not only by its impact on our eye, but by our awareness of its physical presence as well.

A sculptor makes his statements in terms of form and volume, articulated and organized in space. Instead of words, he uses materials. Although there is no vocabulary as such, the mechanical assembly of material parts in sculpture corresponds in a sense to our ability to write syllables and make sounds. A sculptor needs to know how to join pieces of wax together, mix plaster, bend wire, drive nails; or how to do whatever is necessary in constructing his work. It is essential that he learn to handle such things easily, almost unconsciously, as it is essential for him to pronounce words in verbal language.

Yet sculpture is not primarily a technical process. Technique only enables the artist to get on with what he has to say. When he has mastered technique well enough to take it for granted, then his imagination becomes free. Then the creative action of his hand can submit itself, uninterrupted, to the creative judgment of his eye.

I The Figure

Because people are interested in other people, the figure is a natural subject for art. It's a world in itself for the sculptor to discover and explore. In the eye of the artist, the figure is a continual source of freshness and surprise.

Since the figure is so charged with human associations, we are tempted to believe that its mere use will be automatically expressive. For no matter who the artist is, or whatever his medium, the figure nearly always transmits feeling. This seems to operate even outside the province of art. Expressive references to the human figure abound in our language: the head of the bed, the foot of the hill, the arm of the law, the eye of the hurricane, etc.

Even the untrained hand, drawing the figure, is expressive. Psychological tests, based on such drawings, are said to reveal something of the emotional makeup of the subjects. This is because each of us—trained in art or not—has a personal concept of the figure and responds to it in his individual way.

But before we go a step further, we must make a sharp distinction between art and life. The figure in art is not a pseudo-person, but a *man-made* concept. Kenneth Clark, in his book *The Nude*, tells us the figure is "not a subject of art, but a form of art." It is, he says, "an art form invented by the Greeks in the fifth century B.C., just as opera is an art form invented by the Italians" more than twenty centuries later.

The figure *in art* springs not from nature, but from the human mind. It differs from its flesh and blood counterpart in every respect. Structurally, the living figure has remained relatively unchanged for centuries. In art however, one change in the concept of the figure after another has been reflected by one change after another in style. In other words, while man's body has remained essentially the same, his ideas and images of that body have been continually in flux.

As a theme of art, the figure has demonstrated its staying power by proving extensive and adaptable enough for artists throughout history to express a wide range of human feelings within its scope. How the figure will be interpreted—next by present artists or later on by future artists—we cannot predict. But we can foresee that the figure with its inherent potential and richness will retain its fascination as an art form.

A GALLERY OF MASTER SCULPTORS

A visit to any art museum quickly demonstrates that the figure is in a class of its own. Throughout the history of art, it has appeared in many places and in many forms. On the following pages, examples of the figure are shown, covering a span of more than two thousand years. The artists who created these figures are obviously individuals of distinct backgrounds and temperaments, who together make up but a tiny sampling of the figurative tradition. Yet clearly, all are joined in a single fraternity: all are dedicated in their work to the same fascinating and persistent theme.

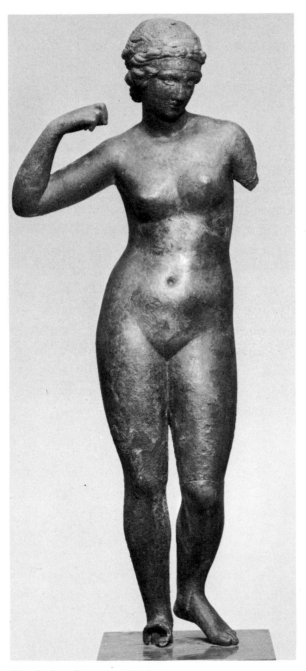
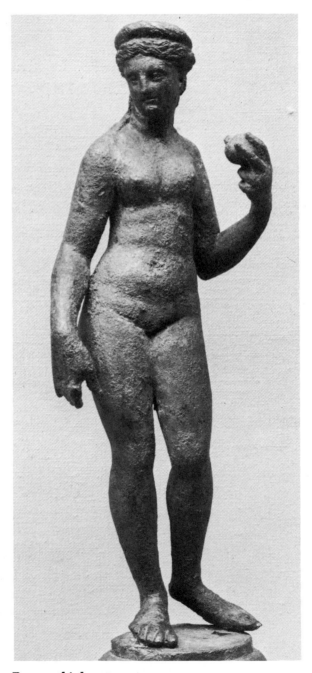

Greek, fourth century B.C. **Roman, third century**

Venetian, sixteenth century

Venetian, sixteenth century

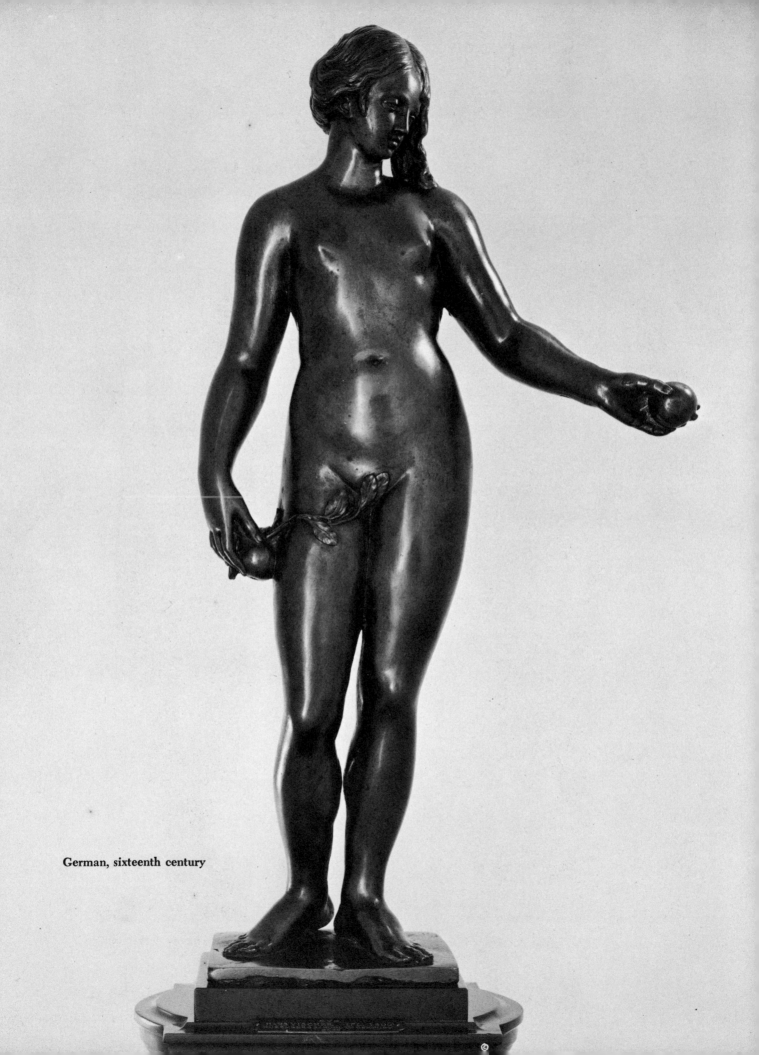

German, sixteenth century

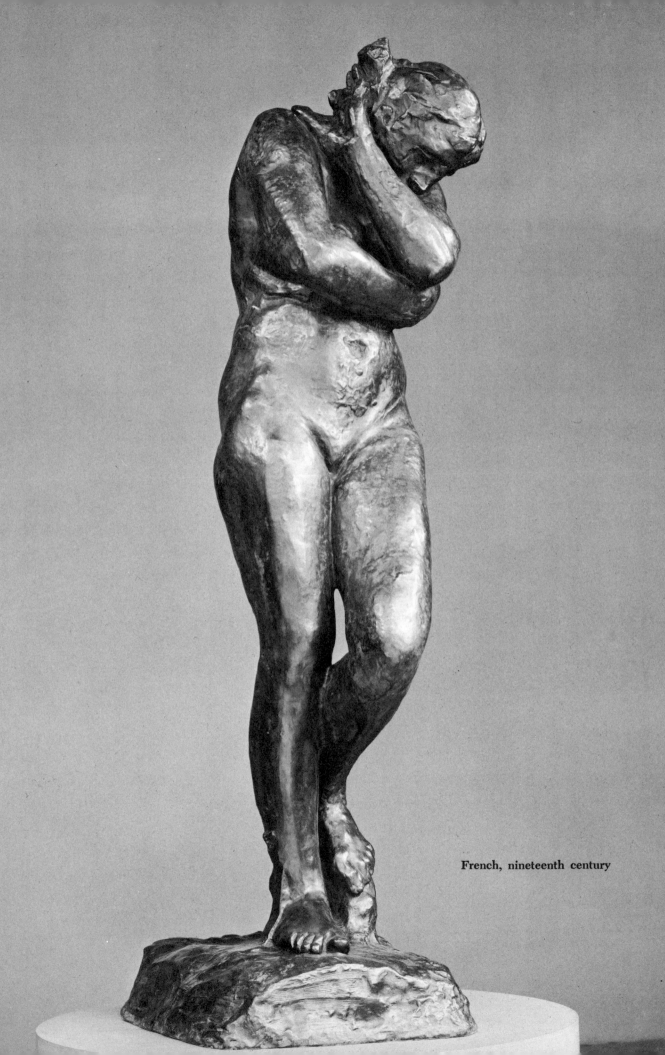

French, nineteenth century

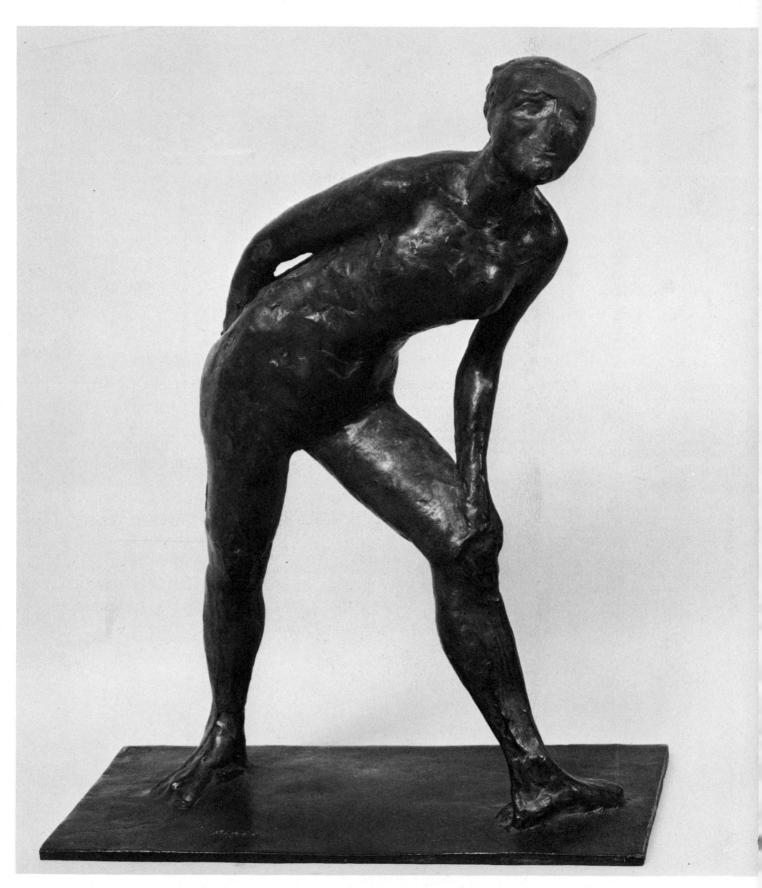

French, nineteenth century

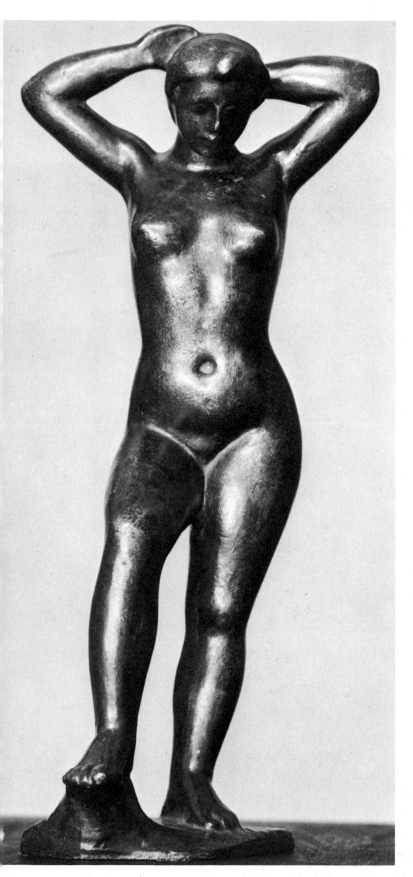

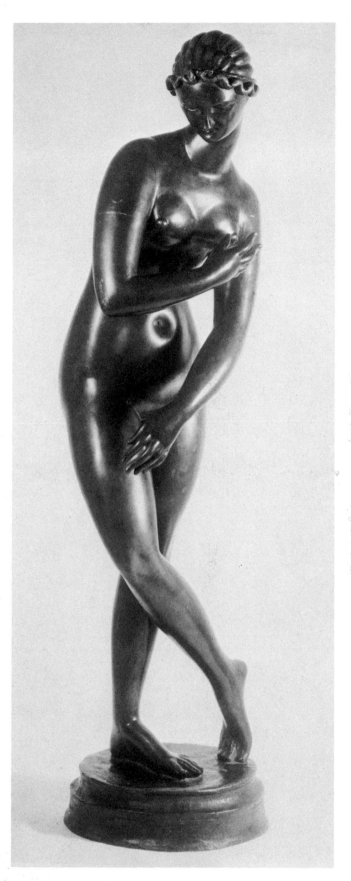

French, nineteenth century

American, twentieth century

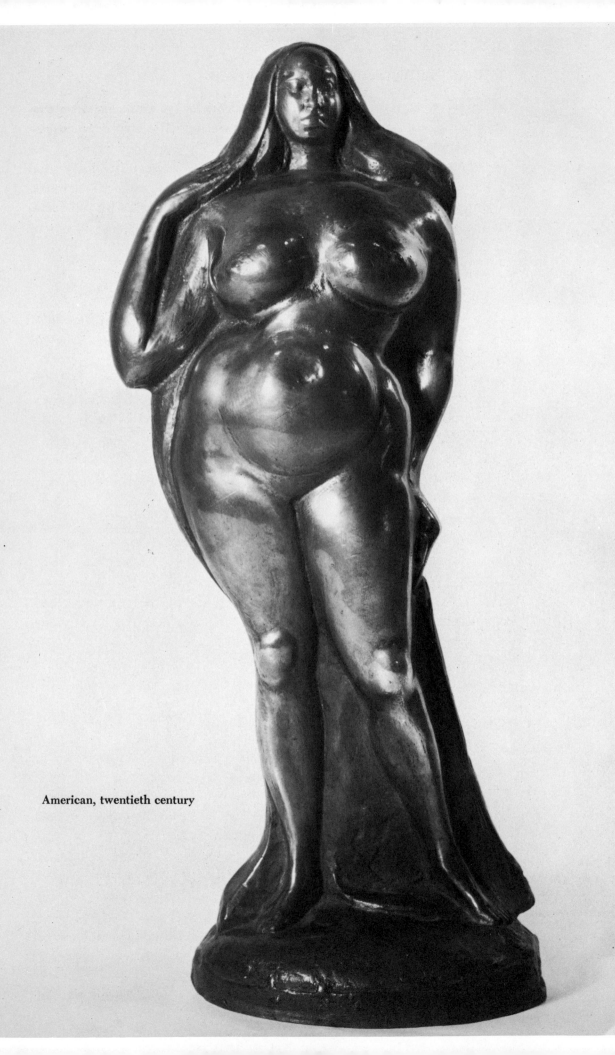

American, twentieth century

THE SCULPTOR'S SOURCE MATERIALS

When we select the human figure as the theme for our work, the inevitable question arises: what will our source material be? The answer is surprisingly simple. An inexhaustible supply exists. We need only glance about us. There are people of all ages to look at: men, women, and children. There are books, newspapers, and magazines overflowing with photographs. There are books on art; books on anatomy. There are works of art in parks, museums, and galleries. There is, everywhere in the world, a multitude of riches for the artist to use.

FINDING A PERSONAL STYLE

But the beginning sculptor may least appreciate the source that's most important to him. That source is himself. Often a person becomes so intent on discovering his own personal style, he overlooks the value of what he, himself, can bring to his work. This includes not only whatever knowledge he has of art, but his total background: his life experience, training, beliefs, observations, memories, customs, and imagination. All these elements combine to become his "inner image" of the world, a kind of model against which he subconsciously measures new data.

The act of creating sculpture in itself helps us form, clarify, and expand our own inner image. As this image continues to grow and be enriched, it becomes the particular and unique character of the artist's work. The work of Degas or Maillol, for example, can be recognized at a glance. Their styles are distinctive and personal. So are those of all great artists. Yet these styles are not contrived nor arrived at by design. They are expressions of deepest conviction and have vital meaning for the artist. One can copy the styles of others and learn from them, but the inner image we each have is unique. It may not be easy to recognize at first, but if it is allowed to grow, it will make itself felt and become clearly distinguishable from the external influences on our work.

WORKING FROM PHOTOGRAPHS OR MEMORY

The beginning sculptor can use as his sources photography, imagination, or a combination of both. Whether he works from photographs or memory, he is in effect consulting these sources in search of facts. These facts provide a starting point: they help to construct the figure, they offer general ideas about it, they also supply specific details.

When using photographs, we need to be aware of the strengths and weaknesses of this medium. Photographs are strong on gesture. They provide ideas and stimulate the imagination. But photographs are weak on form; when it comes to proportion, they can be treacherous. This is because the camera always brings various parts of the figure (which are at different

distances from the lens) into a single plane. The result is then recorded as a two-dimensional image. Thus photographs tend to flatten things out, to obscure relationships and to fix the figure in a picture pattern that is essentially distorted. Photographs are most helpful when the sculptor recognizes what they can offer and what they cannot. (A source of photographs designed specifically for figure sculpture is described on page 152.)

When using photographs or memory, we should act out the gesture of the figure. Feeling the pose or position will help us extract additional facts and ideas for our work. Using a large mirror also has advantages. Since the figure means most when understood in our own terms, there is real value in studying our own physical structure. When we trust our instincts and· sense of proportion, we work by conviction, not by rule. We make contact with our inner image. Our work, instead of being a copy, then becomes truly our own.

WORKING FROM LIFE

Working from a live model, whenever possible, is always best for figure sculpture. Here, however, the situation is quite different. The initial challenge is to select the pose. That pose may either be predetermined by the sculptor for some specific purpose, or taken from a natural gesture of the model.

If the sculptor chooses to invent the pose, the live model will then serve only as a point of reference and the finished work may or may not resemble the model. In this way, the sculptor can—if he wishes—create figures that hold poses which are not possible in life. He will do this by concentrating on only one part of the figure at a time: such as an arm, torso, or leg. The model must then approximate that part of the pose as well as she humanly can. The sculptor can also make his figures more "perfect" than life. He does this by using different models for different parts of the work, because each embodies for him some aspect of a "perfect" figure.

Today's artist usually derives the pose, as well as its various elements, directly from the model. This presents him with a somewhat different set of problems. It's sometimes difficult, when using a live model, to determine whether or not a given pose will be good for sculpture. Quite apart from the artist's ability, a pose that seems interesting in life can lose its interest when translated into inanimate material. Some poses just do not work in sculpture. Others may result in unintentional parodies; that is, the pose, as a piece of sculpture, may take on a startling resemblance to a work from the past, or be so reminiscent of a famous museum piece as to seem a deliberate copy. Yet curiously enough, there's no way to determine the nature of any pose unless it's actually translated into sculptural terms. Therefore, we should always do quick three-dimensional sketches to study

the poses before we devote the time and effort required to develop them into larger pieces.

The best poses are always the most natural. If we give the model a chance to be herself and take the pose in her own way, her relaxed natural stance will contribute much to our work. But if we ask for unessential adjustments (such as telling her to move her arm a little to the right, or her foot slightly to the left) we will make her think in our terms, rather than in her own. When a model is thus made too self-conscious, her natural sense of poise is destroyed. As she tries to be someone she is not, she becomes awkward and wooden. To prevent this, we don't overdirect the model or get too specific. We keep our instructions simple. In a general way, we ask the model to "sit" or to "stand." We give her enough leeway to interpret this in terms that are natural for her. Then she will be at ease, sitting or standing in her own characteristic manner.

We also need to be aware of other problems the model may encounter. Some poses which seem easy can actually cause considerable muscular tension and strain. Some simple sitting poses, for example, put pressure on the back of the legs, even when held for a short time. If the pose interferes with the body's circulation, the hand or foot may go numb, causing sensations of pins-and-needles and sometimes of pain. Most difficult are the kneeling poses, since they put great pressure on the knees. As we work with models, we soon learn to avoid such problems, or to modify them.

Using Professional Models. For those enrolled in a university or art school, figure models are generally available. If not, a community art center might schedule life classes. Many of the larger communities also have co-op studios where, for an hourly fee, one can work from a model without instruction. If such studios do not exist in your community, you might—along with other artists—organize your own group and hire professional models on a share-the-cost basis. Some of the larger cities have special agencies which furnish such models for art classes and art groups.

When posing a model for a group, it's important that she remain relatively motionless. At any given moment, someone in the group, concentrating on the pose, would be inconvenienced if she moved. Thus, poses planned for groups should be comfortable enough for the model to hold for extended periods. When the model works for an individual sculptor, however, there can be greater flexibility. Much more difficult poses can be attempted since the sculptor's attention will be divided between the model and his work. By getting synchronized with the sculptor's working patterns, the model may step out of the pose at intervals, without inconveniencing him or his work in any way.

Professional models, as a rule, work for three- or four-hour sessions. They hold their poses for twenty-minute periods, with brief (five-minute) rests. Early in the session, while the model is still fresh, holding a pose for twenty

minutes is usually easy. But after several such periods, she will begin to tire. Maintaining the pose may look simple, but can be tedious, difficult, and even painful over a period of time. To compensate for this, the model's rest breaks should be spaced at more frequent intervals as the work proceeds. Other considerations for the model's comfort should include having a place set aside for her to dress, and providing cloth or foam padding to reduce the discomfort of holding sitting or reclining poses.

Using Space and Props. A model doesn't pose in a vacuum; she poses in specific space. Instinctively, she needs to relate to something in that space in order to feel comfortable. This may be part of the room itself or an object within it. The object might be a model stand, a prop, or just a specific area of the floor. Although our directions to the model may be general, we should always be very precise as to *where* the pose is to take place. Designating this space will not restrict the model's normal manner. When she knows where she is to pose, she will relate to that space in a natural, comfortable way.

Note: Using some kind of model stand is particularly helpful here. It will raise the subject above eye-level, making it easier to observe her. Ideally, the stand itself should rotate so the model can be seen three-dimensionally from all angles. Then she needn't shift her pose in order to change views; nor will we have to circle around her, carrying our materials and tools. (See Constructing a Model Stand, page 152.)

The setting we choose also lets us influence the pose without making the model self-conscious. (The setting immediately establishes and defines the space in which the model exists.) And if we use props, these will make possible a variety of poses, such as sitting, leaning, resting, etc. The prop might be a piece of furniture or some other inanimate object—a box, chair, or uncomplicated stool. Whatever it is, the prop should be simple in shape and easily incorporated into the sculpture. It should not interfere unnecessarily with the visibility of the figure, nor should it obscure too much of the model's back, the back of her legs, etc.

Since every model will stand, sit, and walk in her own characteristic way, identical instructions—given to different models—can produce a fascinating variety of results. Each model can be counted on to interpret the instructions a little differently. When the general instruction to "sit" or to "stand" is combined with a specific prop or setting, a whole series of variations can be generated. In my own work, I have used this approach with interesting results. Some examples of these follow:

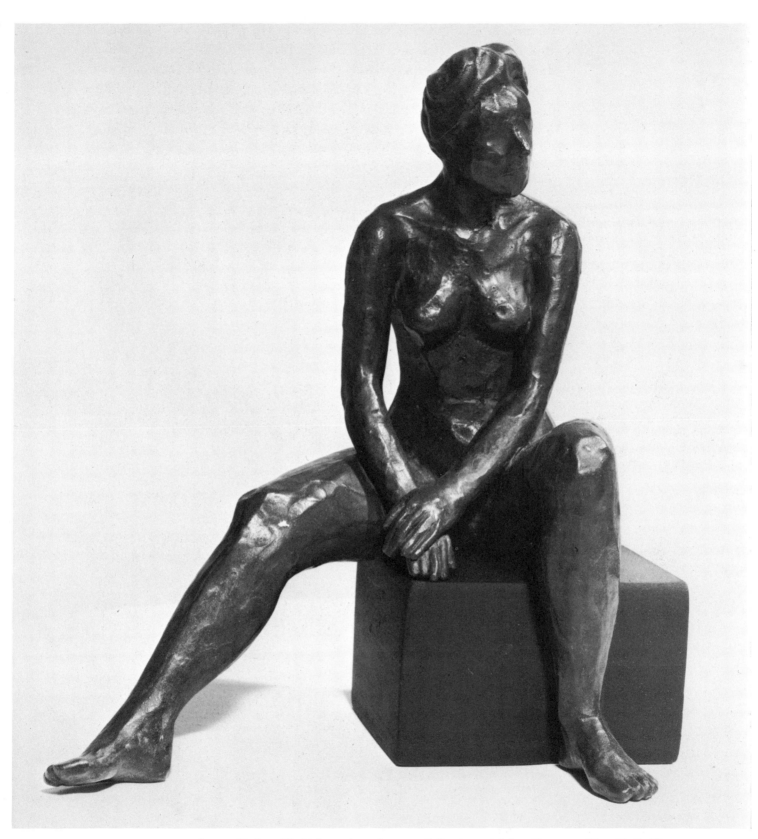

Anne: Sitting. *7" high; unique bronze. Collection of Jules Sherman, New York City.* I often ask the model to "sit," indicating a chair or stool. In this case, the prop was a simple packing box (covered with a cloth pad), placed on the model stand. The model, comfortable and relaxed, took the languid, graceful pose we see here.

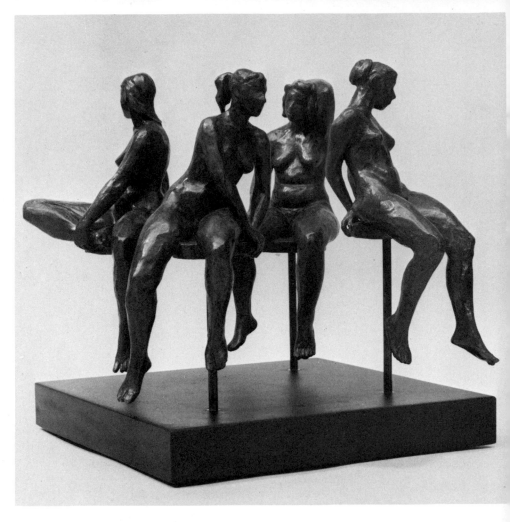

Four girls: Sitting. *10¼″ high; unique bronze. Collection of Mr. and Mrs. W. B. D. Stroud, West Grove, Pennsylvania.* Again my instructions were simply to "sit," but this time on a stool, high enough to keep the model's feet off the floor. Each model posed separately and was not aware that the sculpture would later be incorporated into a more complex piece. In this group and in the groups which follow, the figures were individually made to the same scale so that, when finished, they could be assembled as a unit. The stools in this piece are set in special sockets at the four corners of the base. Their stems can either be rotated individually or lifted completely out of the sockets and interchanged to create variations in the grouping.

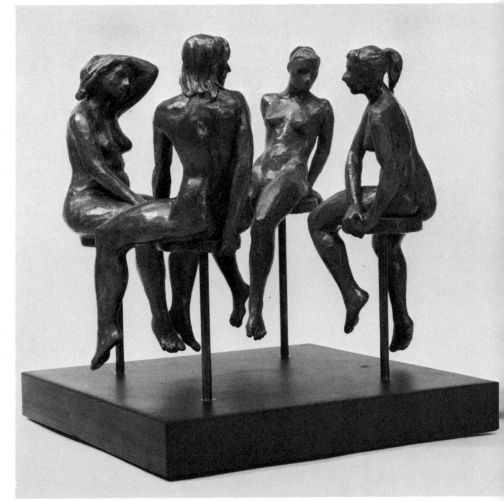

Four girls: Sitting. *10¼″ high, unique bronze. Collection of Mr. and Mrs. W. B. D. Stroud, West Grove, Pennsylvania.* The figures of the previous group are now in a new relationship. Notice how this juxtaposition has changed the mood of the work. The figures seem closer to one another and more animated. By rotating the stems of the stools, we can turn the figures in other directions and change the mood again.

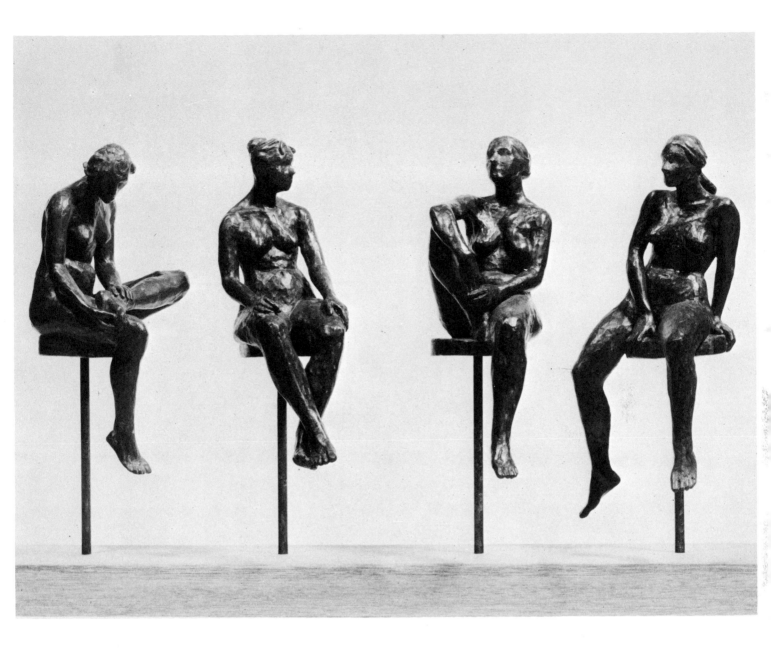

Four girls: Sitting. *10½″ high; unique bronze. Collection of Mr. and Mrs. S. A. Marrow, New York City.* Here the stool and the instructions to "sit" were the same, but the models were not. Notice how differently they sit from each other and from the four other models in the previous group. Most let their feet hang, but some held onto one foot or propped their heels up on the stool.

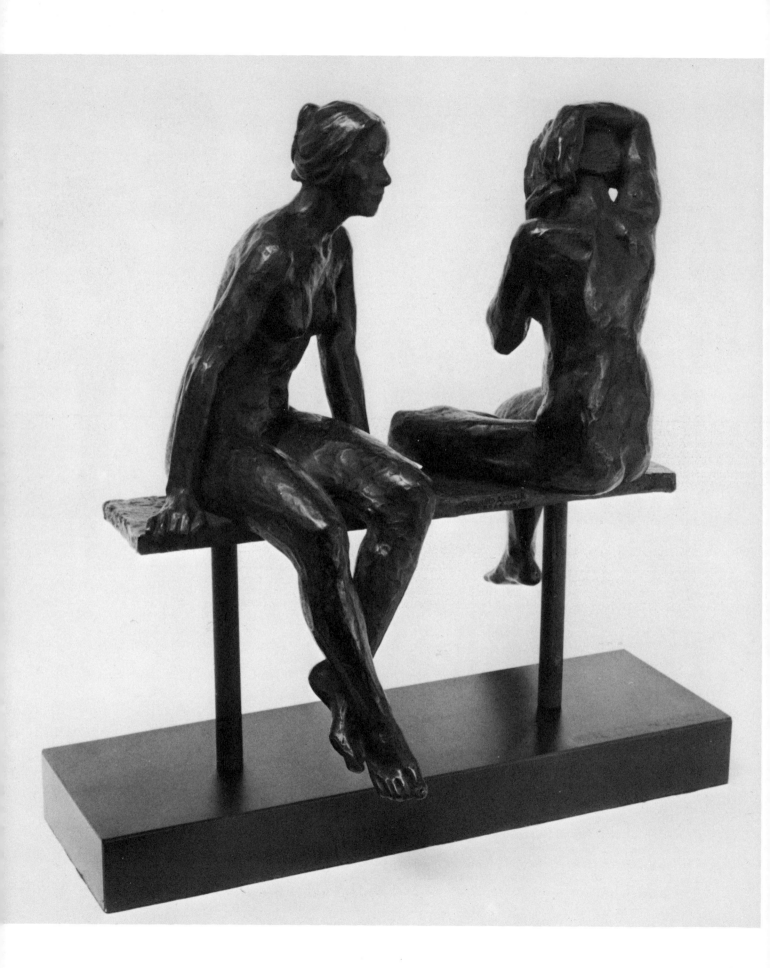

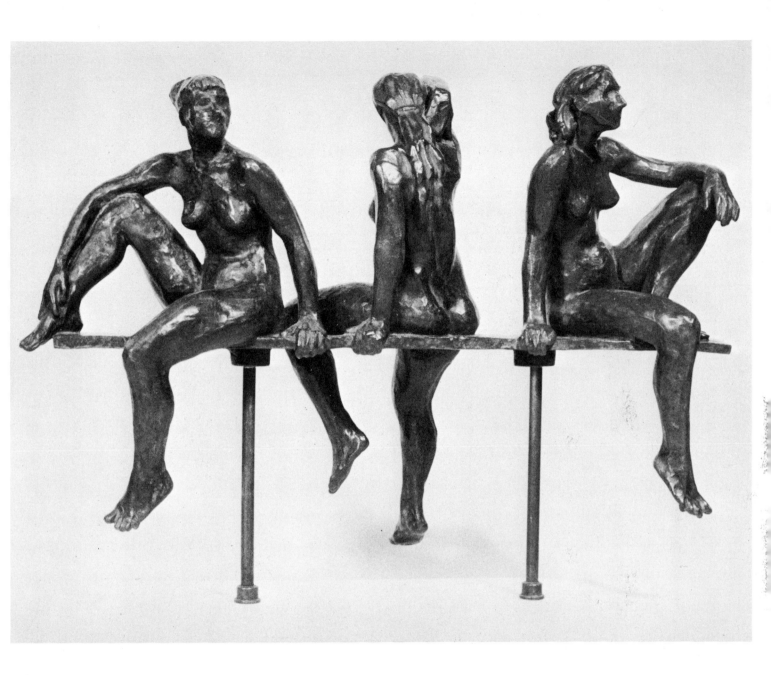

(left) **Two girls: Sitting.** *13½″ high; bronze edition of 7. Collection of Ted Post, Los Angeles, California.* These models, seated on a narrow plank, related to it differently than they would have to the individual stools. For this piece, several figures were done separately, without any advance planning as to how they might be combined. Later, I tried a number of arrangements before deciding on the combination of these two.

(above) **Three girls: Sitting.** *9⅝″ high; unique bronze. Private collection, Chicago, Illinois.* The plank here is the same as in the previous illustration, but the models differ. Although the girls posed at different times, the prop and the instructions were identical. The model in the center tried with her right arm to do something she thought would be appropriate and interesting. The other two simply relaxed. The actual plank wasn't long, but note how it was extended in the finished piece to accommodate several figures.

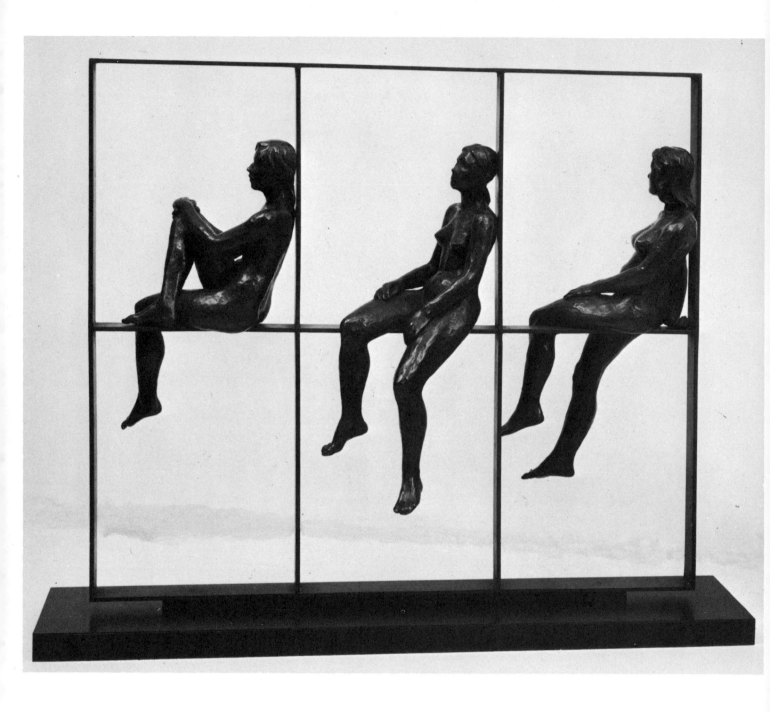

(above) **Three girls: Sitting.** *23" high; bronze edition of 7. Collection of Lawrence Bloedel, Williamstown, Massachusetts.* To extend the range of sitting poses, I added a backrest to my original plank. This was a second plank, fastened in place vertically, against which the models could lean. The rectangular frames, seen here, were designed afterward, as a device for mounting the group. In turn, this suggested using an actual frame as a special prop for the model.

(right) **Sandy: Seated in a Square.** *15" high; bronze edition of 7. Collection of Senator and Mrs. Jacob K. Javits, New York City.* The window-like frame, suggested by the last piece, was solidly built onto the model stand. It became an important element in the sculpture itself, creating a relationship between the solid volumes of the figure and the open spaces within the frame. This relationship resulted, not so much from design, as from the model's natural grace in accommodating herself to the unusual requirements of sitting inside the frame.

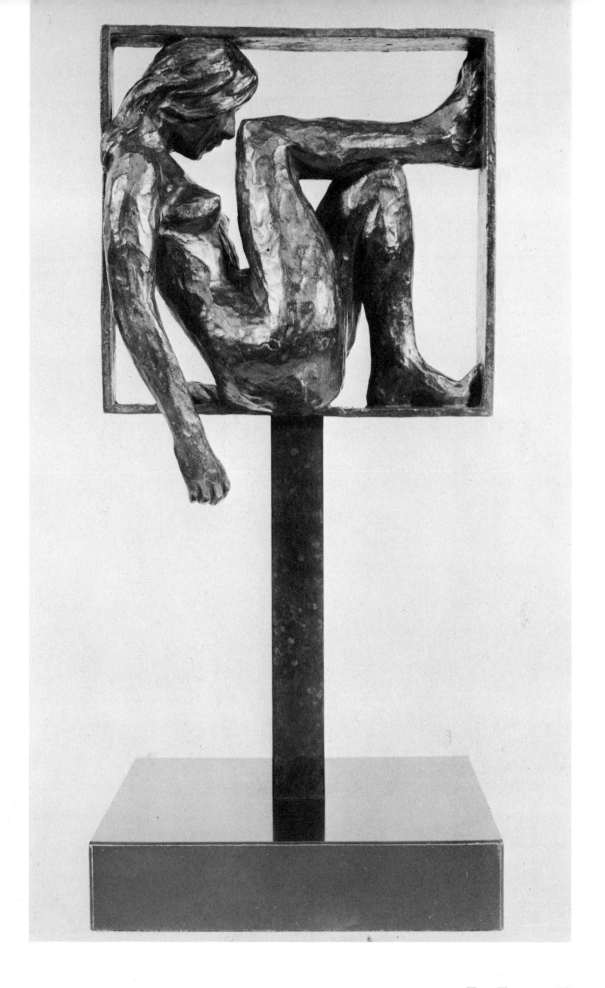

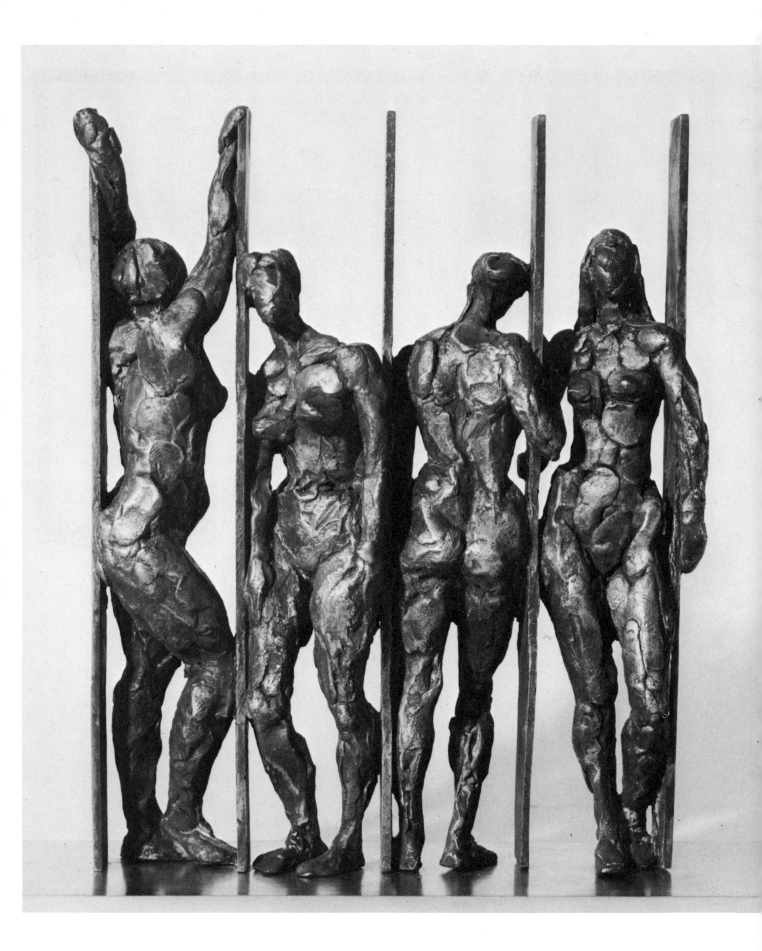

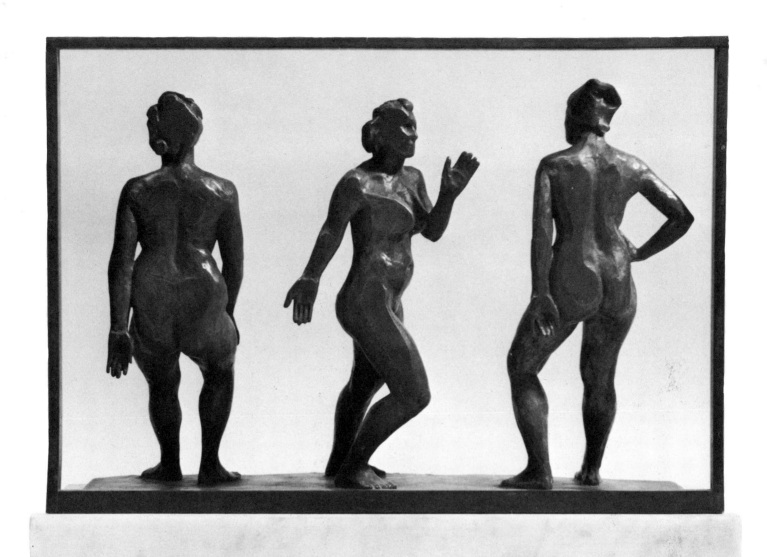

(left) **Four girls: Enclosed by Verticals.** *9¾″ high; unique bronze. Private collection, New York City.* For this sketch, two closely-spaced vertical planks were constructed. The figures themselves were modeled at different times, over a period of several weeks. Although these are rapid sketches, the individual characteristics of the models can be seen. (The two figures in the center are of the same model.) The repetition of the verticals gives the piece a unity and a certain mood.

(above) **Three women: Leaning.** *10⅝″ high; unique bronze. Collection of Dr. and Mrs. Fred P. Handler, Jefferson City, Missouri.* By mounting a large sheet of plate glass vertically on the model stand, another kind of enclosure was created. The sculpture here suggests that the frame actually holds a piece of glass, although it does not. The illusion is strong enough however, that people have tentatively put their fingers to the frame to assure themselves that the glass isn't really there.

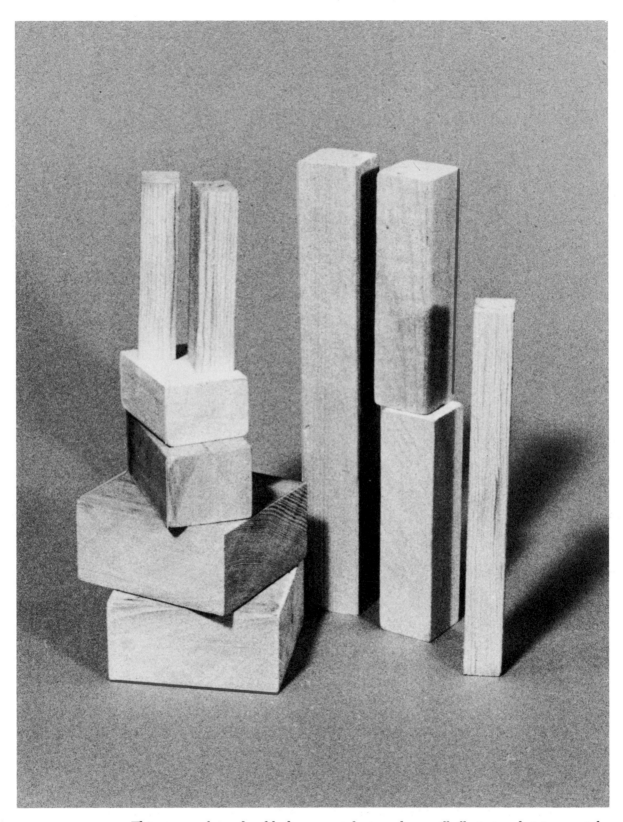

This group of wooden blocks, arranged at random, will illustrate what is meant by sculptural analogy. The pieces of wood in themselves bear no resemblance to the elements of the human body, differing as they do in number, size, and shape. Yet we shall see, that—by means of relative location alone—they will create an unmistakable analogy with the human figure.

2 Conceptual Tools

Before we begin to make sculpture, we'll need some concepts to help us approach the figure so we may grasp the work with our minds as well as with our hands. We'll need some idea of what the figure is, how it's made, what it looks like. We must also recognize that a sculptural representation of the figure—in any three-dimensional medium—always depends on some *analogy* between the sculpture and that of actual human form. This chapter will consider these various problems.

WHAT SCULPTURAL ANALOGY IS

There are two distinct types of sculptural analogy. The first has to do with the location or arrangement of the parts in space; the second with the shape and volume of these parts.

We can demonstrate the analogy of the relative location of the parts in space simply with rectangular blocks as in the photograph illustrated at left. Collectively, these blocks have no resemblance at all to the human figure. Nor do they separately suggest any specific parts such as the head, arm or leg. Yet when these blocks are arranged in space, in positions relative to the salient elements of the human body, they become more than mere blocks. Suddenly they become a figure. The essence of that figure obviously is not the parts themselves; the blocks are not important. (Any assortment of objects, such as corks, paper tubes, or machine parts would do as well.) The essence lies in the relative location of these parts in space.

Our second type of analogy is a reversal of the first. It concerns the shape and volume of the parts without regard to their location. It is these volumetric characteristics which give the parts their identity. In the illustration on page 34, when we substitute a lower leg and foot made of wax for the wooden block, the shape of the leg—apart from its location—makes it easily recognizable. Thus the parts can be identified independently to the degree that their shape resembles the corresponding shape of the human body.

When either of these analogies is carried into great detail, we call the work "realistic," when it is not, we call it "stylized." However, the similarity must exist to some degree, or else the work will not be seen as—and cannot be called—a figure.

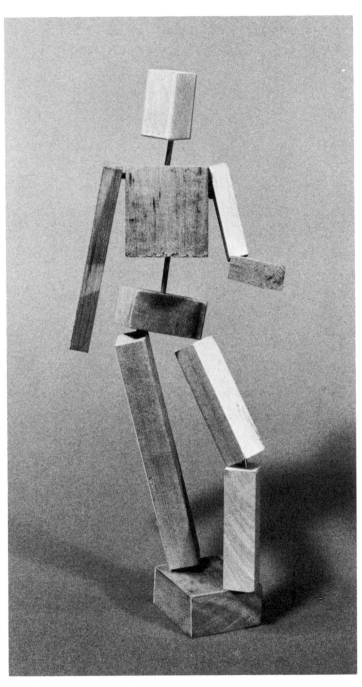

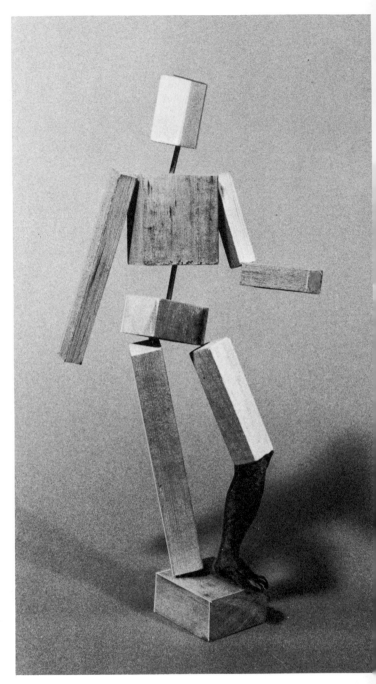

Suddenly, the wooden blocks come to life. We simply arranged them in positions analogous to the elements of the human body and now, they're easily seen as a human figure.

We demonstrate a second kind of analogy when we replace the wooden block, that originally represented the left leg, with a form modeled in wax. Here, the shape of the wax—even more than its location—enables us to read it clearly as a leg.

To get started on an actual sculpture of the figure and to begin putting together our first bits of wax or plaster, we'll need some sort of scheme or idea of what we're trying to create. Instinctively, we conjure up a surrogate image, stripped of all detail and having a minimum of parts. It is not specific, not complete, but an image of the human body nevertheless. We call it the schematic figure. It will serve as a temporary mental stand-in for us, while we pull together our materials and thoughts.

The schematic figure is our means of thinking about relative location in space and about volumetric shape without recourse to words. Its purpose is to help us substitute simple forms for the complex structure of the body's flesh and bones, and to enable us to navigate freely in three-dimensional space. Since the all-purpose schematic figure resides in the mind's eye, it may assume any shape or combination of shapes that best helps us conceive the form of our actual sculpture. It might be based on geometric blocks or on other solids. These could be cylinders and cones, rectangular blocks, or elliptical spheroids, as in the illustration on page 36. The image of the schematic figure is never fixed. As the work progresses, our stand-in figure changes frequently, while it variously adapts itself to the needs of the piece.

To be most practical, our schematic figure must be a concept that's highly flexible. It must be capable of assuming any pose and of taking on any proportion. It must do so easily, without forcing our attention too soon to problems of detail. We must not confuse the schematic figure either with our final sculpture or with the living figure itself. We must recognize it for the tool it is in helping us begin our work and then in controlling its development.

At first our sculptural material will be relatively shapeless. It will aspire toward the figure, guided by our schematic idea. Then to develop it further, we can use any or all of the related conceptual tools described below. These include:

Points. Points are marks made, or small pellets of wax placed, on the figure to establish precise locations. At any early stage of our work, such marks or pellets—placed on the shoulder, elbow, wrist, hip, knee, and ankle—will respectively mark off the length of the arm, forearm, thigh, and leg. They will enable us to judge whether these extremities are too long or too short.

Such points can also be used to establish direction. For example, a pellet marking the chin not only helps us indicate the size of the head, but the direction in which it is tilted as well. In other words, points serve as guideposts: locating specific features on our simplified figure and helping to establish its general proportions.

Axial Lines. Axial lines are imaginary lines, running lengthwise through the centers of the arms, legs, head, torso, or any other part of the body. These

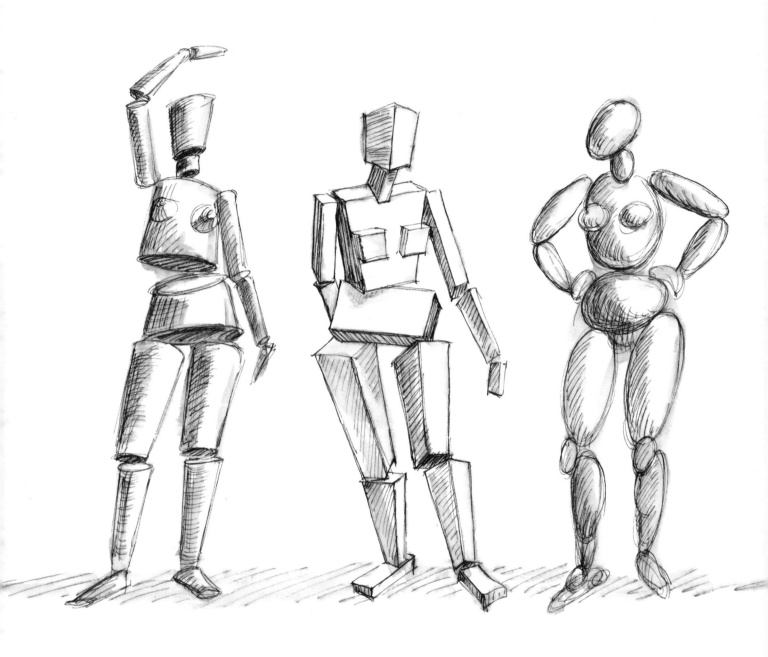

The schematic figure uses geometric solids to represent the major volumes of the body. Three possible variations are shown here. Whatever form the schematic figure may take, its function is always to provide a structure for the sculptor's specific ideas and observations. First, the sculptor will use it as a kind of shorthand notation. Then, as he proceeds with his modeling, he can modify and change the schematic figure as much as he likes.

lines establish the direction of thrust of the various elements and help locate each in relation to the other. Taken together, they make up a simple stick figure, an uncomplicated abstract device which enables us easily to establish our spatial relationships and to indicate the direction taken by various parts of the body.

Planes. Planes are the surfaces that define the outside volume of space the figure occupies. Although planes in geometry are defined as flat surfaces, curved planes are essential to sculpture. For our purposes, therefore, planes are defined as the simplified surfaces of the figure. Such planes enable us to incorporate a large number of minor surface features into fewer, more concise units. Planes, in other words, help us reduce the figure's complex surface to simpler, more general terms.

Surface Lines. Surface lines are *actual* lines drawn on the work, to serve a temporary purpose: we use them on work-in-progress to mark the median line of major elements of the figure, to designate the boundaries of forms or to indicate other features on the surface. (Although these are more practical than conceptual, they are included here because of their direct application to the schematic figure.)

The Plumb Line. The plumb line is the path traveled by the mighty forces of gravity, an invisible line pointing directly toward the center of the earth. We can quickly make this reference line visible by taking a length of string, attaching a lump of wax or any weight at one end, and letting it hang suspended in the air. It will always point to the earth's gravitational center. In sculpture, this ever-present force tells us whether our figure is standing or leaning, and about the general distribution of its weight.

OTHER PRIME CONSIDERATIONS

Working on the figure in sculpture means working on several aspects at once. When we have given our general schematic figure tangible form, we're then able to consider the figure's gesture. After stating that roughly, we can modify the figure's proportion to get it the way we want it. Since gesture and proportion are problems we must deal with from the start, let's see what they involve.

Gesture

Gesture has two related but distinct applications for the figure sculptor: it refers both to the movement of sculptural form and to the movement of the body itself. In either case, gesture refers—just as it does in ordinary usage—to *significant motion.*

All of us, in communicating with others, use gestures of the hand and body. These help us to emphasize, modify, and sometimes even to dispense

with words. Although people may know nothing of each other's language, they can manage to communicate essential ideas through gesture alone. Unconscious gesture can also be telling. It tends to reflect our innermost feelings as well as our mood. Because gesture is understood so universally, we are—as sculptors—instinctively sure of the "meaning" of a specific gesture in a figure we create. It's natural for us to read "meaning" in the basic gesture of our model, as well as in the gesture of our work, even though there may be no precise words to describe that meaning.

When gesture refers to the significant motion of sculptural form, this doesn't mean actual motion—sculpture needn't actually move—but *apparent* motion, the feeling of motion. With true sculpture, whether figurative or abstract, the forms are never static. They always appear to be "doing something," to "move" in relation to one another. Our eye, scanning a complexity of forms in space, sums up their shapes, volumes, and relationships. Instantly, it reads them as the unequivocal pattern of rhythmic movement that we call gesture. This marvel of human perception, although in no way cerebral, has the brevity of a mathematical equation. Quick and compact, it has neither the time nor space for words, yet with great clarity and strength it conveys feeling for us. Gesture, in this sense, is an animating force, giving life and vitality to such inanimate materials as wax, plaster, and etc.

In order to capture the feeling of any pose, it's essential that we establish its gesture accurately. We can imitate or recreate that gesture by literally putting ourselves in the given position. By simply doing with our own bodies what we want the piece of sculpture to do, we can sense the gesture of the figure kinesthetically and begin to understand it. For example, when working from a photograph of a walking figure, we would take the pose not merely to mimic it, but to *feel* it. We might shift our weight to one hip as the figure is doing, then examine the gesture. (If the arm is extended, we would thrust out our own arm.) We would be conscious of the shape of our back, the direction of the different parts of our body, the tension in our muscles. We would think about the locations of various parts of our body: where our ankles, elbows, and knees are in relation to other parts of the body. We would become aware of the weight, the direction, and location of the body's elements. By following this simple approach, we find we can flesh out the photograph specifically, and deepen our understanding.

When we do a figure, gesture is always the first thing we try to establish in our work. In addition to telling us what the figure is doing, it tells us what the figure is saying—and ultimately—what the figure *is*.

PROPORTION

Proportion deals with comparative size and with dimensional relationships between the various parts of the figure. Proportion, which is as important

as gesture, has two aspects: (1) the comparative size of one element to another—such as the thickness of the leg compared with the thickness of the torso; and (2) the comparative dimensions within a single element—such as the length of the leg compared with its thickness.

We can see both aspects simply and simultaneously in the illustration below. We have two identical cylinders, each 6″ tall and 1½″ in diameter. If we cut 2″ from the top of one cylinder, it becomes proportionately shorter than the uncut cylinder. At the same time, it becomes proportionately thicker in relation to its new, reduced length.

More perhaps than we realize, we are all sensitive to proportion. Most of us would notice quickly if a friend lost or gained weight. And we do not hesitate to describe certain people as short or tall, wide or narrow, thin or stout. Most of us have firm opinions about such things. Yet in making these judgments about comparative size, we are expressing views on proportion. Should a scientist use calipers to objectively measure some of those individuals we call long-legged, or short-legged, tall or squat, stout

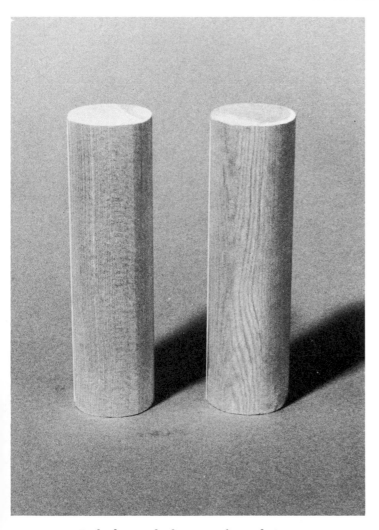

Both these cylinders are of equal size.

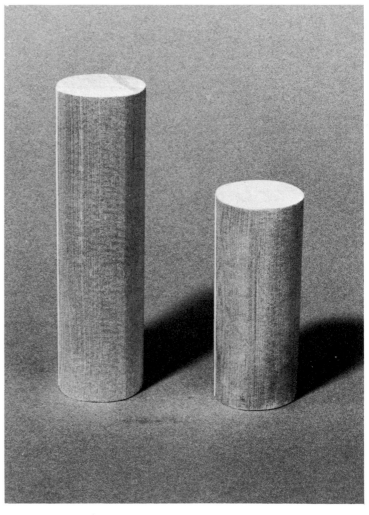

Here, the cylinder on the right has been shortened by one-third.

or thin, he might find the degree of difference between them to be relatively minor. The curious fact is, we are much more sensitive to proportion than we know. This sensitivity will prove useful to us in our figure sculpture.

We can use any of three basic kinds of proportion in our figure sculpture: natural, ideal, or exaggerated. Natural proportion is concerned with using the same general dimensional relationships we find in nature. The other two depart from nature in specific ways. Ideal proportion stems from classic Greek sculpture and attempts to establish a "best possible" proportion. Exaggerated proportion emphasizes some aspect of the figure by making it either larger or smaller. Some artists prefer ideal proportion, others lean toward the natural, while still others favor the exaggerated.

No approach, in itself, is better or worse than the other. No rule can firmly establish the rightness or wrongness of the proportion we use. These are matters of personal preference. The effectiveness of a given sculpture is not determined by its system of proportion, but what is done within that system. In this book, all subsequent examples are based on natural proportion, but this may of course, be modified in the work, whenever so desired.

ANATOMY

Anyone who works with the figure invariably becomes involved with problems of anatomy. The beginning sculptor wonders how deeply he needs to explore the subject; how much he should learn about it.

Anatomy is factual information about the body's structure. It can be a subject of infinite complexity. Even today, specialized branches of science and medicine have not answered all the questions about the body and how it functions. Many mysteries still remain. We should not, however, be unduly intimidated by the seemingly staggering mass of facts that anatomical study offers. While the surgeon, in order to function, needs exact and detailed knowledge of anatomy, the sculptor operates primarily on his feeling for gesture, form, and space. Anatomical information can enrich our vision, aid and inform our observing eye, but has no further function for us.

Although useful, anatomical study in itself is not a prerequisite for sculpture. The classic sculptors of Greece did not study anatomy. And the nineteenth century conviction that this subject must occupy the first and foremost place in a sculptor's education no longer seems to apply. As sculptors, we need be concerned with only some anatomical knowledge: we should have a basic understanding of the body's mechanical structure; of its bones and superficial muscles. A study of these will help us comprehend and perceive the figure more fully. It will also prove useful when we come to do specific details.

For this reason, it would be helpful to acquire a book or two on anatomy. We can turn to it, as we would to a dictionary, using it as a source of specific information. When we have a problem in doing a figure, we can

then refer to our anatomy book. Getting information this way, when we need it most, will make a stronger impression and the lesson will probably stick. Particularly after we've done a few figures and encountered various structural problems in the process, we'll find that browsing through anatomy books is beneficial. Later, should we wish to get more deeply involved, we can always study anatomy more systematically.

Even without consulting a single book, we already know a great deal about anatomy. (Most people know more about the human figure than they realize.) We know the figure has a head, a body, two arms, and two legs. This is anatomical information. Let's just think about the head. We know the face well. Stored up in our individual memories are all sorts of ideas and images of many faces. Think about it for a moment, beginning with the forehead, then the eyebrows, lids, lashes, nose, nostrils, mouth, lips, teeth, chin, then down under to the Adam's apple and neck. What mental images this simple list evokes. Yet none of these anatomical features is new or strange to us.

Consider the arm as another example. In our lifetime, we have already stored up many images and ideas here too. We already know the arm has two major divisions: from the shoulder to the elbow, from the elbow to the fingertips. Let's look at the second division alone: below the elbow is the forearm, wrist, hand, and finally the fingers and fingernails. There are many other subdivisions. We have always been aware of them. If we begin to concentrate, we'll find ourselves understanding these both as individual forms and as elements within a harmonious whole.

We can spend a lifetime studying the figure in its many aspects, with its infinity of surface features and subtle forms. The landmarks become a little more familiar with each figure we do. But we can never know everything. As artists, we continue to build on our knowledge. We always try to deepen our understanding of the figure: we go to museums, look at books and at life itself. We're always reaching for new insights. And we find that the more we learn to look at the figure, the more we begin to see.

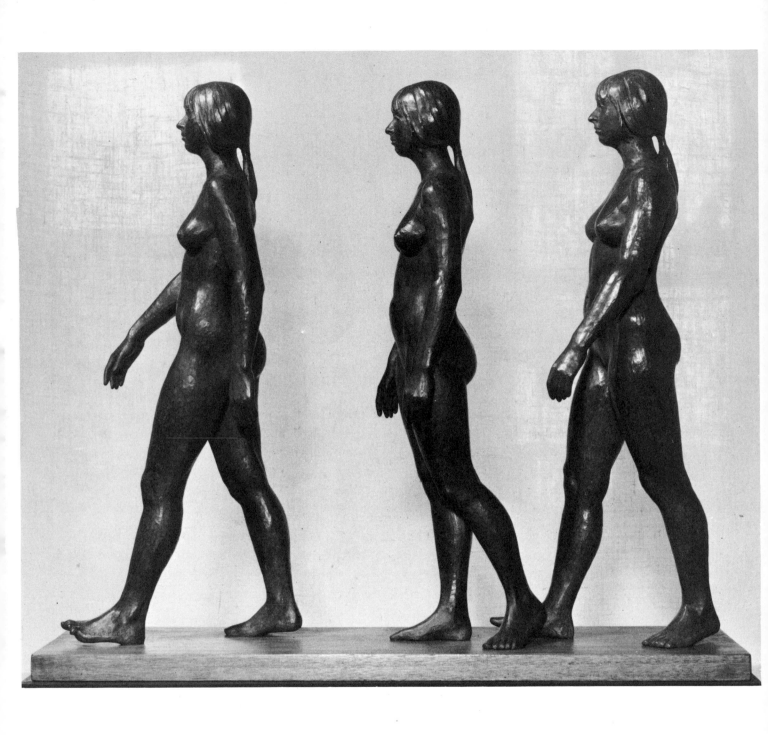

Mary: Walking Sequence. *30⅝″ high; bronze edition of four; Richard McDermott Miller. Collection of Edward H. Bennett Jr., Lake Forest, Illinois.*

3 Working With Wax

The first material we'll explore is wax. This material has many desirable qualities for the sculptor. It is strong, cohesive, and lightweight. It can be carved, cast into molds, and modeled. It produces no dust, is relatively clean to work with; and doesn't shrink or dry out, so it can be kept indefinitely as a finished sculpture. It can also be transposed directly into metal sculpture by the "lost wax" method of casting.

THE NATURE OF WAX

"Wax" applies to a great number of materials which differ in origins and characteristics and vary considerably with climate and locality. Industry defines wax loosely as an "unctuous" or oily solid which will melt readily, and which has—in varying degrees—the properties of plasticity, gloss, and slipperiness.

Waxes have been classified as natural, modified, and compounded. Natural waxes may be vegetable, animal, or mineral in origin. Modified waxes are natural waxes, treated chemically to alter their properties. Compound waxes are physical mixtures of various waxes, or waxes with resins.

The most commonly-used wax for sculpture today is a natural wax of mineral origin. It's derived from petroleum, formed by the decomposition of organic substances over vast geologic periods of time. Originally, petroleum waxes were developed as by-products of the oil-refining process. (Lubricating oils had to be de-waxed to keep them fluid at low temperatures and to prevent them from solidifying.) Today, extracted petroleum waxes have become important in their own right and are manufactured in greater quantity than all other waxes—from all other sources—combined.

There are two general types of petroleum wax: paraffin and microcrystalline. These differ both in their basic crystal characteristics and in how they are separated from the crude petroleum product. Paraffin, the familiar white kitchen wax, is highly refined. Microcrystalline wax is less so. Generally speaking, microcrystalline wax has a higher tensile strength and a higher melting point than paraffin. It is also tougher, more flexible, more adhesive and less slippery, making it more suitable for sculpture.

Microcrystalline wax, which comes in convenient ready-to-use blocks, is inexpensive and widely available. These blocks are about 19″ long, 11¾″

wide, and 1½" thick. Each weighs about eleven pounds. Many varieties of microcrystalline wax are manufactured, but all are not equally suitable for sculpture. (A great range of difference exists in their physical properties.) When ordering microcrystalline wax directly from the refinery, it's important to always specify the right grade for sculpture modeling. (See Buying Wax, page 153.) When selecting such wax at an art supply shop, holding a bit between the thumb and fingers, and pinching it, will provide some idea of its inherent plasticity.

Although such petroleum waxes are commonplace today, animal- or vegetable-derived waxes were once the chief source of natural wax for sculpture. Stearine, a white crystalline wax, came from the more solid animal and vegetable fats. Beeswax and Chinese wax were produced by insects; while vegetable waxes came from the palm, the carnauba, and the bayberry.

Modifying Waxes

Some waxes in their "natural" state are suitable for modeling; others must undergo special chemical modifications first, either by the manufacturer or by the sculptor himself. Sculptors of the past used various materials for modifying and blending animal and vegetable waxes. Though modern chemistry has superseded their earlier technology, many of the basic ideas and recipes developed centuries ago are still of practical use to present-day sculptors. These are the methods sculptors use to modify waxes:

To soften wax: add oily materials, such as cocoa butter, Venice turpentine, or petroleum jelly (vaseline).

To harden wax: add resins or a harder variety of wax.

To color wax: add oil-soluble dyes or small amounts of dry pigment.

To add body to wax: add quantities of pigment, such as fine clay or whiting. (This is for permanent wax sculpture only, not for the "lost wax" process, which will be described later.)

For special conditions and uses, many variations on these basic blending principles have been developed. Recipes, going back to the earliest books on art techniques, have sometimes been repeated in later books with little or no change. Here are two variations that appeared more than three hundred years apart:

Modeling Wax No. 1*

Fine white beeswax, 1 pound

Venice turpentine, 3 to 4 oz.

Flake white, 2 oz.

* Giorgio Vasari (1511–1571), author of "Lives of the Artists" and treatises on techniques.

Grind the color with Venice turpentine and add to melted wax. Thoroughly mix while heating. *Note:* Add a bit of vermilion to the flake white for flesh color.

<div align="center">

MODELING WAX NO. 2**

Common beeswax, 1 pound

Rosin, 4 oz.

Lard, 2 oz.

Spirits of turpentine, 1 oz.

</div>

Put all together in a vessel with a little water, boil and skim it. Yellow ocher, light red, or any dry color may be added. More or less lard must be used according to the season.

Note: When blending or melting waxes, we must never allow them to overheat. Since wax heated directly over a flame might catch fire, it's best to use a double boiler. Should a fire occur, it can be smothered with a lid or extinguished with several handfuls of baking soda. *Water should never be thrown on burning wax.* Water, being heavier, will sink beneath the molten wax, turn to steam and cause explosive eruptions.

The microcrystalline waxes can be treated like other natural waxes, but are special in a number of ways. They have many advantages for blending purposes, being compatible in all proportions with other mineral waxes, resins, and most vegetable waxes. Also, ordinary lubricating oil can be added to most microcrystallines to increase their plasticity for modeling purposes. The harder the wax, the more oil is required. *Note:* By contrast, oil added to paraffin does not increase its plasticity. Instead, it causes it to crumble easily. Paraffin does have its uses, however. Small amounts added to melted microcrystalline wax will lower its melting point and viscosity, making it flow better when poured into molds for casting purposes.

THE USE OF TEMPERATURE

Whether we buy wax ready-made or blend our own, it must meet certain basic requirements as a medium for modeling. It must have plasticity—be malleable, pliant, and receptive to being shaped. It must be cohesive, so as to bond easily to itself without being sticky. But we must also keep in mind that these properties, and others, are variable in relation to the temperature of the wax. Heat will soften wax, while cold hardens it. (We will take advantage of this phenomenon as we work and modify the wax further by altering its temperature.) But no matter how often we harden or soften the wax, its original stability will return with normal room temperatures. We want the finished piece to be strong enough so it doesn't sag, and firm enough so it won't easily be damaged by handling. Therefore,

** From "Handbook of Modeling and Sculpture" by F. Rondel, published by F. W. Christern, New York, 1868.

in buying wax, we should select one with our own climate—and local summer temperatures—in mind.

Note: The physical changes the sculptor effects on the wax during modeling—by the application of heat—should not be confused with the chemical changes discussed earlier. The chemical modifications must be made *before* the modeling process begins, while the use of heat is part of the modeling process itself. Applying heat or cold to wax can create these diverse conditions:

Hot wax is liquid and may be poured or applied with a brush.

Very warm wax is slushy and may be spread like butter.

Warm wax has plasticity, and is easily modeled.

Room-temperature wax is tough, light, and strong.

Chilled wax, being stronger and more rigid, can be carved or engraved.

Frozen wax can be broken, filed, and sandpapered.

In making sculpture, we are free to soften wax with heat or to harden it with cold as often as we need to. We can revise, correct, even remelt the wax at will. Since it is infinitely changeable and revisable, we can at any time carry a wax sketch—with additional work—to a more polished and detailed stage of development.

TOOLS FOR WORKING WITH WAX

In working with wax, we need tools for cutting and modeling, and devices for heating and cooling it.

Tools for Cutting and Modeling Wax

For scoring and carving wax, an ordinary kitchen knife (either for paring or boning) is invaluable. It's also helpful for cleaning modeling tools.

For cutting wax blocks into smaller, more convenient pieces, a rocker knife is helpful. (It causes less friction and so can cut into the block more quickly and deeply than an ordinary knife.) Still another useful technique is pulling a thin wire through the block of wax.

For modeling wax, steel tools, such as dental tools, clay modeling, or plaster tools are recommended. A particularly versatile plaster tool is rounded at one end with a skew angle at the other. The angled end is used to cut off wax and carry it away. The rounded end works well in hollows and concave areas. It can also carry soft wax to the work and be used to press it into place.

Tools and Devices for Heating Wax

To soften wax, we set a reflector and light bulb over an ordinary five-gallon tin can. (Making such a reflector light is described on page 155.) The tin can may be of the type used to pack eggs, lard, or modeling clay, but any metal can or bucket will work as well.

After we have put the chunks of wax in the can, the heat of the light bulb will soon soften them. As studio or climatic conditions require, we can establish different levels of heat merely by changing the light bulb. An ordinary 100-watt bulb will normally warm the wax as fast as needed to do a small figure. Should we need more heat, a 150-watt bulb can do the job. Should the wax get too hot and slushy, we can use a 60 or even a 25-watt light bulb.

Note: In softening wax, hot water can substitute for the reflector light. Here we immerse the wax chunks directly in the warm water. Although this method effectively softens the wax, it does create problems later. When a hot tool is used on the surface, the contact produces a sputtering or sizzling effect because the wax still contains numerous droplets of water.

In order to have localized control of surface forms in modeling the wax, we can heat and fuse its surface directly with an electric tool.·This wax-fusing tool, either a low-wattage soldering iron or wood-burning tool, will provide a good, steady, and not-too-hot temperature. (For details on acquiring such tools, see page 156.) Steel plaster or dental tools, heated in the flame of either a gas burner or a simple alcohol lamp, can substitute but tend to become either too hot or too cool and must be constantly adjusted.

To soften the edges of wax or to fuse broad areas of its surface without making tool marks, we use a small torch—its cotton wick soaked in alcohol. (This is described on page 158.)

Devices for Cooling Wax

For cooling wax, we can use ice water or cold tap water. But here again, entrapped water droplets will cause considerable sputtering if the surface is worked later with a hot tool. Actually a refrigerator will cool the wax faster and better. It can be used either to chill the wax (usually 15 to 20 minutes is sufficient) or to freeze it. An ordinary household refrigerator thus becomes one of the most valuable pieces of equipment we have for working with wax.

4 Sketching a Small Figure in Wax

To really understand the properties of wax, we will model an actual figure in this material. We will use a block of microcrystalline wax as it comes from the refinery, and develop our figure from it. We will permit accidentally—created pieces of wax to suggest various parts of the figure. We will begin with a vague approximation of what we want to do—rather than a preconceived idea—and let the work evolve by a process of modification and improvement.

Our first demonstration will show the development of such a figure in an abbreviated or speeded-up way in order to provide a quick overview of its development. This will be followed by a second, more detailed demonstration, shown step-by-step.

1. We begin by twisting off a good-sized piece from a softened block of wax.

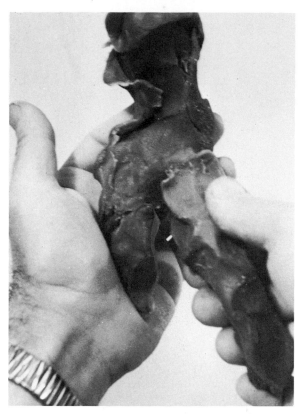

2. It suggests a torso: one hip thrust out, the waist and chest above, an indication of a leg below.

3. We develop the idea by attaching a crude piece of wax to make the second leg.

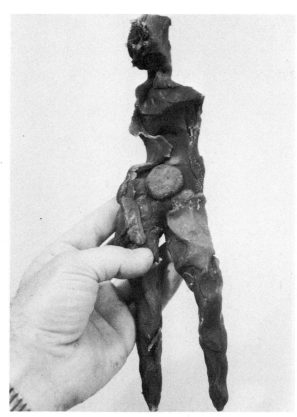

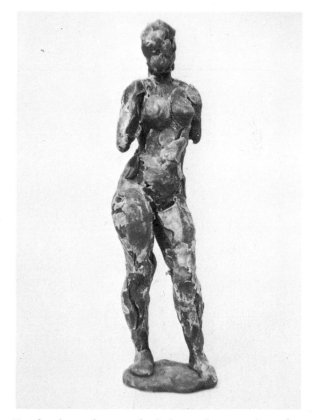

4. We carry the first leg further; then add the head; and clarify the torso with a rounded pellet to indicate the abdomen. Now the figure has a vague gesture with the weight on the right leg.

5. The figure has reached the mid-stage of its development. The base on which it stands has also been added.

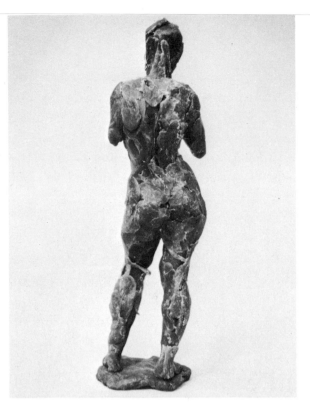

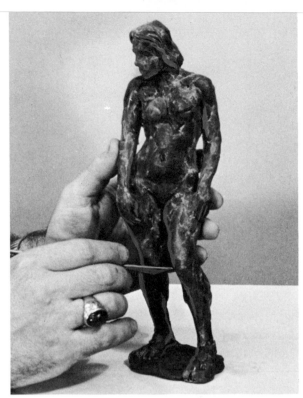

6. At this stage, the back as well as the front has been developed.

7. As the figure nears completion, we use incised lines to emphasize such details as the hair, the fold of the legs, etc.

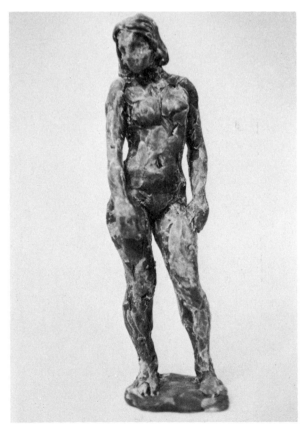

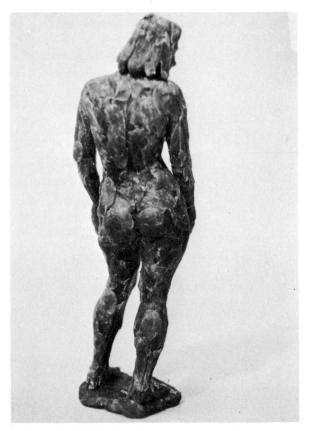

8. The wax sketch is now complete. We have suggested both gesture and proportion with a minimum of detail.

9. We've also suggested greater detail in the torso, arms, legs, head than was actually rendered.

THE APPROACH TO THE FIGURE

In our speeded-up demonstration just completed, we first made the idea (or the schematic figure) tangible with a piece of wax. Then we worked to capture and state the gesture, to adjust the proportions and finally to clarify the forms. No attempt was made to "perfect" any one aspect of the figure. Rather, the process was one of continuous modification and improvement of all aspects as the work moved along.

As we worked, we asked: What does the figure have? What does the figure need? We made various adjustments of proportion or form, as we saw the need for them. The effort to produce a piece of sculpture made us conscious of the gaps in our information. It told us to look for answers, to look at ourselves, to look around us.

This general approach will apply to every figure we model, whether we sketch it quickly or develop it further to a more finished piece. Let us proceed now more slowly to sketch another figure in wax. We will again begin with a block of microcrystalline wax and take it more gradually to its completion, step-by-step.

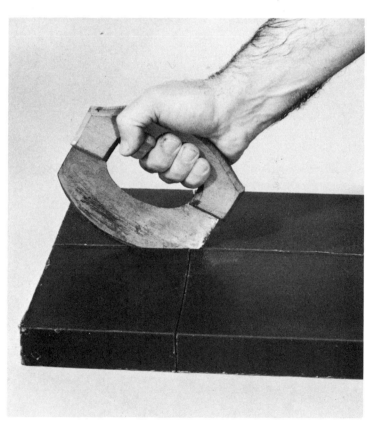

10. The block of wax is being cut into smaller pieces for convenient use. We score deep lines with an ordinary kitchen knife, repeatedly drawing it over the wax before we attempt to break the block. We do this on both sides of the block making these lines at least ½″ deep.

11. A quicker and easier method of cutting the wax is to use a rocker knife. We rock the blade back and forth to deepen the cut so the wax will break easily into pieces. (Regardless of the knife used, we scrape off any wax that adheres to the blade to prevent friction.)

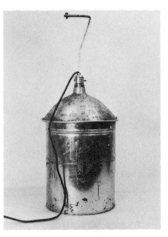

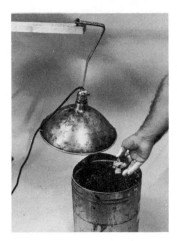

12. The wax chunks are placed inside the large tin can. We plug in the reflector light and place it over the can to heat and soften the wax. (With a 100–watt bulb, this will take about 20 minutes.)

13. When the wax is ready to use, we momentarily set the reflector light aside or hang it by its handle.

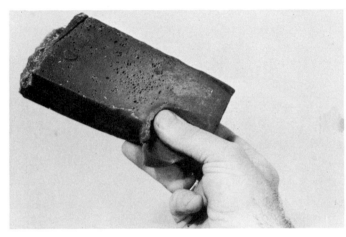

14. Our small piece of wax, looking like a chocolate bar, is at room temperature. The larger block has been warmed sufficiently to be pliable and easy-to-handle. Note the difference in color between the two. (Dark waxes become lighter when warmed, but darken again when cool.)

15. Our wax is quite soft. We can easily press our thumbs into it.

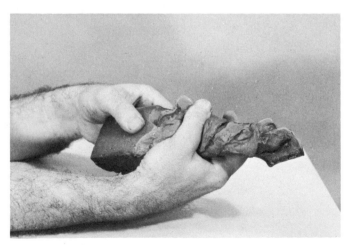

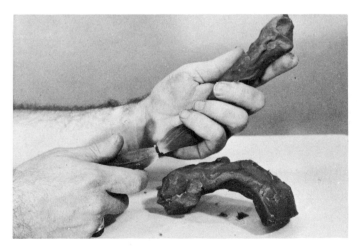

16. With a twisting motion, we elongate the wax, giving it a new shape. It begins to suggest a torso, its back arching forward.

17. We set aside this bent "torso" for a moment. We twist, stretch and elongate a second piece. It will be used for the legs.

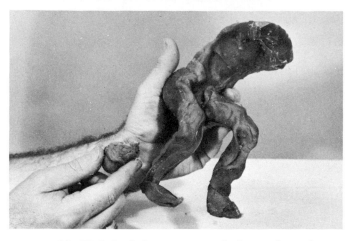

18. With both legs now attached, our figure begins to emerge. All our wax at this point is soft and easy to manipulate. The lump of wax, held in the right hand, will soon become the head and neck.

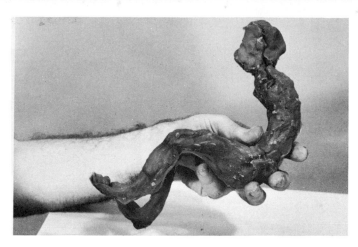

19. The head helps us establish the full length of the figure and makes the arch of the back clear. There is already a feeling of gesture. Without any detail whatever, we know the figure is crouching.

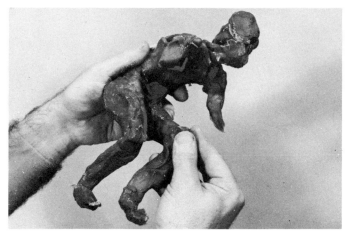

20. We strengthen the gesture by beginning the arms. These are developed only to the elbow. (For the time being, we omit the forearms because they will interfere with our work on the legs.) A pellet of wax, put on the leg, establishes the "point" of the knee.

21. We develop the head further, using smaller pieces of wax. After stating the major parts of the figure—with gesture and approximate proportions both suggested—we chill the piece in the refrigerator for 10 or 15 minutes. This will make the wax strong and firm.

22. After cooling, we're ready to look at the figure more critically. Now we can begin to shape it by cutting away any wax that seems excessive to us.

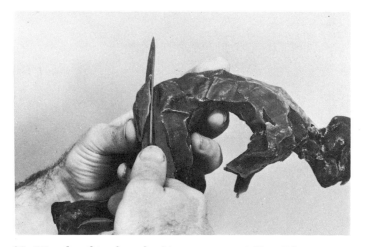

23. We do this first hacking-away quickly. It's better at this point to cut off too much, rather than too little.

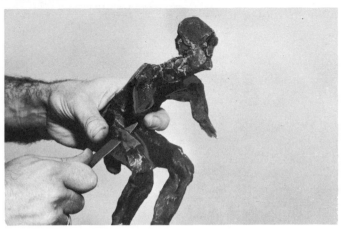

24. The first cutting involves the entire figure, removes excess wax from all parts of it. This produces flat facets which start to describe the final forms. The surface begins to develop.

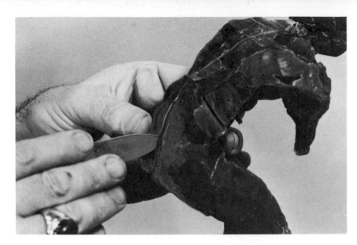

25. We can now inscribe some surface lines as visual guides to help with our modeling. Here we use the tip of the kitchen knife to indicate the median line of the spine.

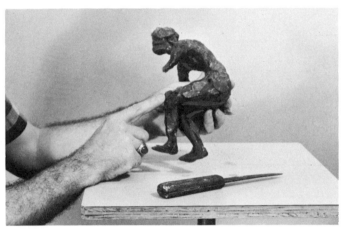

26. Now we begin again to build up, modify, and improve the form. We get soft, pliable wax from the warming can and add it in small pieces to the cut surface of the cold wax. (A number of such pellets have already been added.) Here, we press a small piece into place to show the "exact" location of the kneecap.

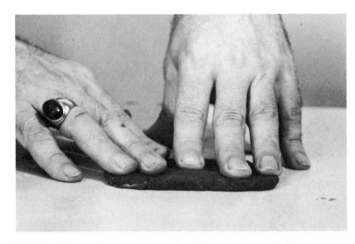

27. At this point, we want the figure to stand by itself and so set it aside briefly to create a base for it. Here, we flatten a chunk of wax, pressing it firmly against the flat surface of the table. (Before attaching the figure to the base, we must first separate it from the table.)

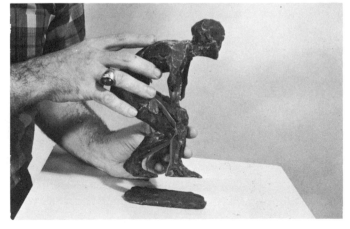

28. Note how we hold the figure firmly in order to preserve its gesture, while attaching it to the base with either pressure or the wax-fusing tool.

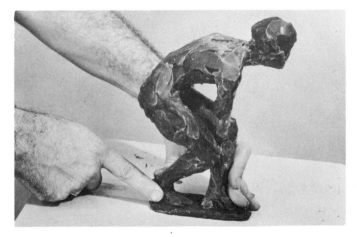

29. Since this activity may have softened the weight-bearing ankles and legs somewhat, we re-chill the figure briefly to firm them up again.

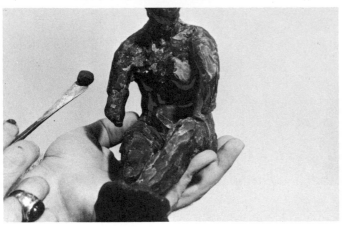

30. As our figure develops, it becomes difficult for the fingers to reach certain areas. Here a steel tool is used for this purpose.

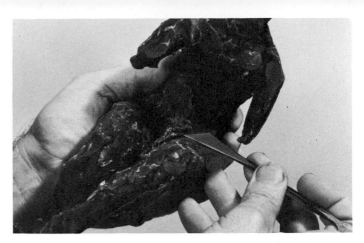

31. Our tool presses the wax onto the upper thigh, then begins to shape it.

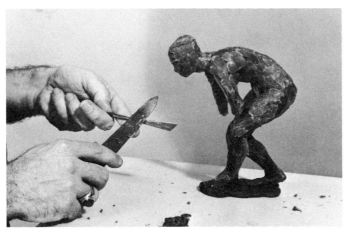

32. By now our figure has advanced nicely: the gesture is clear; the secondary forms of the torso, legs, head, and neck are established. (With the kitchen knife we scrape away accumulations of wax from the steel tool. We do this whenever necessary, because the work goes better with clean tools.)

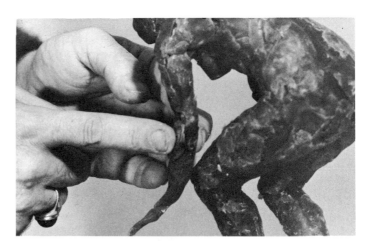

33. With the legs sufficiently developed, we can now add the forearms. The arms must go through the same steps as the figure itself did: they're added first as rough pieces of soft wax, then chilled, cut away, and built up.

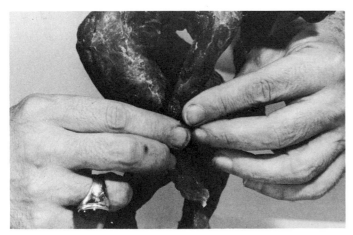

34. Here we use firm pressure to join the soft wax at the elbow. We will then chill the piece briefly again to harden the wax.

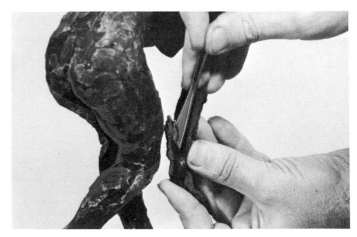

35. After chilling, the wax is resistant enough to be carved. Now we can use the small steel tool to remove the excess wax and shape the forearm.

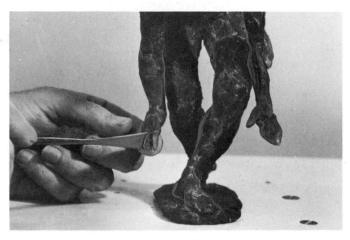

36. We use the same tool to roughly indicate the fingers. Note that the thumb has already been added as a separate pellet.

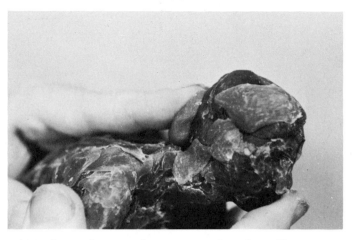

37. As the work proceeds, we can work with smaller units, adding and subtracting smaller and smaller pieces of wax. Now we can add other small forms. The soft wax pellet, pressed firmly against the head, begins to indicate the hair.

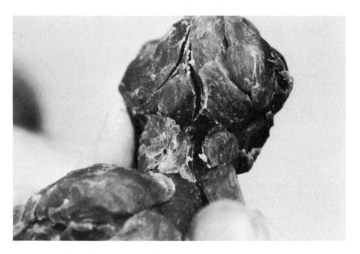

38. Certain details are now emphasized with surface lines. We use the steel tool to make an incision indicating the hairline. (The head is seen here in profile looking to the upper left.)

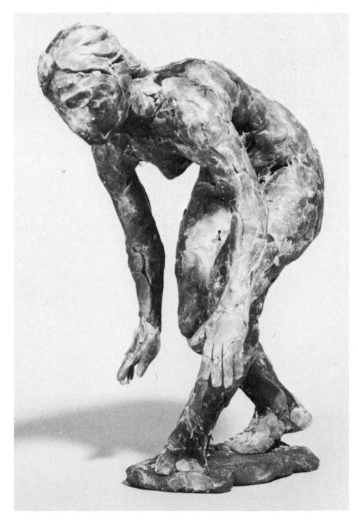

39. Although not developed in great detail, our figure convincingly suggests the natural form of the human body.

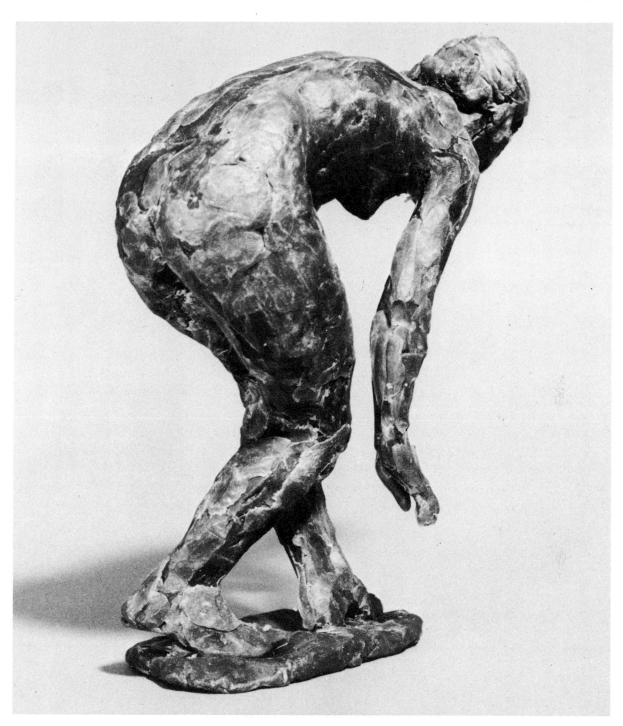

40. In this view, as in the others, the gesture and form are clearly evident.

To summarize: Although many steps have been shown in this demonstration, only four basic steps were involved: (1) making the work tangible; (2) stating the gesture; (3) adjusting the proportions; and (4) clarifying the forms. To implement these basic steps, we have four separate and distinct processes: (1) shaping the wax roughly; (2) chilling it; (3) cutting it away; and (4) building it up with soft wax pellets.

58 FIGURE SCULPTURE IN WAX AND PLASTER

5 Modeling on a Wax Armature

An armature, in sculpture, is an internal frame designed to support the work in process. As we have just seen in the last chapter, a wax figure can be made without any armature, because the wax is strong enough to support itself. Nevertheless a wax armature can be used to advantage.

THE ADVANTAGES OF A WAX ARMATURE

Armatures, used with clay, are generally made of aluminum or lead wire. These can also be used with wax. More preferable, however, is an armature made of the same material, of the wax itself. This has a number of distinct assets. It can provide a kind of instant stick figure which is easily bent into any gesture. (It then needs only to be fleshed out with additional wax.)

Still another advantage is that a figure made on a wax armature is all wax. It can be quickly revised by shortening or lengthening certain parts. If, for example, we wish to change the proportions of the arm by altering the length of the forearm, we can cut it apart between the elbow and wrist, then add or remove wax as needed. To shorten the forearm, we would cut away some wax; to lengthen it, we would add soft wax in the middle. In either case, the parts are easily rejoined without disturbing the modeling of the hand or elbow in any way. A metal armature inside the work would make such changes more difficult for us and might involve remodeling either the hand or the elbow. The absence of a metal armature is also an advantage should you wish to use the "lost wax" casting process: an all-wax figure can be melted out of the mold entirely, while one with a metal armature obviously cannot.

We can make wax armatures in two ways: by rolling out sticks of softened wax and joining them together, or by precasting the complete armature in a mold. The latter process (described on page 118) can be used in making a number of armatures quickly. Thus if a number of figures are to be made as a group, the cast-wax armature will establish a uniform size and scale for every figure. A number of these armatures can also be bent into a kind of three-dimensional diagram of the group. They can then be kept intact as the "diagram," while fresh armatures are used for actually modeling the finished figures.

The following demonstration shows the step-by-step use of the wax armature. A pre-cast armature (as described on page 120) was used here.

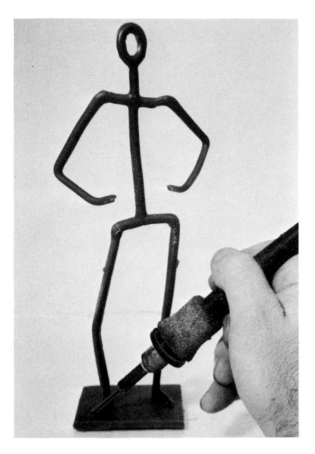

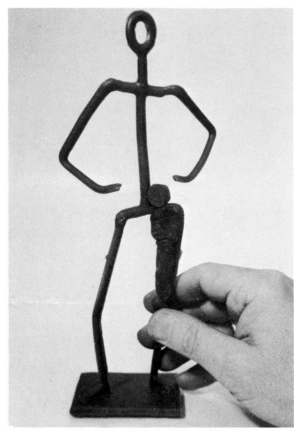

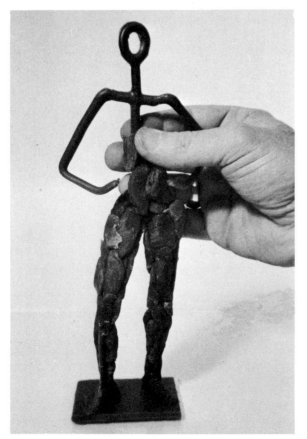

1. (above left) We attach the armature to its wax base. The wax-fusing tool melts the feet, fusing them onto the base. Then we put the piece in the refrigerator to be thoroughly chilled.

2. (above right) We do the legs first since they will support the weight of the body. Here the left leg is built up with pellets of soft wax, in various sizes.

3. (left) Now we build up the right leg. Since the legs will support the body, they must be strong and firm. Should they become weak as we add the warm wax, we must chill the piece again.

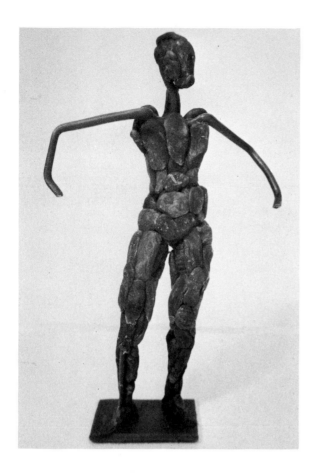

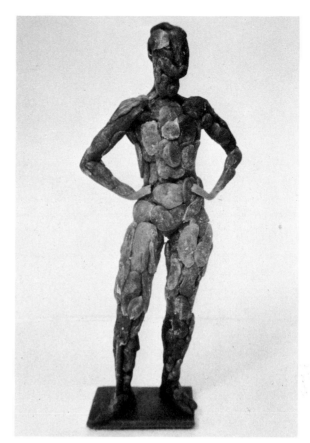

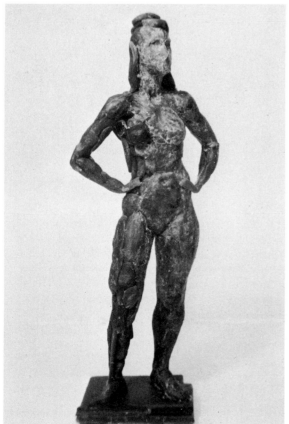

4. (above left) We temporarily move the arms aside to make working on the torso easier. Here we build up the upper part of the torso and head with soft, rough wax pellets.

5. (above right) We have now filled out the main volumes of the figure; the gesture and proportion are well-established. Little detail has been developed at this point, because the soft wax doesn't lend itself to this.

6. (left) Once the highspots of the pellets have been cut away and the spaces between them filled in, we can begin to develop our surfaces.

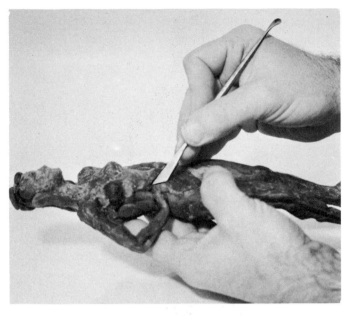

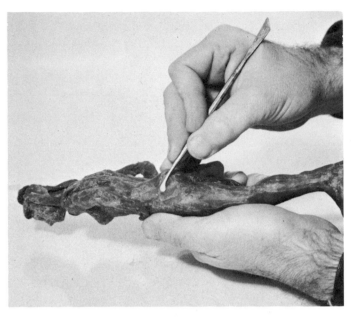

7. We use the same steel tool for cutting and filling in. Its skew-angled end—designed for convex forms—does most of the work since most of the forms are convex.

8. We use the rounded end of the tool to reach the concave areas. It does both the cutting and filling in here.

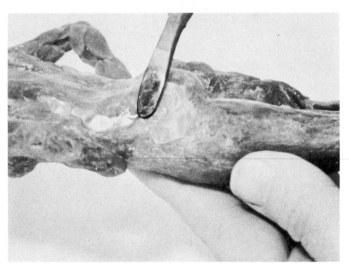

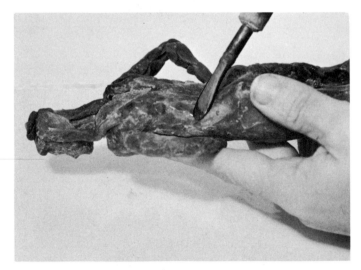

9. We use the wax-fusing tool to liquefy the wax surface. (The tool's heated tip turns the small spot it touches into liquid wax. When it is removed, the wax solidifies again almost instantly.)

10. Because of gravity, the wax in its liquid state will run off the figure. To prevent this, we use the left hand to tilt the figure and direct the flow, while the right hand intermittently applies the wax-fusing tool to the surface. Positioning the piece thus becomes an important element in controlling our work. If the surface is softened by this activity, we briefly chill the piece again.

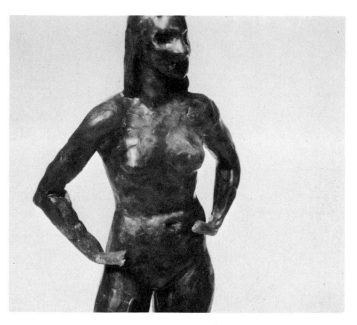

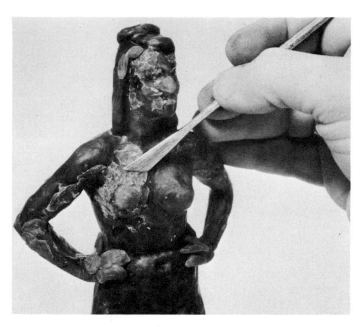

11. This is still an early stage of our work. (The hands have not yet been developed. The liquid-like wax texture does not constitute a finished surface in itself.) The figure will be modified a number of times before we can consider it completed.

12. The steel tool cuts away wherever necessary, this time in smaller amounts. Then we add bits of warm wax, spreading them over those sections of the surface that need building up.

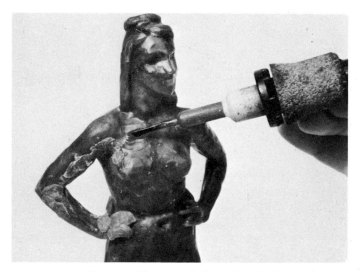

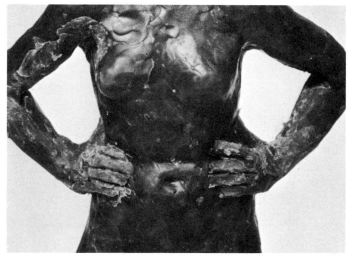

13. The wax-fusing tool then blends these changes together again. No matter how many times we make such changes, we can always use the hot tool to revise the surface.

14. Since the hips have already been developed, we can now turn our attention to the hands. We gradually build these up and blend them in, as we have the rest of the figure, with the wax-fusing tool.

Note: In my own work, after making all the necessary modifications, I prefer to retain the liquid-like texture of the wax as my finished surface. It can however, be carried further to create a smooth, hard finish. This is done by freezing the completed figure, then filing, sandpapering, and scraping the wax to the desired smoothness; and—as a last step—polishing it with a soft, benzine-moistened cloth.

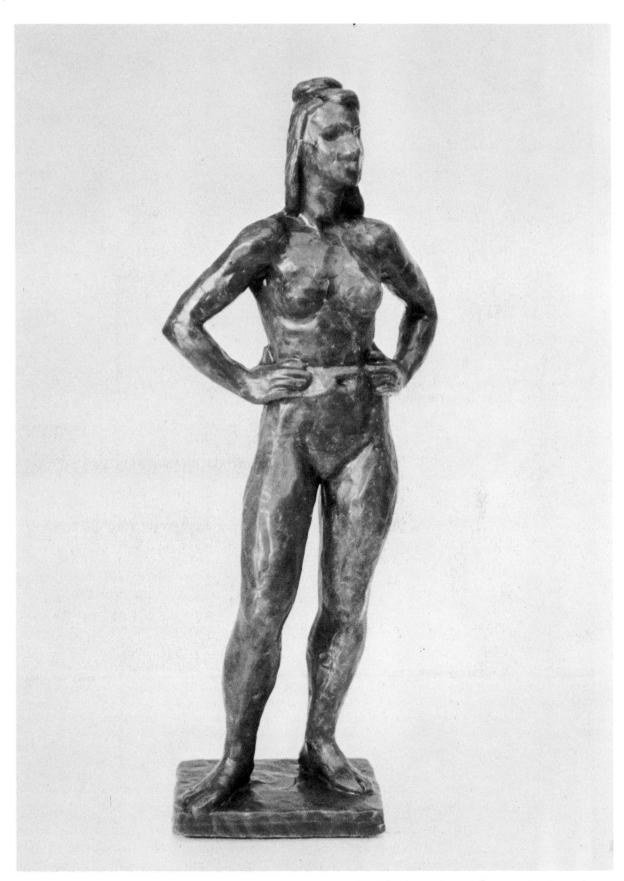

15. The front view of the completed wax figure.

6 Hollow Wax Modeling

Wax can be modeled hollow as well as solid. The most obvious advantage of hollow figures is that they require less wax and therefore less time to produce. Also, a hollow piece is lighter in weight. Such lightness is important because, when melting the surface with the wax-fusing tool, we want to be able to lift and tilt the entire piece, so as to control the gravity flow of the liquid wax.

The following demonstration shows how we use the hollow modeling technique to create a wax torso step-by-step:

1. After warming and softening the wax block, we squeeze it between our fingers to flatten it.

2. It is now of the same general thickness throughout, yet still warm enough to be rather limp.

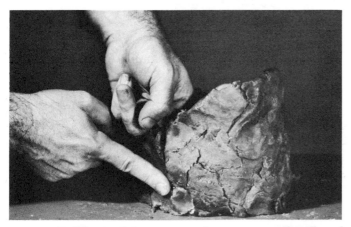

3. We stand the wax on edge, as a curved wall, and now add a similarly flattened piece to create a shape like a low cylinder.

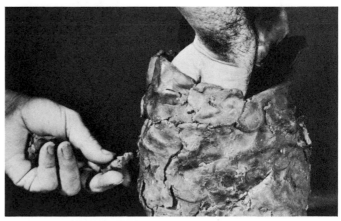

4. We use flattened pellets of wax to build the cylinder higher. We support the work from the inside, while developing the form with the other hand.

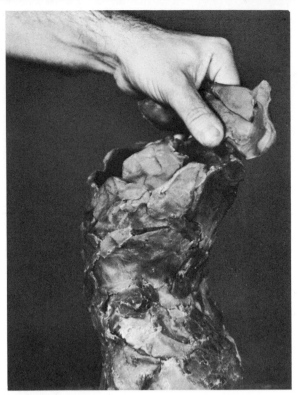

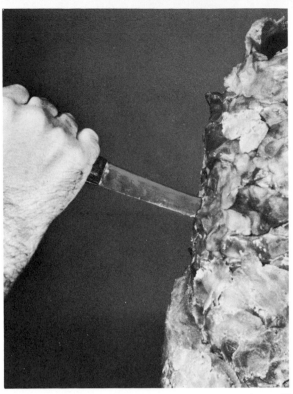

5. The form of the torso, shown in profile, begins to appear. We now put the piece briefly in the refrigerator to chill.

6. We correct the rib cage by cutting into the cold wax. The neck and pelvis have been developed, but the breasts have not yet been added.

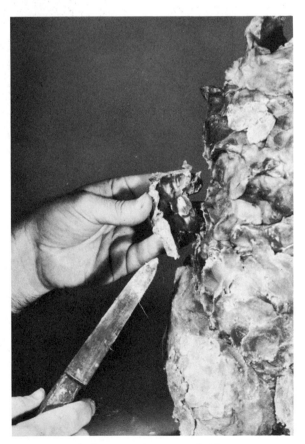

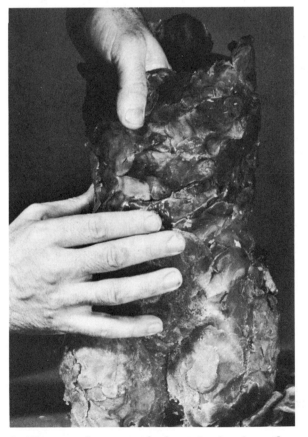

7. To narrow the waist, we completely cut out sections of the wall.

8. We press the gap with the right thumb to close it. Additional pellets of warm wax will be used to seal the surface.

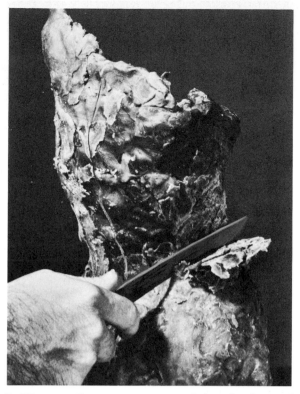

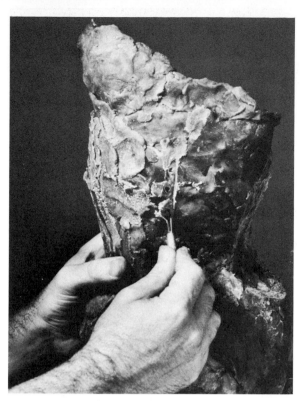

9. We now do more cutting to define the form of the hip. Note the surface line that's been incised to indicate the spine.

10. More wax has been added to the buttocks. We now develop the mid-line of the back.

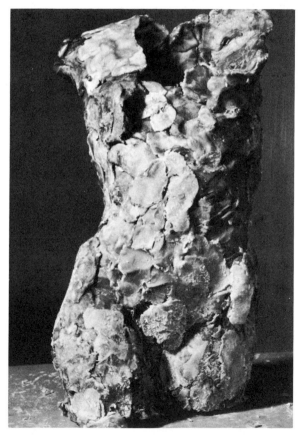

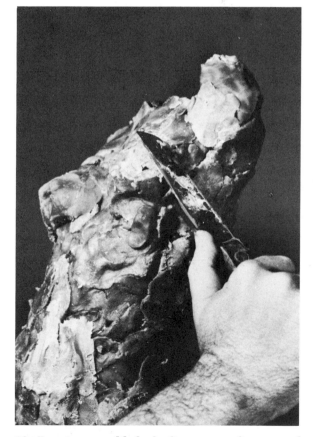

11. The upward stretching gesture of the torso becomes apparent. The weight is clearly placed on the left hip.

12. Breasts are added: built up as soft wax and cut away where necessary after the wax has been chilled.

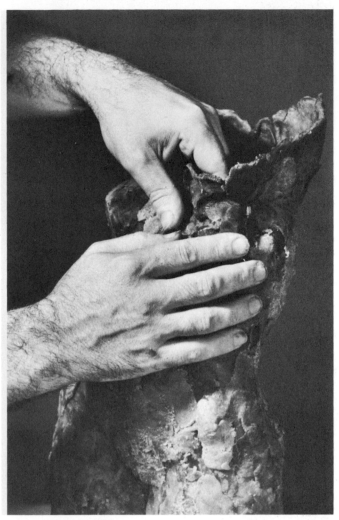

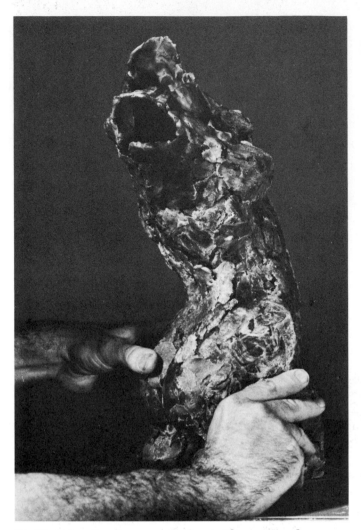

13. We continue building up the torso. Notice how the work on the figure is done both inside and out.

14. The torso has been roughed out. The arms and neck have been located.

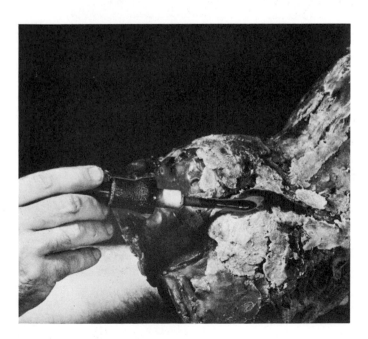

15. (left) We begin to melt the surface with the wax-fusing tool. Notice the liquefaction of the wax on the right buttock.

16. (right) After several hours of work, we have consolidated the entire surface.

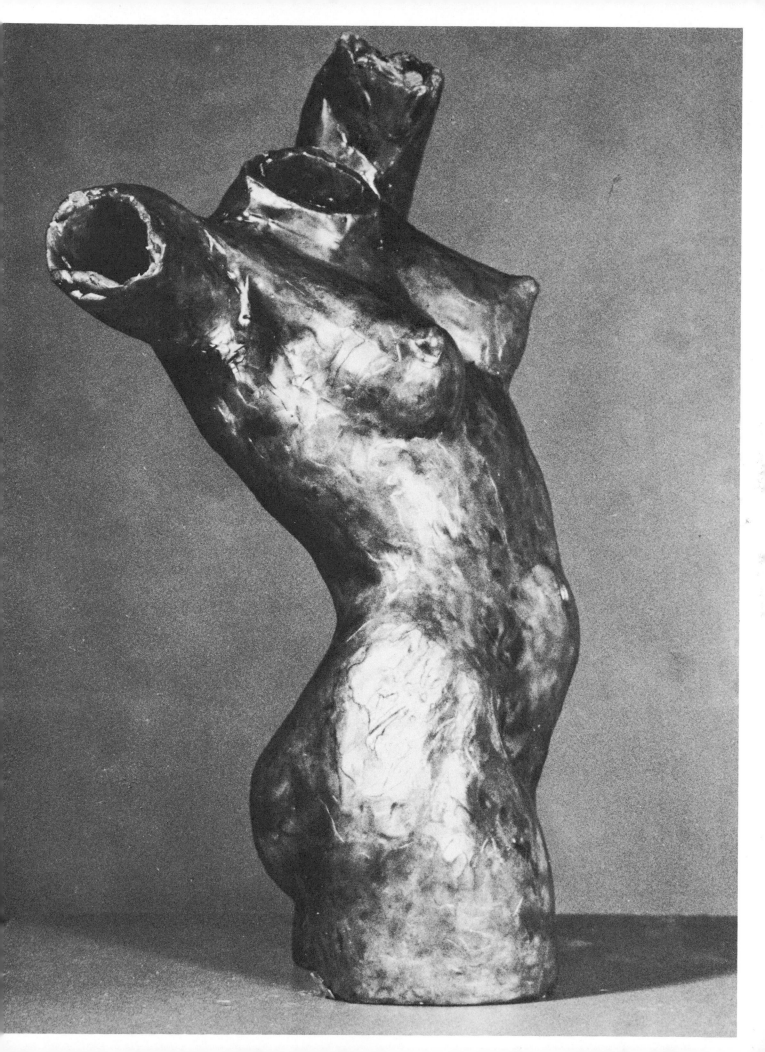

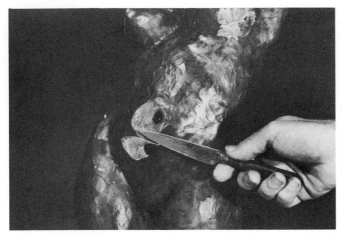

17. Additional corrections need to be made. We chill the wax, then cutting begins again to correct all parts of the figure which may need it. Here the abdomen is being modified.

18. Now we use warm wax to fill out the form wherever necessary. Here we work on the pectoral muscles.

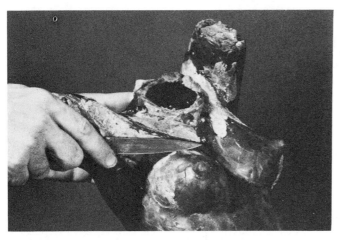

19. Building up the wax is followed frequently by cutting some of it away.

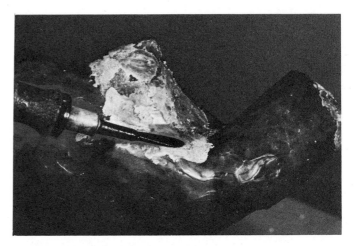

20. The wax-fusing tool easily blends in our changes, making the wax surface consistent again.

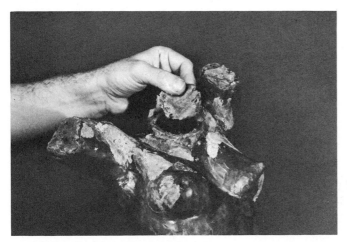

21. We use a large piece of wax to close the opening of the neck.

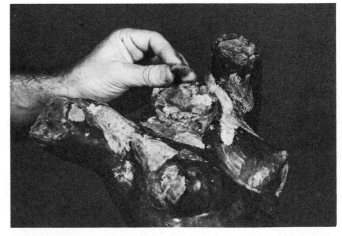

22. We then seal the neck with smaller pellets. The arms have been sealed in the same manner.

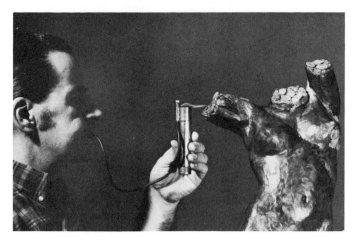

23. Here, to smoothe the surface of the wax without actually touching it, we use an alcohol torch. A pinpoint of flame accomplishes this purpose. (See page 158 for details.)

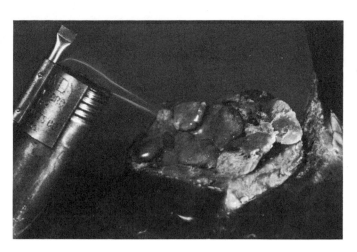

24. We control the flame by blowing air through the rubber tube. In this way, we can precisely pinpoint the heat on our work, fusing the pellets, without obliterating their basic shape.

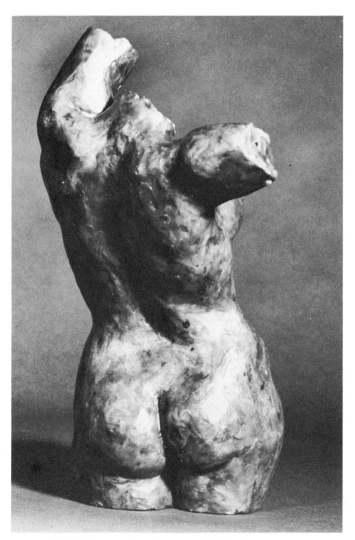

25. The completed torso in hollow wax.

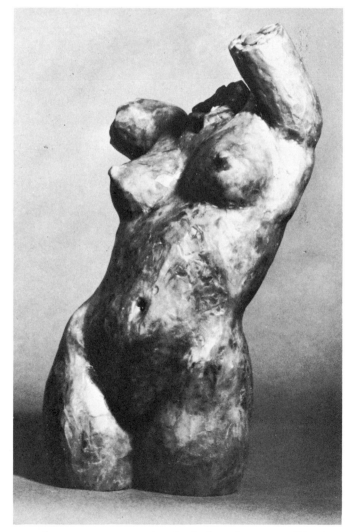

26. The torso now suggests both the rib cage and the pelvis, although neither is developed in detail.

7 Working With Plaster

Plaster, a fundamental material in making sculpture, is fast, inexpensive, and requires no elaborate equipment to use. It's suitable for molds, casts, and armatures; it can be converted into blocks for carving. And it can also be used for direct modeling. This is why sculptors have long relied on plaster and why we ourselves should have a basic understanding of this versatile medium.

THE PROPERTIES OF PLASTER

Plaster is manufactured from gypsum, a rock mineral found in large deposits throughout the world. Its manufacture is not complicated: the gypsum rock is first quarried, then crushed and heated. Next, it's dehydrated to drive off most of its chemically-combined water. Finally, it's ground into a fine powder and packaged for distribution. The unique—and still remarkable—property of plaster is that it can be almost completely reconstituted. When its water is restored, it recombines chemically with the powder. The plaster soon "sets" or returns to a state remarkably like the original gypsum rock from which it came.

Plaster is deceptively easy to use; it seems one can hardly make it *not* work. Even as inexperienced or casual users we are pleased to find, that almost in spite of ourselves, our results will be passable. Passable, that is, in relation to our limited expectations of plaster and, consequently, our limited ambitions for it as a medium.

But a much fuller range of benefits awaits the sculptor who acquires a "feel" for plaster's unique properties and who learns to handle this material with accuracy and understanding. Good results in working with plaster are assured as soon as we have a solid grasp of the few simple fundamentals involved. This chapter is intended to make these fundamentals clear.

Types of Gypsum Plaster

Plaster is known by a variety of names based either on its intended use (such as pottery and dental plaster) or on its brand-name designations. Despite this diversity, there are only two basic types: soft and hard. Soft plaster, such as molding or plaster of Paris—also referred to as common plaster—is the long-established one. Hard plaster—often referred to as gyp-

sum cement—has greater strength and durability. It is manufactured to more exact specifications and is a more recent development—having been introduced commercially in 1930 under the trademark "Hydrocal."*

The difference between hard and soft plaster is essentially a difference in density. Hard plaster has the greater density. This can readily be seen by comparing standard 100-pound bags of hard and soft plasters. Although the weight is exactly the same, the soft plaster requires a bag one-third larger than that of the hard plaster. This is not so much due to chemical differences as it is to difference in the shape of the dry plaster particles. A typical particle of soft plaster is fluffy and irregular, comparable perhaps to a grain of popcorn. A typical hard-plaster particle is smooth and regular, more like a grain of corn which has not been popped. As might be expected, the smoother, more regular grains of the hard plaster fit more closely together. This is the reason for its greater hardness and durability, for the strength of any "set" plaster is always in direct ratio to its density.

Both hard and soft plasters have advantages for the sculptor. Soft plaster is less expensive and easier to handle for direct modeling. It also makes better waste-molds (see page 122). Hard plaster has the advantage of greater strength and durability, and is much better for making casts. A wide range of plasters and gypsum cements is available to the sculptor. A number of the latter, tailored to specific uses, are listed on page 161.

WATER, KEY TO UNDERSTANDING PLASTER

Dry plaster is converted back to its original rock-like condition when combined with water. This setting or hardening of plaster—called hydration—is a process in which a certain amount of water recombines chemically with the plaster to replace the water previously removed in the manufacturing process. To bring about complete hydration, physical stirring or mixing is essential. The mixing itself, however, requires a considerable amount of water, more than can be chemically combined with the plaster. Therefore, in addition to the water that will combine chemically, we must also have sufficient water for mixing. This "mixing water" must reach every particle of plaster: to flush away the layer of air that envelops each dry particle, and to wet the particles sufficiently so they flow together in a fluid mixture, called a "slurry."

Because water is an important factor in the over-all density of the mixture, it directly affects the resulting hardness and strength of the "set" material. This strength, which develops during the setting process, results from the formation of needle-like crystals. As these crystals develop, they interlock to form a solid, rock-like mass. The density and strength of the mass depends on the amount of space between the crystals and the space

* Registered, U.S. Patent Office by United States Gypsum Company.

itself depends on the amount of mixing water used. Thus, an excess of water will rob the plaster of strength: more water will hold the crystals farther apart; while less water permits them to knit more closely together. When this uncombined water eventually evaporates, it leaves open spaces between the crystals. The larger these spaces between the crystals are, the less dense the mass of set plaster and therefore, the less strength it can have.

The use of water, therefore, is the key to understanding plaster. The relationship between water and strength follows this general rule: the less water, the more strength; the more water, the less strength. But this should never mislead one into using too little water. The full strength of plaster can never be achieved without sufficient *mixing* and such mixing is possible only when enough water is present to make a fluid "slurry."

This relationship of water to strength explains the functional differences between soft and hard plasters. More water is required to fill the spaces between the irregular particles of soft plaster, than between the densely-arranged particles of a hard plaster of equal weight. The fluffier soft plaster particles also have a greater surface area per pound to wet down. Therefore, soft plaster is soft because it requires more water to make a slurry; while hard plaster is hard because it needs less water to make a slurry. A typical soft plaster, for example, needs 70 parts of water by weight to 100 parts of plaster. By contrast, a typical hard plaster needs a ratio of 40 to 100. After both plasters have set and fully dried, the compressive strength of the soft will be only 2000 pounds per square inch as compared with 6000 pounds for the hard. This three-to-one difference in strength is due entirely to the differing quantity of open space left between the crystals by the departure—via evaporation—of the mixing water.

The Free Water: For hydration to occur in both hard and soft plasters, the water needed to combine chemically with 100 parts of plaster is less than 20 parts of water by weight. The quantity used, over and above the 20 parts, is mixing water. Its sole function is to make the particles wet enough and slippery enough to be mixable. Once the plaster has been mixed, the mixing water—having fulfilled its function—and being no longer needed or wanted, is referred to as "free" or excess water. It will eventually evaporate after the mixed plaster has hardened or set.

Considering the examples given above of hard and soft plaster, if we subtract from each the 20 parts of water needed for hydration, we see that 50 parts of "free" water remain in the soft plaster, while only 20 parts remain in the hard. As a result, soft plaster after setting will dry more slowly because there is so much more "free" water to evaporate. Conversely, hard plaster will dry much faster because there is less "free" water to evaporate.

In working with plaster, we encounter still another interesting phenomenon in connection with the plaster-water ratio. This concerns the

absorption of "free" water from the mix *before* the setting action has been completed. This happens whenever a fresh mix of liquid plaster comes in contact with any material which can absorb some of its moisture. Such absorption is pronounced, for example, whenever liquid plaster is applied to a mass of already "set" or hardened plaster. The set plaster—depending on how dry it has become—will absorb more or less water from the liquid batch. If this reduces only the excess or "free" water, the crystals in the fresh batch will knit together more closely and densely. The result is: the new batch gets much harder than the one to which it has been added. On the other hand, if too much water is removed too quickly, the crystals can't form properly at all. In that case, the new batch will get less hard than the older one. Because of these differences in density, the phenomenon can be more troublesome than useful: it can cause hard and soft spots and make for a poor bond between adjoining batches. A simple way to reduce this effect (and thus help avoid uneven densities) is to wet the set plaster thoroughly with water *before* adding a fresh batch. And to make the new adjoining batch approximately equal in density, we should mix a greater amount of water with it to compensate for the absorption that will occur.

MIXING PLASTER

Once we understand the nature of plaster, then mixing it properly with water is easy to learn. Mixing each batch of plaster involves only three basic steps: (1) sifting; (2) soaking; and (3) stirring. The only equipment we need is a shallow pan or bowl and a large spoon.

THE STEPS INVOLVED

1. *Sifting*. We begin by putting the water, not the plaster into the pan. (The quantity of water used will determine the size of the batch.) Next, we take handfuls of dry plaster and sift these quickly through our fingers into the water. (This sifting breaks the impact of the dry plaster on the water and prevents lumping.) We sift the plaster evenly into the water and continue sifting until a dotting of small islands rises all over the water's surface in an even pattern. The appearance of these islands rising slightly above the surface, indicates the water is fully-saturated. Such saturation generally means the necessary water-plaster ratio has been achieved and the sifting is now completed. (In the case of some specialized gypsum cements, the plaster and water require actual weighing to get the proper ratio.)

2. *Soaking*. The first step in mixing plaster was an active one, but the second or soaking step is characterized by inaction. Here, we do absolutely nothing at all. At this point, we must not disturb the plaster in any way until the dry parts of the islands have soaked up enough water to be visibly

moist. This, which occurs by capillary action, takes two or three minutes.

3. *Stirring*. This last step calls for stirring the batch of plaster. Now our mixing spoon comes into play; or if a large batch of plaster is involved, we can use our hands directly. This stirring operation performs these essential functions: (a) it forces out the air that envelops the individual dry plaster particles; (b) it makes certain that each plaster particle gets the necessary water to begin the formation of the needle-like crystals; and (c) it gets these particles into a liquid-like suspension so that a uniform density can be established throughout the batch.

We continue the mixing until the plaster has "creamed" or thickened slightly. This takes two or more minutes of active stirring (except with very small batches which require less time). When correctly mixed and properly "creamed," the set strength of plaster can be up to 20 percent greater than that of a similar batch which has not been properly stirred.

LIQUID TO SOLID: THE SETTING AND DRYING OF PLASTER

When we mix plaster and water together, we set into motion a chain of events which can be neither stopped nor reversed. Once begun, the batch moves progressively from a thin liquid to a thickened plastic condition and finally to a "set" or hard, solid state. All these activities, from mixing to setting, take place in little more than half an hour. After the plaster has set, the batch goes into the drying stage and continues to gain in strength as its "free" water evaporates. (In contrast to the relatively short setting period, the drying period takes several days.)

During the setting period, two specific phenomena occur. Both in effect are signposts, indicating exactly how far the plaster has proceeded into the setting stage: one concerns its appearance, the other its temperature. When the surface of the plaster loses its wet, shiny appearance, this indicates that the plaster is solid enough to be cut through cleanly, but still retains enough plasticity for the cut-away material to be worked back onto the mass, if desired.

The second signpost comes at the end of the setting period. It's marked by a noticeable increase in the plaster's temperature, accompanied by a slight swelling or expansion of the mass. When the temperature reaches its full heat (we learn from experience how to judge this), the plaster has set sufficiently and is hard, strong, and cohesive enough to be picked up and handled. (Incidentally, the larger the mass of setting plaster, the greater the amount of heat it will generate.)

When using plaster for modeling, the setting time of a given gypsum product is considered its "working" period. This setting time begins when the batch is mixed and ends when the batch "sets" or becomes solid. During this working period, we can model the plaster freely. Once the batch is set, however, we can no longer model it. We can then change it

only by cutting away material with a knife, chisel, or file, or by building on more fresh plaster.

The drying action, as we have noted, is a continuation of the setting action. During this drying period, the change that occurs is slow and quite difficult to detect, but the plaster continues to gain in hardness and strength. (The dry strength of set plaster is almost double its wet strength.) Left to itself, the plaster will dry of its own accord, within a few days. There is no need to do anything, unless we wish to apply paint or some other finish to the work. (See Finishes for Plaster, page 164.) In that case, we must be certain the plaster is completely dry. If it is not, our finish might flake off.

To speed up the drying process, we can use electric fans and/or heat. Fan-circulated air works faster than heat, but the two in combination are best. If a kiln or oven is used, we must take care not to overheat the plaster. There is little danger of this, however—even in a 500° oven—as long as free water is still present in the plaster. (Its evaporation will keep the plaster from getting too hot.) But once the plaster is completely dry, some of its chemically-combined water may be driven off. If this occurs, the needle-like crystals can break down and cause the plaster itself to crumble.

CONTROLLING THE SETTING TIME

Plasters are manufactured with different setting times or "setting ranges." The setting range of soft plaster is usually 30 to 40 minutes. Hard plasters, on the other hand, designed for greater variety, have ranges varying any-where from a quick 20 to 25 minutes to a slower 75 to 90 minutes. How-ever, we need not keep different plasters with different setting ranges on hand. When modeling directly, it's generally better to use one single type of plaster for the whole piece of sculpture. We can control the pace of our work by regulating the *size* of the individual batches we mix, rather than relying on changes in the setting times of different plasters. Nevertheless, we should know that the setting times of plaster can be modified in various ways. We can change our normal mixing procedures by:

FOR FASTER SETTING	FOR SLOWER SETTING
Using more plaster	Using less plaster
Stirring for a longer period	Stirring for a shorter period
Using warmer water	Using cooler water

To modify the setting time, we can also use additives (plaster dust, common table salt, and liquid animal glue). The dust or salt added to the mix, acts as "seed" crystals to speed up the setting action; while the animal glue slows it down. (As a general rule, salts of any kind speed up the setting time, while organic materials slow it down. This is why we should always use fresh uncontaminated water when mixing plaster.)

For speeding-up purposes, plaster dust is generally recommended. This can be made quickly from any old scrap of hard, dry plaster by grazing it with a coarse rasp so the dust falls directly into the mixing pan. (We add this during the soaking step, just before the batch is stirred.) Depending on how much dust we add, our setting time will range from fast to very fast. Plaster dust is preferable to salt because the latter dissolves and migrates to the surface of the set plaster, as the free water evaporates. This creates an undesirable salt deposit on the finished work. When animal glue is used, we always put it into the water *before* we sift in the plaster. The glue will cause the setting time to range from slow to very slow.

TOOLS FOR MODELING IN PLASTER

For direct modeling in plaster, we need a minimum of equipment to begin: a pan and spoon for mixing; a spatula for building and shaping; a knife; a scraper or old saw blade for cutting and smoothing; and a rasp and chisel for carving. Other more specialized tools can be gradually acquired as needed.

Mixing Pans and Bowls. These should be wide and shallow—like a dishpan—with a large surface area. (This will permit the entrapped air from the plaster particles to escape.) Several sizes are needed to mix batches of various sizes. Polyethylene pans are recommended because they're particularly easy to clean. (When a batch is finished, we leave any remaining plaster in the pan to harden fully; then wet it thoroughly with water. When we flex the polyethylene pan, the leftover plaster expanded now by the water comes out neatly—often in one piece—and the bowl is completely clean.)

Mixing Spoons. Steel spoons are traditional for plaster, but molded plastics have made their inroads here too: they're easier to clean, less expensive to buy. (To clean mixing spoons, we either wash them in the rinse bucket (page 80) immediately after use, or let the plaster set fully. Then, when the plaster has set, we wet it thoroughly and strike the spoon sharply against a hard surface. This breaks the plaster shell, separating it completely from the spoon.)

Spatulas. These and other special plaster tools come in a great variety of sizes and shapes. Although certain tools are useful for specialized purposes, most sculptors have one or two favorites they use most of the time. A good general plaster tool should be about 10″ to 12″ long, have a spatula at one end, a serrated scraper at the other.

Knife. Any heavy knife—whether a butcher's boning knife, a common kitchen knife, or a regular plaster knife—is suitable. Although it needn't be very sharp, it should be quite strong and rigid.

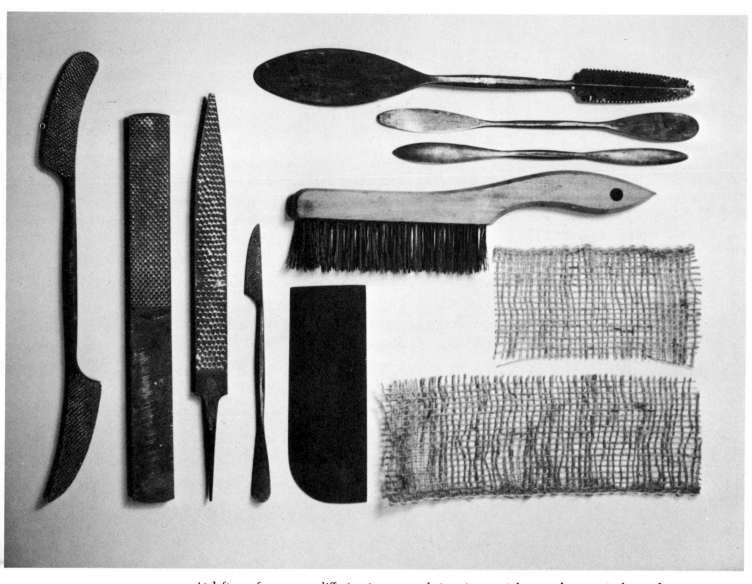

At left are four rasps, differing in type and size. At top right, are three typical spatulas used for plaster. The wire brush in the center is for cleaning the rasps. A cabinet scraper (lower center) with one corner rounded, has been modified with a file. The two strips of open-weave burlap (lower right) are cut in convenient sizes for reinforcing the plaster. (See page 81.)

Scraper. A woodworking tool, called a cabinet scraper, is invaluable for working with plaster. This scraper is essentially a saw-steel rectangle, measuring about 3″ by 6″. We can make our own scraper from an old handsaw by putting the tip-end of the saw blade into a vise and breaking it off about 6″ from that end. Then we straighten and sharpen the edges by filing them perpendicularly square and perfectly flat. (We don't file them to a knife-edge or beveled edge.) We can if we wish, retain the original saw-tooth edge. It's useful for texturing plaster.

Rasps. When working with dry plaster, medium and fine rasps are useful. When working with fully-set, but still-wet plaster, coarse rasps should be used. Those designed for plaster work are thin and have holes punched through them (as vegetable graters do) to minimize clogging. A wire brush is essential for keeping these various rasps clean. Plaster must not be left on rasps because its water content causes severe rusting and rapidly dulls the teeth. *Note:* Plaster should never be left on tools. Even when perfectly dry, it can pull rust-causing moisture right out of the air because of its fundamentally hydroscopic nature.

Chisels. These, available in a variety of sizes and shapes, are excellent for carving plaster. Plaster will cling to chisels, however, causing ruinous rust. To prevent such rusting, we frequently clean and oil the chisels we use for plaster.

Rinse Bucket. This, which is nothing more than a plastic pail filled with water, is essential in protecting our plumbing. Whenever we want to rinse liquid plaster from our hands or tools, using such a bucket will keep the leftover plaster from setting and hardening in the sink and jamming up the drains. When we have finished working, we allow the leftover plaster to set completely in the bucket. Then we remove and discard the solid chunks. Next, we pour down the drain the soft liquefied sediment which remains. In this form, it will not damage the plumbing.

Shellac Bottle. Porous materials such as wood—often used in connection with plaster—need protection from the water of the setting plaster. If wood bases or wood reinforcements were to absorb such water, they would expand, put pressure on the plaster and cause it to crack. We can prevent this by sealing the wood beforehand. A handy means of doing so is by using quick-drying shellac. Shellac can also be used as a sealer on the surfaces of the plaster itself to keep such coatings as wax or paint from being absorbed by the plaster. Therefore it's essential that we have a supply of "cut" or liquid shellac always available.

The most practical way of keeping liquid shellac on hand is illustrated in the photograph at right. The brush, held suspended in the bottle, by the lid, remains soft and ready for use. *Note:* Over a period of time, the shellac will thicken as its alcohol solvent evaporates out. Since thick shellac does

not adhere well to plaster, it should be thinned at intervals with denatured alcohol.

Burlap and Fiber. Using fibrous materials with plaster can add to its strength. When plaster is modeled, such materials often serve as reinforcements under the final surface of the work. (They should not be used however, in those layers that will be filed or carved because they get in the way.) Burlap and fiber can be used interchangeably in most situations. The best burlap to use—and the softest and easiest to handle—is the open-weave variety. The weave permits the plaster to flow through, assuring a good bond between the layers. The best loose fiber is manila long-fiber hemp. Sisal and jute fibers are also suitable. Common packing excelsior, made of wood, although sometimes used for reinforcing, is not recommended because it is coarse in texture and lacking in strength.

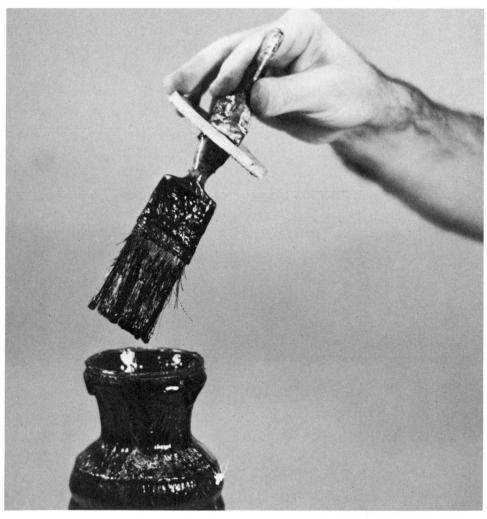

The shellac bottle with its suspended brush. The brush was attached by first cutting an "H" shape into the lid. (If the lid is metal, a hammer and chisel are required; if plastic, a mat knife is sufficient.) The width of the brush handle determines the width of the "H"; the handle's thickness, its height. Once cut, two flaps can then be folded up—parallel to the crossbar of the "H"—and the brush handle inserted in the lid. Finally, cloth tape is wound around the handle to seal it in and complete the process.

8 Getting the Feel of Plaster

Just as a picture may be worth a thousand words, so the direct experience of handling plaster ourselves is worth more than any number of words on the subject.

BUILDING A TOWER

The following demonstration is designed to provide a maximum of experience in a minimum amount of time. Unlike our earlier demonstrations with wax, this is not an exercise in doing plaster sculpture as such. (That is covered in a later chapter.) Instead, this is designed to demonstrate specifically what plaster is all about. Once we've followed the exercise step-by-step, we will develop a lifetime of assurance in working with this splendidly adaptable material.

The entire point of the demonstration is to see just how plaster behaves. Before beginning, the photographs should all be studied and the descriptions read. Then we will mix two sample batches of plaster as described, and handle them for ourselves. Simply by piling spoonfuls of plaster one atop the other, we will be able to observe and *understand* exactly what happens.

In piling up this plaster, we will be overcoming the natural tendency of a liquid, seeking its own level, to flow into a blob-like shape. We will overcome this by building a "tower" of plaster gradually. (Later, when we come to model directly in plaster, we'll see the value of this kind of control over our material.) Once we've completed the exercise, the plaster having fulfilled its purpose, can then be discarded. What we will retain, however, is the knowledge of what was actually happening as the tower went up. And we will have acquired the "feel" of working with plaster as it progressed through its various liquid-to-solid stages. *Note:* Although the setting speed of plaster varies with specific circumstances, the relative time period for each step will be indicated here.

1. (above left) It's advisable to have a clock in plain view, preferably one with a second hand. Note our exercise begins at 9 o'clock. We'll also use: (1) a small pan or bowl; (2) a graduated measuring container, either pint or quart; (3) a mixing spoon; (4) a spatula or two; (5) a serrated plaster tool or sawtooth scraper; (6) a 12″ by 16″ pane of glass; (7) a rinse bucket and (8) soft plaster. Soft plaster is recommended because its period of plasticity is longer, but hard plaster can substitute if necessary.

2. (above right) We have put one pint of water into the pan. (Since the quantity of water determines the size of the batch, this will be a small one.) Now we sift the plaster in large handfuls through the fingers into the water. We do this by spreading the fingers slightly apart and shaking the hand with a wrist action. (Sifting, which prevents the lumping of plaster, can be done very quickly after some practice.) We sift in as much plaster as the water will absorb, allowing small islands to rise slightly above the surface. When the water has been thus saturated with plaster, we look at the clock. We then let the plaster soak undisturbed for at least two full minutes, or until all the dry islands become moist. (This is the soaking step.)

3. (left) Stirring now begins. We keep the spoon moving at the *bottom* of the pan to force out any air that's entrapped in the plaster mix. We will stir this small batch for 1½ to 2 minutes, or until it has thickened slightly.

4. (above left) We place the first spoonful of liquid plaster on the glass pane. (This will serve as our working surface.) Note how fluid and free-flowing the plaster is. Now we check the clock, then sit back and *do nothing* for a full four minutes. Concentrating on this waiting period will give us a sense of timing in our work. It will also help us overcome any feelings we might have—when actually working with plaster—of being hurried by its setting action.

5. (above right) When the four minutes have elapsed, we add the second spoonful of plaster. Although this one is still free-flowing, it's somewhat less liquid, having thickened slightly. At this point, it's best that we pause again for another full minute. (A third spoonful would only collapse into a blob now.)

6. (left) The spoonfuls of plaster now being added are still soft, but gradually getting firmer. Note that the uppermost spoonful has the sharpest outline. Note also the wet shiny look of the plaster, indicating it is still fluid. At the same time, however, its texture as it slides off the spatula looks "torn." (This indicates the fluid stage is nearing its end.)

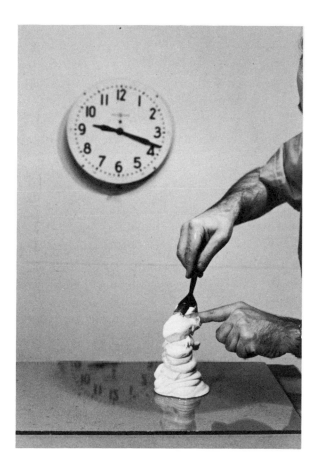

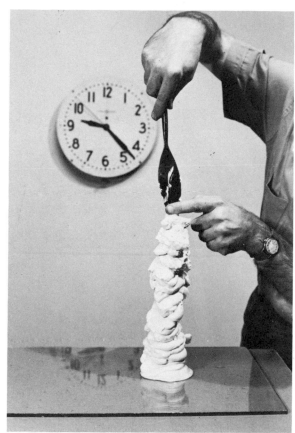

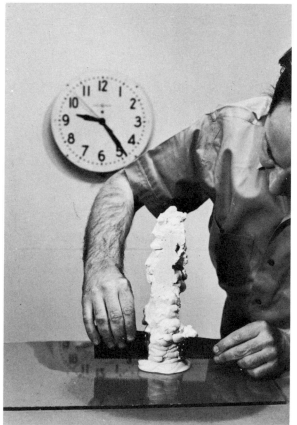

7. (above left) Eleven minutes have passed since we placed the first spoonful on the glass; the characteristics of the plaster have been changing constantly during this period.

8. (above right) Now we have used up most of the first batch of plaster. We can observe the difference in the texture of the layers and see how the top ones are more sharply defined. The wet shiny look is gone, indicating the plaster is at its maximum plasticity. For these remaining few minutes almost anything can be done with it. Although we proceeded leisurely before, we must now work fast.

9. (left) We use the scraper blade to square off the tower and in the process create a texture of vertical lines. The plaster we cut away at this stage is still soft enough to be piled atop the tower.

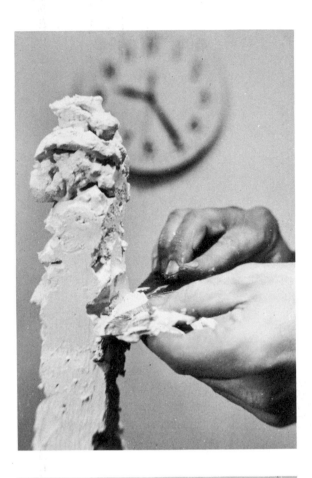

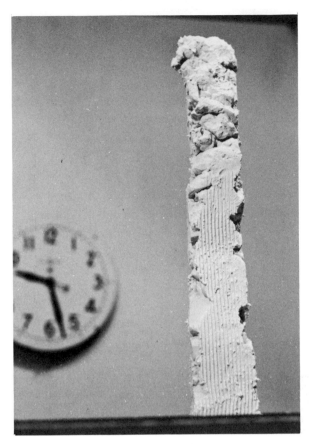

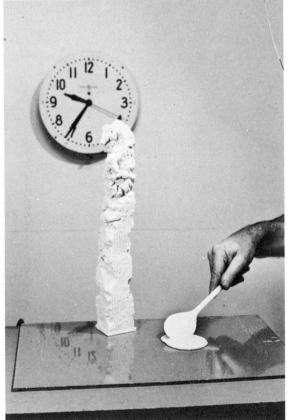

10. (above left) Here the cut-away plaster has been added to the tower. We cut away more from the sides which will also be added to the top.

11. (above right) It is less than 30 minutes since we began our exercise. The plaster is beginning to heat up and lose its plasticity, signalling the end of the setting period. When this first batch of plaster has set, we clean our tools, the pan, and our hands in the rinse bucket. Next, we loosen the tower at its base by splashing some water on the bottom. We put the tower to one side; and clean the pane of glass.

12. (left) After we have dried our hands, we mix a second batch of plaster exactly as we did the first, including the three steps of sifting, soaking, and stirring. We begin as before: placing a spoonful of the fresh liquid plaster on the clean pane of glass.

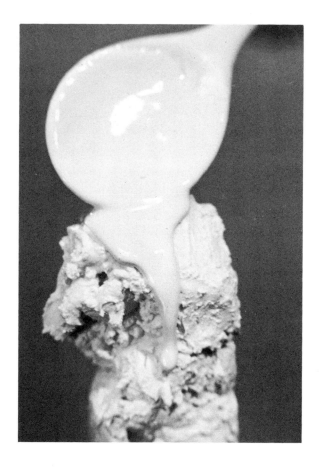

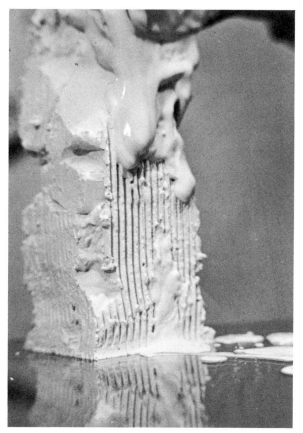

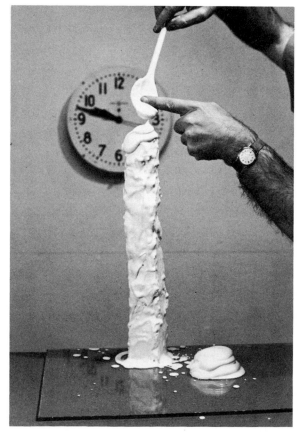

13. (above left) At the same time, we put another spoonful of the fresh mix atop our original tower. We carefully observe the different ways in which these two identical spoonfuls of plaster behave. The one on the glass remains liquid for many minutes (as the first spoonful of the previous batch did); the one on the tower begins to thicken almost at once.

14. (above right) We now add more plaster to the original tower. (The rough sawtooth texture is not merely decorative: it improves the mechanical bond between the old and the new batch.)

15. (left) We alternately add spoonfuls of the new batch to our first tower and to the second one we're building alongside of it.

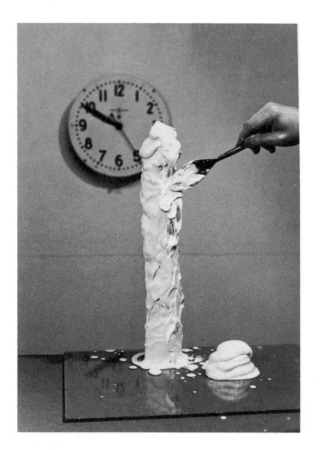

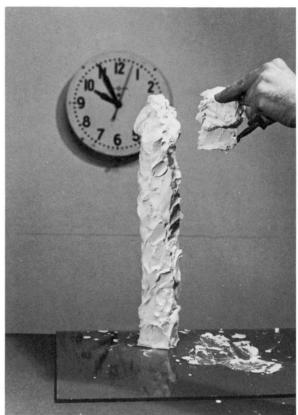

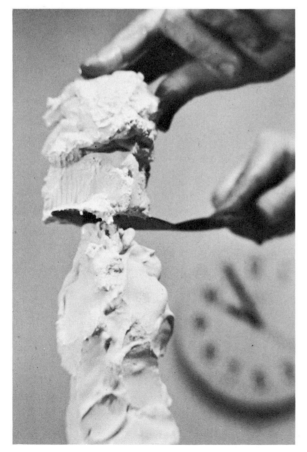

16. (above left) By studying the strikingly different ways in which the plaster "works" on the two towers, we will see that the plaster on the glass or in the pan sets slower than it does on the "set" tower. It is on this important fundamental that the technique of direct modeling in plaster depends.

17. (above right) The new smaller tower is about to be stacked on top of the old one.

18. (left) These two towers will bond together firmly because the plaster of each still retains enough of its plasticity.

19. (right) Exactly one hour has elapsed since we began our exercise. The plaster is warming up and hardening. The tower is already cohesive enough to permit its entire weight to be lifted from the top.

By building up this simple plaster tower, we have gained valuable experience which we can now use in a more creative way. In the next demonstration, we'll be doing a quick plaster sketch of a figure. In later chapters, we'll use our understanding of plaster in numerous other ways.

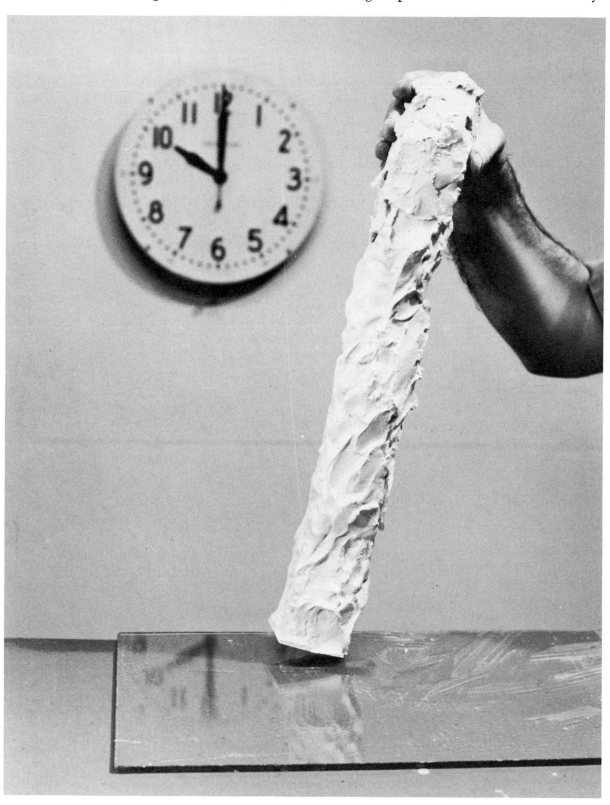

MAKING A SKETCH IN PLASTER

With the tower exercise, we acquired basic experience in developing some control of plaster. Now we're ready to apply this knowledge and extend it, to begin thinking of plaster in terms of figure sculpture. We'll start with a quick sketch, using soft plaster in a free-wheeling way, especially adapted to the making of small figures.

The key idea here is to create and use a "stockpile," or a supply of hardened plaster pieces in a number of convenient shapes and sizes. From this supply, we can select and then combine the parts in whatever way we choose. Besides the hard, set plaster pieces, we'll also be using fresh wet plaster, both as an adhesive and as a modeling material.

As we observed with the tower, the setting time of fresh plaster was hastened by its contact with hardened plaster. This phenomenon will help us here. By using our stockpile pieces, we'll counteract the problems liquid plaster must contend with, when subjected to gravity.

This is how we sketch directly in plaster:

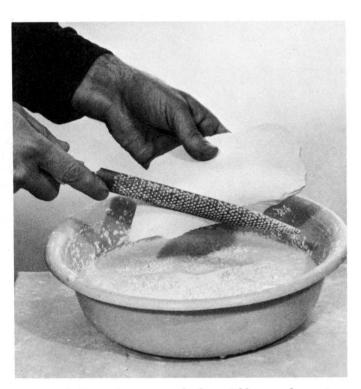

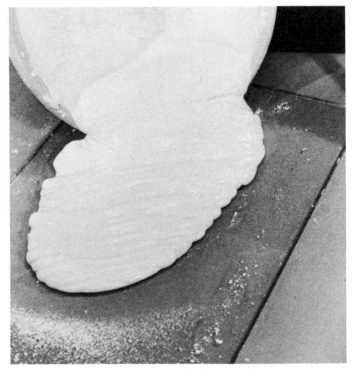

1. To make our stockpile quickly, we first mix a batch of fresh, soft plaster. During its soaking period, we graze over it—with a rasp—a piece of dry scrap plaster. This makes a powder which falls into our soaking mix.

2. When we stir the plaster, it thickens and stiffens quickly. (Normally, liquid plaster would need some kind of enclosure to keep it from running off the glass.) Its solidity, as it's being poured, can be seen here. *Note*: The powder on the glass is fallout from the filing.

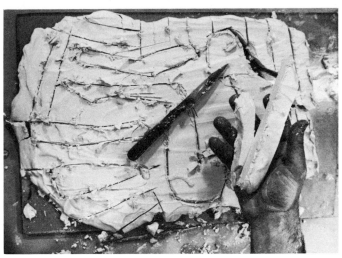

3. With the flat of our hand, we smooth out the plaster into a slab about ½″ in thickness. Now, we roughly sketch the elements of a seated figure on it with our steel modeling tool. (For the drawing, a pencil or other pointed tool will do as well.) The plaster, at the moment, is still soft. Our drawing needn't be elaborate; just a few parts indicated to get started.

4. While the plaster's consistency is still like fudge, we must cut each line all the way through with a knife. At the same time, we also cut up—in the shape of sticks or wedges—all areas outside our drawing. These will later be used to build up the rest of the figure. When the plaster heats up (indicating the start of the setting period) we splash on some water to free the slab from the glass. The miscellaneous plaster pieces will then slide off easily and separately.

5. We now have our plaster supply, and stack the hardened pieces to one side as our stockpile. The knife and steel tool are seen at right.

6. We mix a second batch of soft plaster, smaller and much thinner than the first. (Since we want it to set normally, we won't rasp any dry plaster over it.) Here we dip the two largest pieces from our stockpile into the fresh plaster. These will represent the figure's torso and left leg.

7. While holding the two pieces in position with one hand, we dip a small, hard, set, wedge of plaster into the fresh batch. This will be used to fill the space between the two larger pieces.

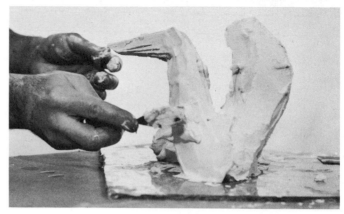

8. (To make these elements bond solidly together, we must hold them motionless in place for 5 to 10 minutes. Although the joint will still be weak then, we can begin to work with the piece, provided we don't move or jar anything.) Here we add the remainder of the fresh plaster.

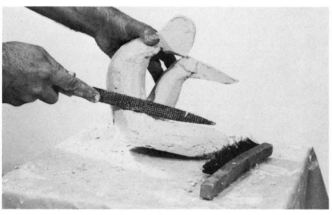

9. After applying another small batch of plaster and creating the head and right leg with other stock pieces, we can begin to rasp our fully-set mass into shape.

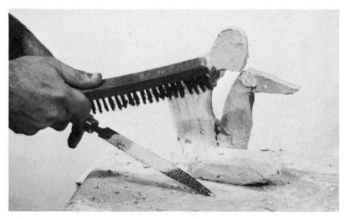

10. Since soft plaster holds a great deal of water, the rasp will clog up quickly with plaster sludge and require frequent cleaning with a wire brush.

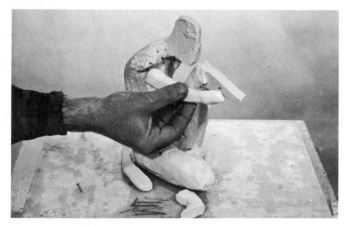

11. We can add other parts from the stockpile at any stage of our work. These may be held in place with small metal pins (made by cutting the heads off wire brads). Here, such pins have been pressed into the partially-completed figure. Then pieces representing the arms are dipped, at both ends, into the liquid plaster.

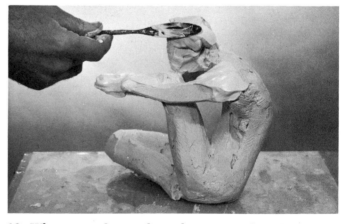

12. When pressed into place, the arms are held by the wire pins. While the arm joints harden, we apply the remaining fresh plaster to the other parts of the piece. The joints, however, must not be disturbed until fully-set since they tend to be extremely fragile.

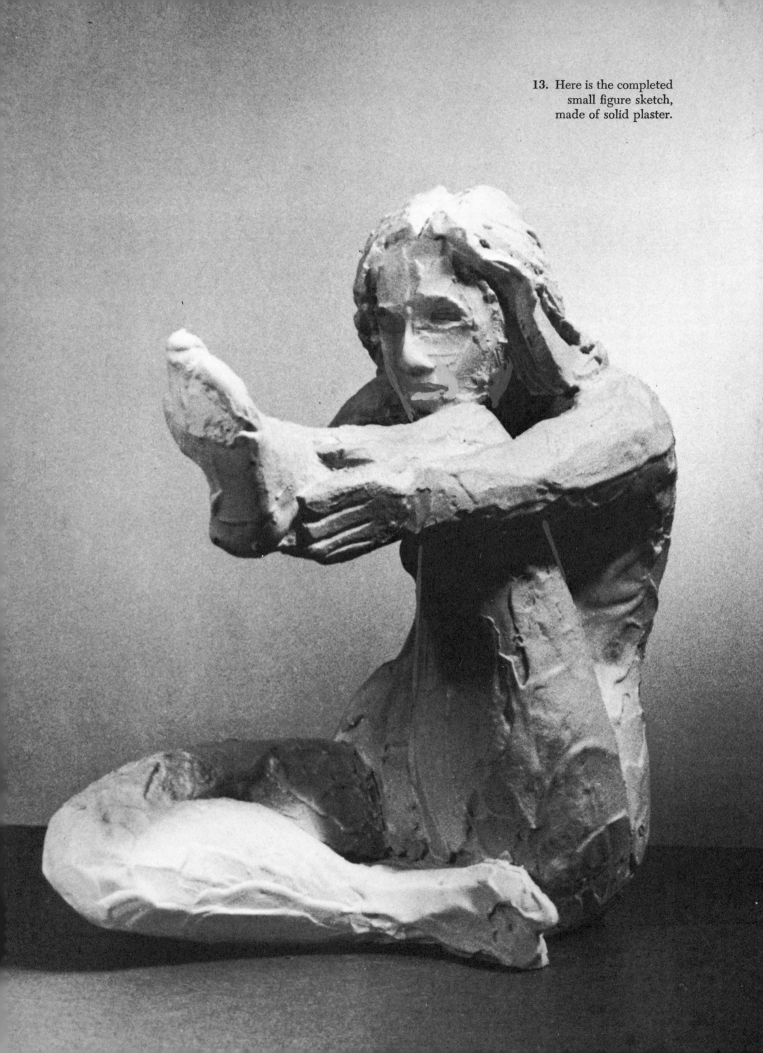

13. Here is the completed small figure sketch, made of solid plaster.

9　Modeling the Figure Directly in Plaster

Having done the tower exercise and the stockpile sketch, our assurance with plaster is growing. We're becoming familiar with its fast-changing properties. We're developing a sense of timing and control. Now we are ready to try direct plaster modeling.

To the sculptor, handling plaster is like the painter's rendering of transparent watercolors; it requires quick decisions and deft skills. Plaster modeling, at the beginning, demands broad treatment. Later it permits involvement with detail, but does not encourage it unduly. Plaster modeling, in terms of technique, is much like building the tower, but there's one big difference. In making sculpture, everything becomes aimed at creating the *image* of the figure. The sculptor must concentrate on the figure's fundamental gesture and on its basic masses. His idea—not the technique itself—is of prime importance. But before he mixes his first batch of plaster, he must plan an armature for his work and build it.

CONSTRUCTING A SMALL METAL ARMATURE

Various pieces of sculpture and various materials require different armatures to support them internally. Wax, as we have seen, can be modeled on a wire armature, a wax armature, or on no armature at all. Plaster, on the other hand, though good in compressive strength, is basically lacking in tensile strength and therefore requires the support of a wood or metal armature, particularly for small figures, where thin projections, such as the arms and legs are involved.

Since the armature must be dependable, we'll use metal rods and fasten these in the firmest possible way. (There's nothing more discouraging than sculpture which begins to collapse even before it has been completed.) To avoid this possibility, we will bolt the feet of the armature securely to a wooden base. (Then other metal rods can be attached with bits of wax. Those rods won't need to be welded or tied with wire, because the plaster itself, reinforced with burlap will hold them firmly together.) Our first rods will need to be threaded at one end, so they can be bolted to the base.

For our purpose, almost any kind of metal will do, provided the rods are easy to thread and not difficult to bend. Aluminum rods—because they are lightweight, do not rust, and plaster adheres well to them—are probably

best. Iron and mild steel rods are also excellent (if shellacked first to prevent the wet plaster from causing rust). Though brass rods don't rust, they are expensive and the plaster doesn't adhere to them as well.

The metal rod may be round, square, or hexagonal and, for small figures, should be about ¼″ thick. Directions for threading the ends are given in the following demonstration. For those who prefer not to thread their own, a rod already threaded along its entire length is available and sold under the name, *Allthread*. It's more expensive, however, and tends to break if bent too sharply at an angle.

Making an armature is part of the creative process because from the very start it will dictate the basic gesture and proportions of our figure; it will also determine to a large extent what can actually be done with the plaster modeling. The way in which we arrange the metal rods is therefore crucial. They become a metal "skeleton" of our figure, a three-dimensional manifestation of its main axial lines. Thus, while concentrating on the physical strength of the armature, we must never lose sight of its importance as an integral part of the sculpture itself.

MATERIALS AND TOOLS

In making our metal armature, we'll need the following: 4 or 5 feet of ¼″ metal rod (as described above); 4 washers and 4 nuts; a wooden board for the base; wax for joining the rods; shellac and pastewax for sealing the wood.

The tools we'll require are pliers, a wrench, vise, and file; a threading die (NC ¼ x 20) and a ¼″ drill.

For our armature, we've selected square rods made of aluminum and we'll begin by threading these:

1. We cut two rods, each about 24″ long (they can be shortened later if necessary) and saw them off squarely as in the rod at the extreme left. The tool at the right is the threading die. We taper the rod slightly with a file, as in the second from the left. Once tapered, we hold that rod in a vise and place the die over its tapered end. Then, to cut the threads, we turn the die onto the rod (as we would a nut). As shown in the center example, we thread each rod about an inch at one end; then add the nuts and washers, as with the second from the right.

2. Since the rods will serve as the "bones" of our figure, where they will bend must be carefully thought out before we begin. (We can even make a quick sketch of the figure in wax or clay to establish this.) The rods can either be bent in a vise, or with a vise-grip plier and wrench as shown here. This rod will represent both an arm and leg of our figure.

3. We have roughly pencilled the feet on the wooden base. Near each heel, we drilled ¼" holes completely through the wood. We countersink these at the bottom (enlarging the holes) so they can receive the washer and nut. To the left is the shellac we'll use in coating the wood.

4. (above) Here the base, turned over, is shellacked. We shellac it on both sides to prevent the board from absorbing any of the plaster's water. When dry, we will coat it lightly with pastewax to keep the plaster from sticking. Notice the holes countersunk at the bottom.

5. (right) One nut has already been threaded onto the rod, about an inch from the end. Now we insert this rod in the hole. It will be pushed through, then held in place by the washer and the second nut, threaded on beneath the base. The second rod, representing the figure's other arm and leg, will be bent into shape and added in the same way.

6. After we adjust the first two rods and tighten the nuts with a wrench, we add a third to support the figure's neck and head. Note that it's held in place temporarily with a small piece of wax.

MODELING A SMALL SOLID FIGURE ON AN ARMATURE

With our armature firmly set and solidly built, we can now begin to model directly in plaster.

MATERIALS AND TOOLS

For our work, we'll need plaster and water. (Either hard or soft plaster may be used. Here, we chose White Hydrocal because it sets faster, files better, and makes for a harder, stronger piece.) We'll also use open-weave burlap, cut in strips measuring from 3″ x 3″ to 3″ x 6″. (We'll need about 12 to 18 such strips.)

Required here also are a bowl, spoon, and etc. (as listed for the tower exercise); a spatula, a coarse rasp and wire brush, and a gas torch or razor blade.

After mixing a small batch of plaster, we begin by saturating a piece of burlap with it:

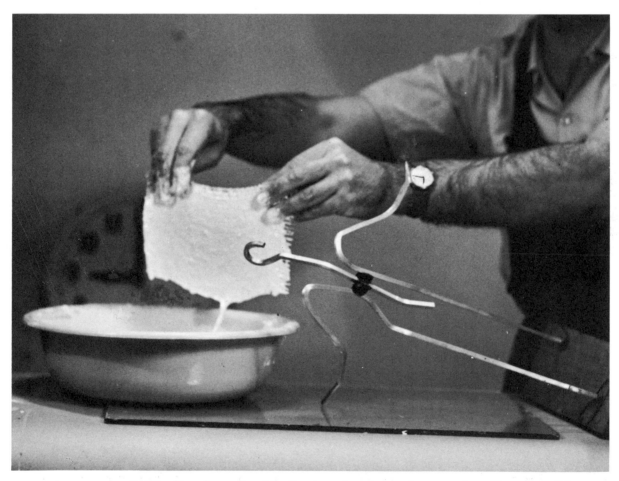

1. We dipped a strip of burlap into the plaster, just enough to be saturated but not swimming in it. The excess plaster drains off quickly here. (As the plaster thickens however, we must remove the excess from the other strips with a kind of squeegee action, wiping it in a downward motion with our thumb and forefinger held parallel.) Note that the time is 9 o'clock.

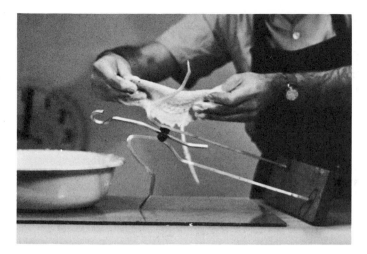

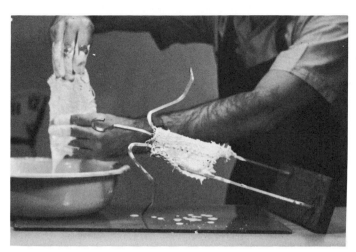

2. After folding the plaster-saturated burlap neatly —it should never be wadded up or allowed to become disorganized—we are about to wrap it around the center of the armature. The armature is placed in a horizontal position so the burlap will not slide down at this point.

3. With the first strip of burlap now wrapped securely around the armature, we dip a second piece in plaster and here wipe it free of any excess with the downward squeegee motion. Note that the glass work surface—not the base—catches the plaster drippings.

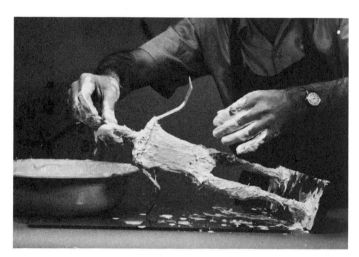

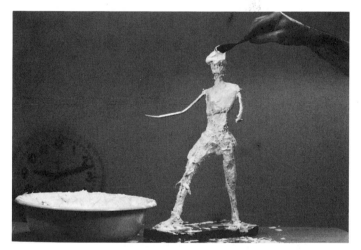

4. We have now added burlap strips to the head and legs as well as to the torso. Note how the plaster thickens on the hands. To remove this plaster, we must wash our hands frequently in the rinse bucket. Keeping both hands and tools clean, when working with plaster, will help avoid frustration and increase our efficiency.

5. As the plaster thickens, the armature—less affected now by gravity—can be stood upright. Note how we use the spatula to apply the remaining plaster over the burlap. This helps build up the form.

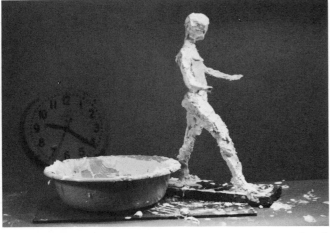

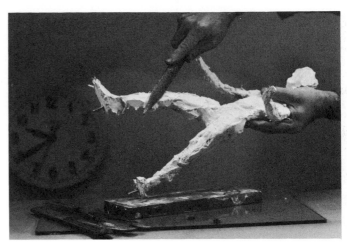

6. The entire metal armature is now covered. Although the figure at this stage is very rough, its gesture and proportions are clearly stated nevertheless. The plaster in the pan has set and should be discarded (see page 78). We don't try to save any of it by adding more water. Such resoftening would only make the surface of our work weak and mushy.

7. We have now unscrewed the nuts and removed the figure from its wooden base, making it easier to work with. Here we use a rasp to cut away the excess plaster, much as we used a knife earlier to cut away the wax when modeling it. (The threaded rod ends projecting from the feet will be used later to mount the finished figure on a fresh wooden or marble base.)

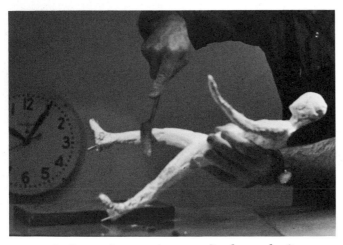

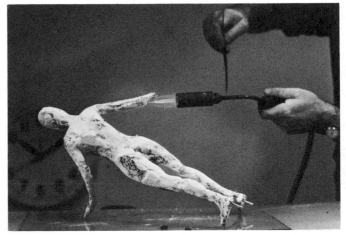

8. Our surface rasping must be thorough. Once any projection or highpoint (of burlap and plaster) has hardened, the spatula can no longer smooth it out as it did earlier. These highpoints will hold the spatula away from the surface and interfere with our control, by determining in effect where the spatula can go and where it cannot. Therefore, we should rasp off every unwanted projection.

9. The rasp does not cut the burlap cleanly but, by its filing action, causes it to fray. These fuzzy burlap areas can be removed with a single-edge razor blade, but the quickest way is with a gas torch, as shown. This chars the fibers without affecting the plaster. (The still-wet plaster can withstand the heat.) Then a steel tool or knife can scrape off the remaining ends of charred burlap.

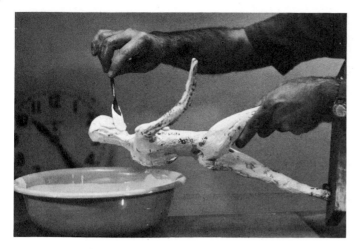

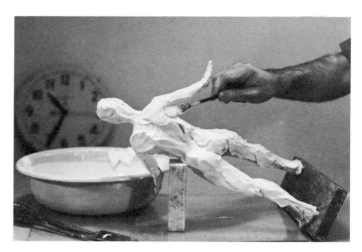

10. The wooden base has now been cleaned and rewaxed. The figure is rinsed off and then rebolted to the base. Any remaining strips of burlap are put away; the pan and tools are clean. Now we mix a second batch of plaster, making it somewhat thinner than the first to allow for absorption between the old and new batches (see page 75). Here, we add it to the head with a spatula.

11. To take advantage of gravity, as before, we place the figure in a horizontal position. Note the small block propping it up at a convenient angle. The new batch sets quickly, setting faster on the figure than in the pan. (We observed this phenomenon earlier in the tower exercise.)

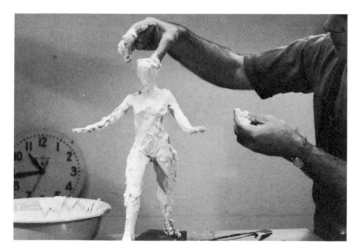

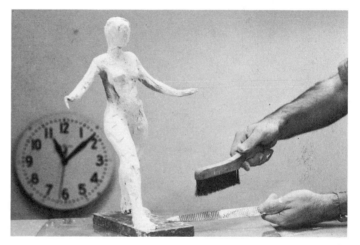

12. As the plaster stiffens, we again stand the figure upright. When the plaster loses its wet, shiny look, we add it very quickly with the spatula. Here, with it nearing its final setting stage, we model the plaster with the fingers.

13. With the second batch of plaster set, we again work the figure over completely with a rasp. Here, we clean the rasp with a wire brush to prevent clogging and rusting.

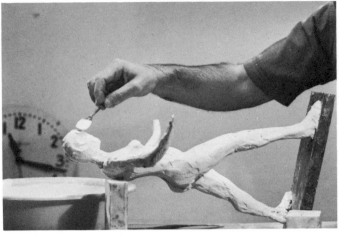

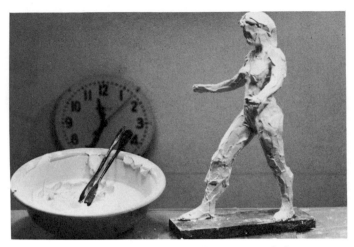

14. We continue building up the figure. A third batch of plaster has been mixed and now is applied in the same way as the second. Depending on the requirements of the individual piece, repeated applications of plaster, followed by rasping, can continue for a number of batches.

15. In order to retain the liquid-like texture of the plaster applied wet, we decided to stop while the figure was still at a sketchy stage. We could, if we wish, carry the surface to a smoother finish by more rasping and carving, followed by sandpapering.

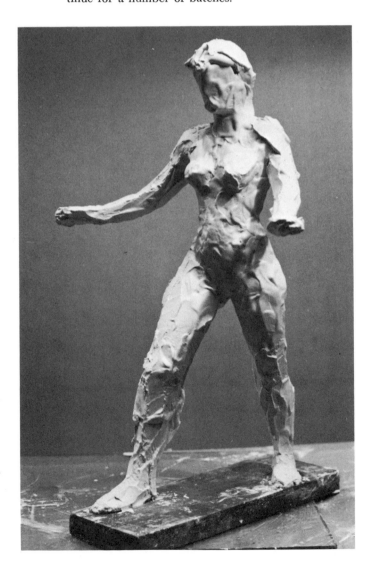

16. Approximately two and a half hours have passed since our first batch was mixed. We see our figure, modeled directly in plaster, standing completed.

MODELING A HOLLOW TORSO

When modeling larger pieces directly in plaster, it's best to make them hollow. The advantages are: they don't require as much material; the work is lighter in weight and easier to handle. And a light plaster shell—being less rigid than a solid mass of plaster—makes for stronger, more durable sculpture.

The plaster techniques called for here are similar to those used before. There will be an armature, reinforced again with plaster-saturated burlap. The modeling itself will consist of small successive batches of plaster, each built up and then controlled—by filing with a rasp—before the next batch is added. The main difference is to be in the nature of the armature. For hollow modeling, our armature will be made, not with metal rods, but with wire mesh. We'll first shape this mesh roughly, to approximate the major volumetric forms of our work; then build up the plaster on its outer surface. (Serving as our model will be the wax figure from Chapter 4. Although this was a complete figure, we'll be concerned here only with its torso.)

For our armature, we'll need a wire mesh, woven into hexagons. (Wire woven into squares doesn't lend itself nearly as well to being formed into curved volumes.) Hexagonal or "chicken" wire is available in hardware stores. The best type, for our purpose has a 1″ weave. About a yard or two of this should be sufficient. The tools we'll require are a pair of wire-cutting shears, needlenose pliers, and a hacksaw. To strengthen the armature, we'll need a length of ½″ plumbing or water pipe, as long as the height of the piece (in this case, about 20″). This is also available at hardware stores. The pipe should be threaded at one end and then fitted with a standard pipe flange.

As previously required for modeling plaster directly, we'll need burlap, plaster, and the various tools for building it up; then rasping it down to develop the form. Hard plaster is recommended for saturating the burlap; soft for the actual modeling (although if necessary, soft plaster can be used throughout).

This is how we construct the wire armature, then model our hollow sculpture in plaster directly over it:

1. First, we create a simple cylinder, the armature's basic form. This is done by rolling the wire mesh into a cylindrical shape, then joining its ends together. Also shown are needlenose pliers and shears for cutting the wire.

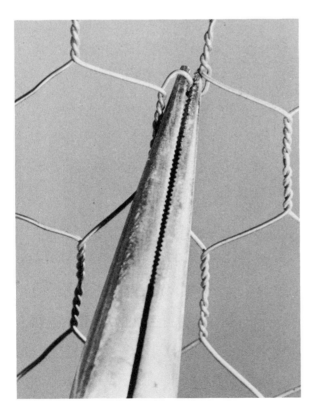

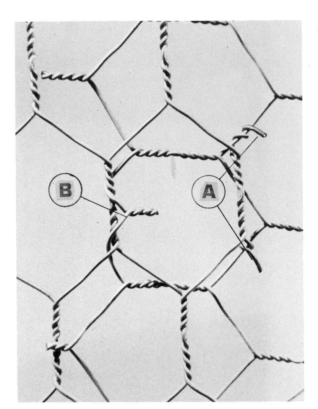

2. This closeup illustrates how the ends of the wires are fastened. The free or cut ends are overlapped about an inch and a half, then tied firmly into the mesh. Note that each hexagon consists of two twisted sides and four single-wire sides. If the free end is a single-wire stub, we wind it around its single-wire counterpart on the hexagon as at A. If it's a twisted stub, we bend it around the twisted side of the hexagon as at B. Twisted stubs can be bent with the fingers, but single-wire stubs should be done with the needlenose pliers. When fastening wire stubs, we must make certain they all point inward. This insures that they'll be out of the way when the time comes to apply our plaster. *Caution:* Such wire stubs can be sharp and treacherous. Wearing an old pair of gloves to protect the hands is recommended. Leather is best, since fabric gloves give little or no protection against the piercing ends.

3. The next step is to shape the wire mesh for the torso. This is done by shortening the sides of the individual hexagons. Here, the uncut wire is grasped with the needlenose pliers and twisted into an "s" shape, thus bringing two of the hexagon's corners more closely together.

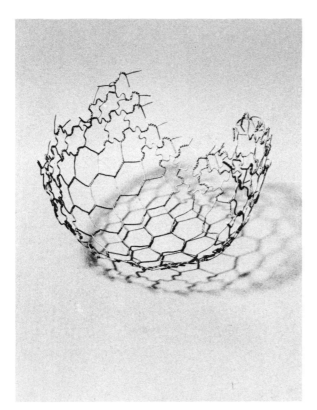

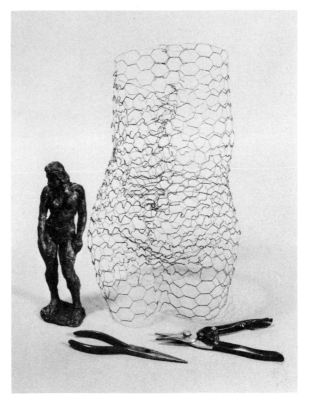

4. If we were to start with a flat rectangle of chicken wire and systematically shorten the sides of the hexagons along its edges, these edges would force the center to warp out of the original flat plane of the rectangle. Thus, as shown, the rectangle becomes transformed into a nearly hemispherical shape.

5. By bending the sides of some of the hexagons into the "s" shape, we begin to give our wire cylinder the form of a human torso. Working with the needlenose pliers in this way is a modeling process in itself, because we can see and feel the changes in the form as they occur. By shortening the sides of the hexagons, we pull in the surface at that point and so reduce the volume of the form. At the same time, we can always lengthen our "s" sides—because of the reserve of wire "stored" there—making the same form potentially expandable. Thus we find we have considerable control since any area which seems to have been pulled in too far, can be pulled out again with the fingers. *Note:* When the sides of hexagons are shortened, this in turn, makes the over-all volume of the cylinder somewhat smaller. Therefore, in order to compensate for this reduction in size, when planning a hollow sculpture we should always make our original wire cylinder somewhat larger than the finished armature. (At left is the small wax figure which serves as our model, along with the tools used for shaping the hexagonal wire.)

6. We now use our length of plumbing pipe, splitting its unflanged end with the hacksaw, then bending its sides outward as shown. (This makes it possible to join the pipe firmly to the plaster so it won't twist loose from the finished piece.) The pipe itself serves a dual purpose: it will provide both a strong internal support for the sculpture and a way to attach the work to its base.

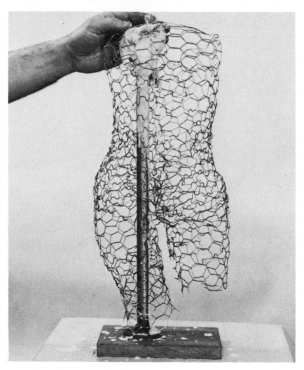

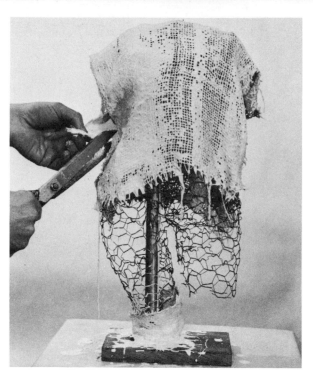

7. The flange-end of the pipe has been attached with screws to a rough board, which serves as a temporary base. After mixing a small batch of plaster—preferably hard plaster—we saturate a piece of burlap with it and wrap the burlap around the split-end of the pipe. Then we slip and position the wire armature over the pipe, anchoring it in place by pulling some of the burlap up and over the wire mesh. The piece will now stand firmly. Shown here is the pipe inside the mesh armature. Note also that the figure has been made less static by lengthening the right leg with the addition of a smaller shaped-wire mesh cylinder.

8. We dip a larger piece of burlap in our original batch of plaster and now also drape this over the wire armature. With scissors, we cut away the excess fabric to avoid any overlapping layers of burlap which might cause troublesome lumps later. (The scissors should always be wiped with a damp cloth or paper towel before the plaster sets.) Note how the right leg is anchored with a burlap strip, wrapped around the pipe flange.

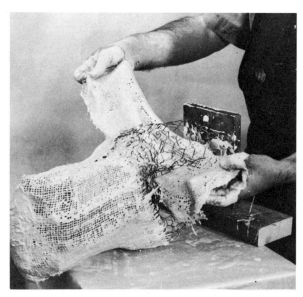

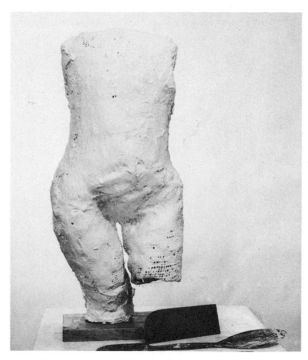

9. Here, we wrap burlap, saturated in a second batch of plaster, all the way around the right leg. It will then be trimmed with scissors so its ends can be joined in a flat—not an overlapping—seam.

10. The wire, now completely covered with burlap, is beginning to look like our contemplated sculpture. The legs have been wrapped in such a way that they can be later modeled individually.

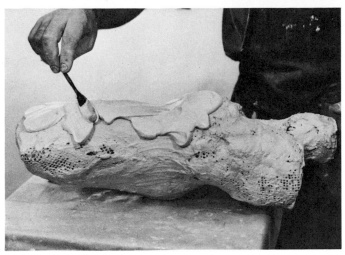

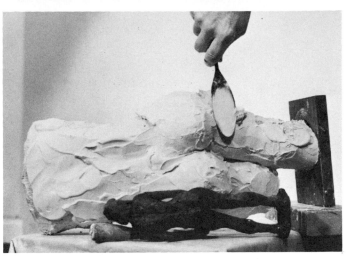

11. We apply our third batch of plaster—using soft plaster this time. We place the work in a horizontal position to take advantage of gravity, as we did when modeling plaster directly before (see page 101). Using our spatula, we apply the plaster in large flat blobs, with a minimum of smoothing.

12. When the plaster sets sufficiently so it can't slide off, we give the piece a quarter-turn and continue coating it with additional blobs. By rotating our wax model to the same relative position, we can make comparison between the two easier.

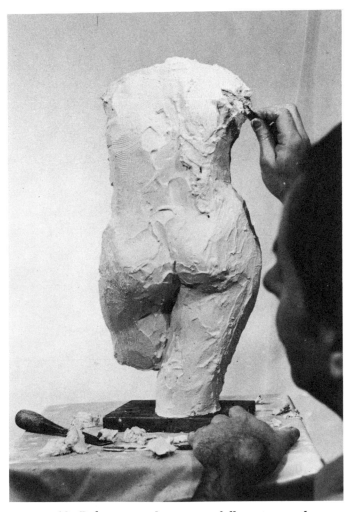

13. Before our plaster sets fully, we use the serrated end of the spatula to cut away any excess material. At this point, we can carve the form very easily.

14. The serrated tool leaves a distinct pattern on the plaster, helping us to see the form more clearly.

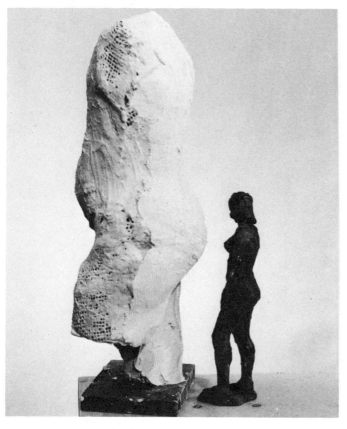

15. Now the back of the torso has been roughly done. The front will be modeled in the same way with subsequent batches.

16. The plaster has set and is quite hard now, so we use a straight rasp to file and form the convex surfaces.

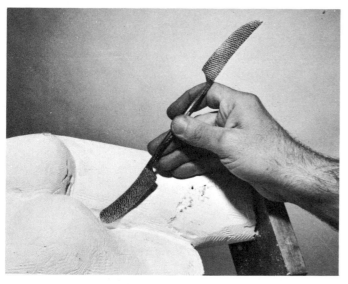

17. We reach the deeper, more difficult surface areas with this special rasp. Chisels and knives are also useful for such hard-to-reach places.

18. As we work—should any area of wire or burlap protrude from the form and interfere with our modeling—we can simply crush or push it inward with our hammer or chisel. (This is another advantage of working hollow on a wire mesh armature.) Our next layer of plaster will then rejoin the fragments, restoring both the surface and the strength of the sculpture itself.

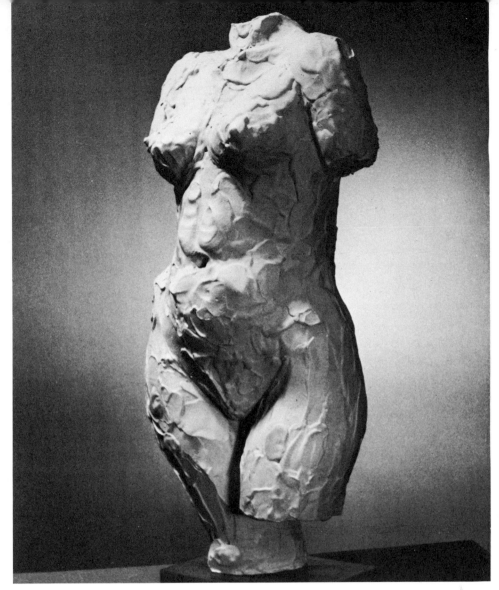

19. The texture of the final surface can derive from building the plaster up with the spatula or cutting it away with the rasp; or perhaps a combination of both. Here, on our torso, the small facets left in the wet plaster by the spatula have been retained.

Note: We have now had a wide range of experience in the use of plaster, with each exercise serving to illustrate one fundamental point. The "tower" demonstrated how plaster changes as it sets. The small sketch showed us how parts or components are joined and how to use liquid plaster in combination with scraps of set material. We also saw how figures are reinforced internally with armatures made of metal rods and burlap strips. And, finally, we learned the basic way to construct hollow forms through the use of a wire mesh armature.

Although each demonstration made its specific point, there's no reason why these various approaches cannot be brought together, either in an individual piece of sculpture, or in whatever way seems useful to our work. These materials and methods have but one purpose: to serve the needs of the artist. Once understood, they can be used in any sculpture with great freedom and flexibility.

10 Casting Wax from Plaster Molds

In previous chapters, we used wax and plaster as separate modeling materials. Now—in this chapter and the following one—we'll apply our knowledge to working with them in combination. Also, for the first time, we'll learn about mold-making techniques which make such combinations possible. Since molds in themselves extend the sculptor's range enormously, they will be described here in some detail. In addition, a Terminology of Molds and related information appears at the end of Chapter 11.

Wax and plaster, when linked together, have many advantages. They can extend each other's usefulness in the following ways:

1. Plaster, used as a mold, can give wax various and special shapes.*

2. A plaster cast can be made of a wax sculpture.

3. Wax and plaster, used in combination, make possible the "lost wax" process of casting metal.

Note: The first of these wax-plaster combinations will be described in this chapter; the remaining two in the next.

PRE-CASTING WAX COMPONENTS

Wax naturally lends itself to being pre-cast into convenient components which can later be assembled. In abstract sculpture, this process is often an end in itself. In figure sculpture, it becomes a valuable preliminary.

Plaster molds can be designed for casting wax elements of virtually any shape. For our purposes, we will plan them for pre-casting wax into its most useful forms; into sheets, rods, and armatures. (Each of these forms and the molds required to make them will be described in separate demonstrations.) The time and effort required in making them will be well-spent because these plaster molds enable us to produce such wax components in quantity. As for the molds themselves—being plaster—they will keep and can be used again and again, for many years.

* Since plaster is able to hold a great deal of water in its open crystal formation, it has two distinct advantages when used with wax. The water it contains separates the wax cast from the plaster mold. The water also quickens the cast-making process by cooling both the solidifying wax and the plaster mold itself.

A mold, simply defined, is a cavity or container into which a positive may be poured. To demonstrate the simplest kind first, we'll make a one-piece, open-face plaster mold from which the positive wax sheets can be cast. (These wax sheets will have many uses. They can be stretched, folded, and bent to indicate volume and form in our sculpture.)

We call the object to be duplicated by the mold-making process the model or pattern. For our first mold, the model or pattern will be a simple sheet about ¾₁₆″ in thickness. We've chosen a sheet of plastic for demonstration purposes, although any number of other smooth-surfaced materials such as plywood, Masonite, rubber, linoleum, or glass might be used. *Note:* Plywood and Masonite, being porous, need to be sealed first with shellac, then coated further with pastewax when dry to prevent the plaster from sticking. Plastic, linoleum, rubber, and glass on the other hand, don't require such special sealing. Plastic, rubber, and linoleum patterns have the added advantage of flexing easily out of the finished plaster mold.

Materials and Tools. We have our plastic model or pattern cut to the same size and thickness we want our wax sheets to be. (Suggested dimensions: 8″ x 11″, with a ¾₁₆″ thickness.) Again, as a convenient easy-to-clean work surface, we use a pane of glass. Other required materials are: four wooden rails to act as a dam or enclosure for the plaster mold. (All four are ¾″ thick, 1½″ wide, and 12″ long.) These rails, being porous, must be sealed with shellac and pastewax. We'll also need small nails to tack the rails together, plasticine clay, plaster, water, and microcrystalline wax. Shown in the illustration below: the glass work surface, the plastic pattern, and the wooden rails.

For our tools we'll use a plaster bowl and mixing spoon, a knife or small plaster tool, and an old coffee pot for heating and pouring the wax.

Now we're ready to make a plaster mold for casting our wax sheets:

1. The plastic pattern and four wooden rails used in making a sheet mold.

2. First, we make sure our glass working surface is clean and level. Then we position the plastic pattern on the glass, holding it in place with narrow rolls of plasticine pressed against its four edges. Here, the plasticine is being cut neatly to a bevel so that the pattern will easily come out of the mold later.

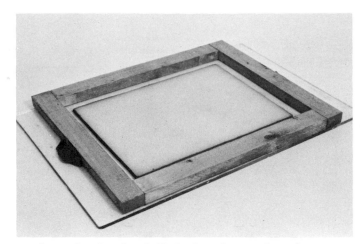

3. The rails—already shellacked and coated with pastewax—have been tacked together with the small nails and positioned around the pattern. They make a dam or enclosure that's larger than the pattern by about ½" on all four sdes. To hold this frame firmly to the glass surface, we anchor it at either end with lumps of plasticine.

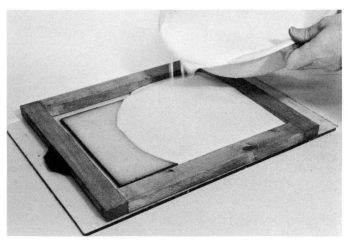

4. Having mixed our plaster, as described in Chapter 7, we now pour it into the dam or enclosure. We begin to pour at one end, letting the plaster flow across the glass surface (to avoid entrapping any air). For the same reason, we shake or bump the table lightly a few times. (This helps break the small bubbles in the plaster or at least to float them away from the surface of the plastic pattern.)

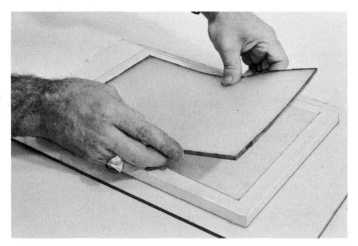

5. When the plaster sets, we remove the wooden rails and turn the mold over. Here, we flex the plastic pattern to lift it out. Note the beveled plasticine on its edges.

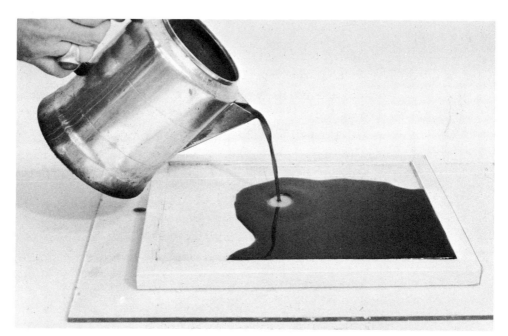

6. The wax, heated in the coffee pot, is now liquid. The plaster mold, resting on a level surface, was first thoroughly soaked in water. (This will keep the wax from sticking.) Then we pour the wax in and fill the mold. As soon as a solid film forms, we immerse the entire mold in a sinkful of cold water. As the wax cools, it shrinks slightly; the wax sheet frees itself from the mold and floats to the surface. Any number of sheets can be quickly cast in this manner. *Note*: The wax can be left to cool naturally and then removed, but the plaster mold must be soaked again each time it is used.

7. We can also cast wax sheets with special texture, if we wish. For this plaster mold, two pieces of rubber matting served as the pattern.

Our second demonstration will be of a two-piece closed mold. (The previous mold was one-piece and open-faced.) This one will still be a simple mold because its two halves fit together in an uncomplicated way, involving no undercuts. (See page 150.) This two-piece plaster mold will be used in casting wax rods. These rods, which look like heavy wire, can serve either as linear elements in our sculpture or they can be joined together to form a mass.

For our pattern or model, we'll use a number of straight round dowels of equal length. These can be of metal, plastic, or wood. (If they are wood, they'll need to be sealed with shellac and pastewax to prevent the plaster from sticking.) Again, a pane of glass will serve as our work surface.

Materials and Tools. These include 6 to 12 rods, ½" in diameter and about 12" long; four wooden rails, each 1" thick and 1½" wide; four flat border strips, made of wood, metal, or even cardboard. (These must be exactly half the thickness of the rods or dowels. Thus, for ½" rods, the thickness of the border strips should be ¼".) The function of these strips is to divide the model or pattern into two equal halves, and so form a parting line at which the two main sections of the mold will fit together. The other materials we'll use are plasticine clay, plaster, water, and pastewax.

In addition to the glass work surface, we'll need a round-ended knife, a straight-edged tool, a plaster bowl and mixing spoon, and an old coffee pot for melting the wax.

Here is how we make plaster molds to cast wax rods:

1. On the glass work surface from left to right are the knife, border strips, rods, and wooden rails.

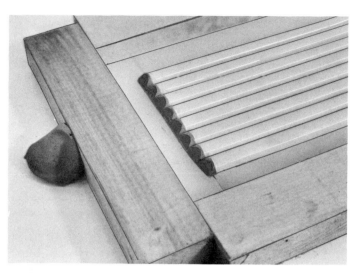

2. The rods, serving as our pattern, are lined up tightly together. The flat border strips, placed on all four sides, secure them in place and let only half of each rod show. (Only half-round rods are visible.) Plasticine clay, placed at one end, is beveled as it was for the previous mold. This permits both halves of the mold to be drawn apart later, without damage to either. The flat border strips in turn, are enclosed by the wooden rails which are not tacked together, but anchored in place with bits of plasticine.

3. Everything is ready now for the first batch of plaster, which will make the first half of the mold. The height of the wooden rails above the border strips will regulate the thickness of this plaster. (Note that the 1″ x 1½″ rails are set on their sides, making them ¾″ higher than the border strips.) When the plaster loses its wet look and begins to set, we draw a straight-edge over the rails to level off the plaster, making it exactly ¾″ thick.

4. The plaster has been mixed and poured; the first half-mold has already hardened. We now turn it over and remove the flat border strips. The rods, still in place, remain undisturbed and we again bevel the clay at one end. Also note the indentations: there are two, cut into the edges at either end. These, called registration keys, will help us lock the two halves of the mold together. In addition, we have soaped the plaster. (See Separating Mediums for Plaster, page 163.)

5. We have placed the rails on their edges to bring their height to 1½″. (This is so each half-mold will be ¾″ thick.) We pressed the rails into place against the first half-mold, using lumps of clay. We mixed a new batch of plaster and here pour the second half of the mold.

6. The second half-mold—with its positive registration keys—has set; the pattern rods have been removed. With the knife, we now cut away some plaster at one end, from both halves of the mold. (This will become the opening or sprue through which liquid wax can be poured.)

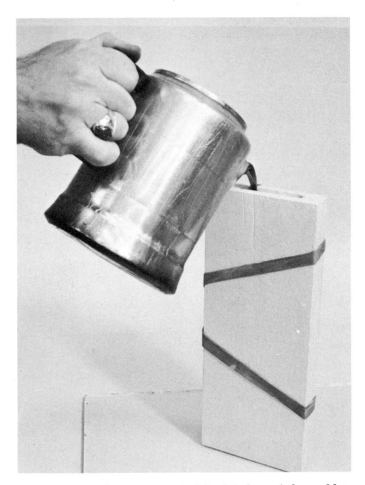

8. The wax rods, now cast, are broken apart and separated. In the foreground, we see the sprue which has been broken off. (This wax will be returned to the wax container and used again.)

7. We have now soaked both halves of the mold in water. We put the halves together, holding them in place with a heavy rubber band. Here we pour heated wax into the mold opening or sprue.

Molds, other than plaster molds, can be used for wax. "Ready-made" metal molds, in the form of hollow pipes, can produce wax rods; while flat rectangular pans will work for wax sheets. These don't have plaster's advantages of using water and so they require other separation techniques: either oiling or heating them to release the wax. Both approaches present certain problems. When the mold is oiled, the wax absorbs some of the oil and alters its own composition. When the mold is heated—as with a torch—the wax nearest the surface of the metal will liquefy and lose some of its texture. The advantages of these metal molds, however, are their availability and convenience.

CASTING WAX ARMATURES

An armature mold is especially useful for doing figure sculpture in wax. Like the rod mold just described, this is also a two-piece mold. Yet here no pattern or model is involved; the design instead is carved directly into the plaster. Since there isn't a pattern, the plaster will be cast directly on the pane of glass to produce a perfectly smooth surface. We plan the design on paper beforehand in the form of a 10″ stick figure (see diagram, page 118). We cast a block of plaster for the first half-mold, then trace the design onto it. By bearing down heavily with our pencil, we inscribe the design into the smooth surface. Then, after soaping the first half-mold (see Separating Mediums for Plaster, page 163), we pour the second half-mold over the first and automatically duplicate our stick figure design in perfect register. (Both half-molds—which are merely rectangular blocks of plaster made to the same dimensions—are held in alignment by registration keys.)

Materials and Tools. For our work, we'll need four wooden rails (all ¾″ thick and 1½″ wide; two are 4″ long; two are 14″ long). All have been sealed with shellac and pastewax. We'll also use plasticine clay, plaster, water and microcrystalline wax.

Our required tools are a china marker or indelible pencil, a round-end knife, steel straight-edge, half-round wood gouges, a plaster bowl and mixing spoon, and a coffee pot for melting wax.

The plaster mold to cast wax armatures is made as follows:

1. The stick figure design for the wax armature. The dotted lines at the foot end represent the sprue. (See Step 9, page 120.) Those near the arms represent the vents and must be lightly incised in the plaster to permit the escape of air.

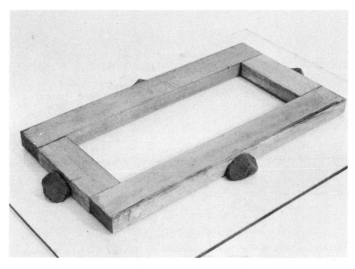

2. From left to right on the glass work surface are the wood gouges in two sizes, a china marker pencil, and the wooden rails.

3. As in the other molds, we position the rails on the glass surface and anchor them in place with lumps of plasticine. (The size of the dam or enclosure is determined by the size of the design to be used. In this case it was 4″ x 11″.)

4. The plaster has been mixed, poured, and leveled to the top of the dam to make the first half-mold. We have traced the stick figure onto it and inscribed it lightly. Here, we rotate the round-end knife to cut out a small hemisphere which will serve as our registration key. (This form of registration functions as the notches did in the previous mold.) Then we soap the mold, as described in Separating Mediums for Plaster. (See page 163.) Finally, we reinforce the design lightly with our china marking pencil.

5. We place our first half-mold face up on the glass. The rails are set in place—on edge this time—and anchored with lumps of clay. (Because the rails are twice as wide as they are thick, setting them up in this manner will make the two mold halves equal in thickness.) We mix the second batch of plaster and now pour it to form the second half-mold.

6. When the second half has set, we open the mold and strengthen the drawings as needed with either the china marking, or an indelible, pencil. Note the four registration keys. These points will realign the drawings with one another on each half of the mold.

7. We now begin to carve out the design. One half-mold has already been completed. We use the lump of plasticine at right, as the cutting proceeds, to make test impressions: to check to see if we have cut deeply enough. Notice that in cutting straight lines, we use the steel straight-edge as a guide.

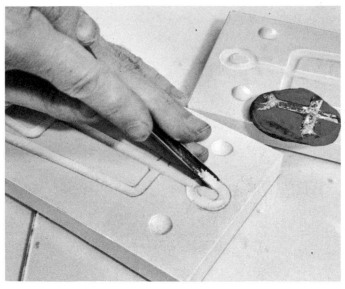

8. Meanwhile we cut the curved lines free-hand, and use the wood gouge to carve out the head of the figure. Our left hand supports this tool firmly, while our right guides it in the proper direction. As a last step, we cut a sprue opening for pouring in the wax at the foot-end of both halves of the mold.

9. We have heated and poured the wax. The mold here is shown with one wax figure in place, including the lump at its feet which had been the sprue. The figure to the left has its sprue removed. The three wax armatures in the background are bent in animated poses, showing how they can be used. Note how they stand without additional support.

SOME TIPS ON POURING WAX INTO PLASTER MOLDS

Since plaster molds soak up liquids like a blotter, we must always saturate them fully with water before adding liquid wax. Hot wax poured into a dry plaster mold will ruin it. It will enter the pores of the plaster, lock into the open crystal structure (described earlier) and harden there. Once this happens, no amount of water can dislodge it. Therefore, when getting ready to pour wax, we must soak our mold in a sinkful of cold water until saturated. (The water, not the plaster, keeps the wax from sticking.) We let the excess water drain off the mold, then put both halves together, holding them in place with a strong, extra thick rubber band. *Note:* We keep the water in the sink since it will be used again later.

We melt the wax—and before pouring—let it cool somewhat. The wax should *not* be any hotter than is necessary to keep it liquid. If it's too hot, it will drive the water away from the surface of the plaster, causing the wax to stick to the mold. Also, when the wax is overheated, the cast is slower to cool. Therefore, the less heat we use, the more time we save.

When we have soaked our two-piece mold and heated the wax properly, we pour the mold full of melted wax. As soon as a solid film forms and seals the sprue opening, we submerge the still-closed mold in our sinkful of cold water. Then after a few moments, we open the mold gently under water. The wax cast, cooled by the water, floats easily to the surface. We leave it there, supported by the water, until it is strong enough to be handled. While the wax cools and hardens, the mold can be drained briefly; its two halves joined and another wax cast made. This cycle can be repeated any number of times.

The one-piece mold we made for casting wax sheets is treated in the same manner. After the wax is poured and a solid film forms on its surface, we submerge the mold gently in cold water. Soon the wax sheet will free itself from the mold and float upward to the surface.

Note: The wax casts in our previous demonstrations were made solid because the molds were designed for thin or shallow shapes. When we want to do larger figures or objects with bigger cross-sections, we can use "slush" casting, a method for casting the wax hollow. This is described on page 170.

11 Making Plaster Molds from Original Wax Sculptures

Although a finished wax sculpture can be kept indefinitely, this is not necessarily the final stage in the work. Some soft waxes, needing preservation, are made more durable when cast into plaster. Others are cast in metal, either to preserve them or because metal has desirable sculptural qualities.

We'll use plaster molds to convert our wax sculpture into both plaster and metal casts. The metal casts will be made in "lost wax molds," the plaster casts in "waste molds." We can use both molds only once because, in each case, the original wax sculpture and the mold itself will be destroyed by the process. (The plaster or metal cast will remain, of course.) To demonstrate how wax sculpture is translated into these more durable materials, we'll follow both these mold-making processes step-by-step.

MAKING A PLASTER CAST FROM A WAX ORIGINAL

A plaster cast is the simplest and least expensive way to preserve a wax original. The waste-mold technique it uses here is similar to that used in casting clay sculpture. (See Terminology of Molds, page 150.) Due to the inherent differences between wax and clay, however, the process will differ in several important respects.

Wax can be removed *before* a mold is opened, merely by melting it out. Clay usually cannot be removed until *after* the mold is opened. When a clay original is used, brass shims are needed to divide the mold, so the clay can be removed. When a wax original is used, the division is made by cutting through the outer layer of the mold only. Then later, after the support from the wax original has been removed by melting, the inner layer is not cut—but broken—apart. (The wax original must be removed before the mold is broken open, or the mold will not break evenly.) For melting out purposes, we may apply heat to the wax original by steaming it (see page 142); or, if the original is hollow, by circulating hot water within it, then scooping the wax out by the handful.

In any case, when casting plaster from wax, we must open the waste mold to coat its interior with a separating medium. To do this, we crack the empty mold open with wedges along a cut extending from its outer surface almost to its inner one. As we will demonstrate, we make this cut

by pulling a strong string through the outer layer of plaster just before it finally sets. This leaves only a thin inner layer intact and—when the time comes—we can break this easily by the pressure of the wedges. The advantage is that when the broken halves are rejoined, their seam line will be almost invisible. (Other mold-dividing devices, such as shims, create seams of considerable width, which can be removed from the finished cast only by extensive retouching.)

For the demonstration which follows, our starting point will be the hollow wax torso we made in Chapter 6.

Materials and Tools

For this we'll need soft plaster (which is always used for waste molds); hard plaster or Industrial White Hydrocal (for the cast itself), microcrystalline wax, dry blue pigment or liquid laundry blueing, nylon fish line, strips of burlap, splints made of wood or metal pipe, small wooden wedges (sawed from any convenient board), Murphy's oil soap or other separating medium, and heavy thick rubber bands, about ¾" wide.

In addition to our glass work surface, we'll need an electric wax-fusing tool, a cabinet scraper, spatula, hammer, and chisels.

This is how we make a plaster cast from a wax original:

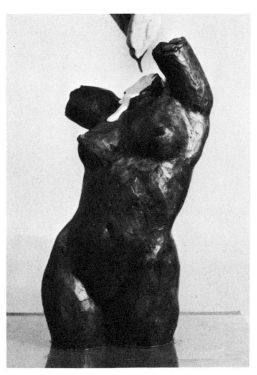

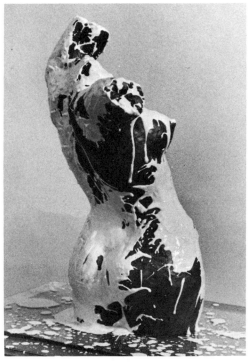

1. We have securely attached our wax torso to the glass work surface with the wax-fusing tool. We colored some water with ¼ cup of laundry blueing, then mixed a small batch of soft plaster with it. Here we throw the bluish plaster by hand, directly onto the surface of the wax original.

2. We throw the plaster with impact against the wax to break the surface air bubbles. We build a thin coating of blue plaster all over the wax. Note how the liquid plaster tends to run off the waxy surface.

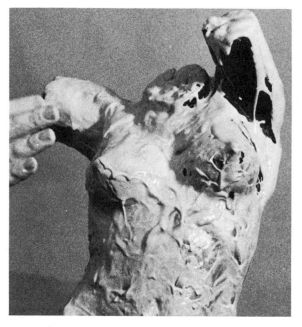

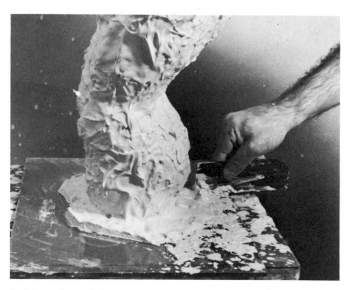

3. As the plaster thickens, we build up a rough-textured, but fairly uniform, blue plaster coating about ⅛″ thick. When we come to break the mold off later, the color will warn us that the chisel is getting very near our plaster cast.

4. Now the cabinet scraper removes excess plaster from the surface of the glass. Note the plaster "ring" about 1½″ around the figure. This will later serve as a guide for the second (or white) layer of the mold.

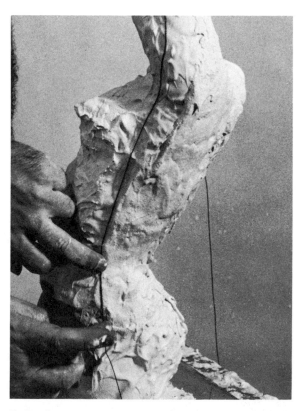

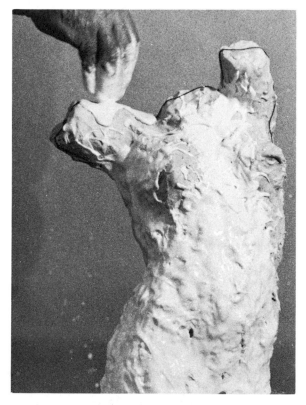

5. In the meantime, we lightly oil some nylon fishline. When the blue-plaster layer sets, we place the fishline around the widest silhouette of the figure, as shown here. We let it extend down to the glass and out past the guide "ring" on both sides. We space tiny pellets of wax at intervals to hold the fishline in place.

6. We mix a second, larger batch of plaster—this time, without blueing—to cover the entire blue coat with a ½″ thick layer. We must also build a 1″ "wall" directly over our fishline. Here, still visible, both at the top and sides, are sections of this line.

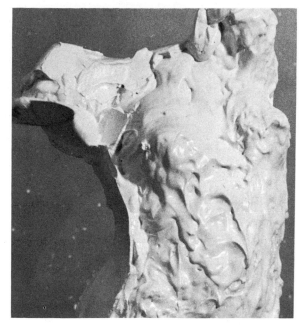

7. As the plaster thickens, we complete the fishline "wall" with our spatula. It *must be completed with this batch.* If we haven't mixed sufficient plaster, we must give priority to this wall. If need be, we can mix more later to cover the rest of the blue coat.

8. Just after the plaster loses its wet look and is still soft (but not so soft that it can flow back together) we will cut the outer layer in two. We do this with a steady pull upward of either free end of the fishline. This will make a sharp, neat cut through the white plaster.

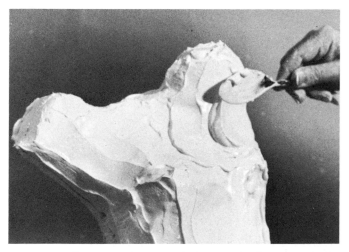

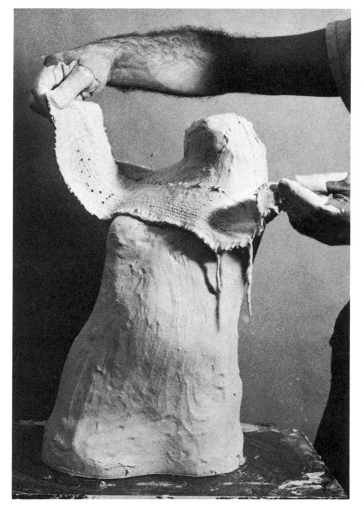

9. If we need more plaster to finish covering the blue coat, we mix a third batch. We must not however, cover up the fishline seams. One such seam can be seen at the left. Although we applied the plaster with a spatula, we now smooth it by hand as it sets. (We use only our hands, *not* any water. Water at this point, would weaken the plaster and make it mushy.) The smooth surface will prove helpful later when we come to remove the mold.

10. At this point we need "splints" to strengthen our plaster mold. These must be fixed solidly in place with burlap and plaster. Here we've already mixed more plaster and saturated the first strip of burlap. We place this strip against the mold, then press and rub it firmly to make it adhere, but leave the ends free.

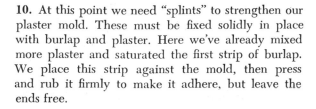

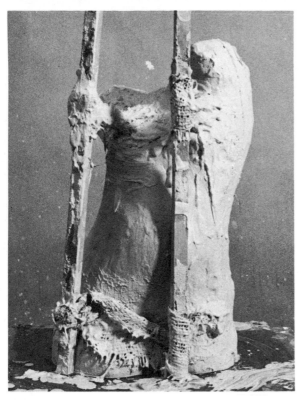

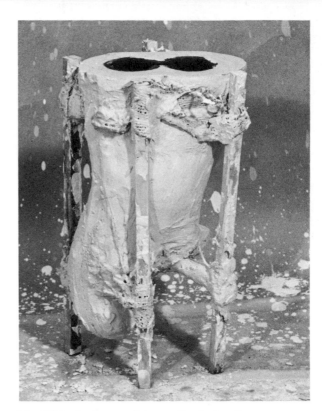

11. We have positioned two splints and tied both ends of each with strips of burlap. In similar fashion, we will attach two other splints of equal length to the back of the mold; then we let the plaster set for a few minutes. Our splints will serve as handles and legs, as well as support for the mold.

12. With the four splints set firmly in place, we can free our mold from the glass surface and invert it. Since the splints are made somewhat longer than the mold, they now serve as legs to hold it. *Note:* The two dark areas at the top indicate the legs of our hollow wax sculpture.

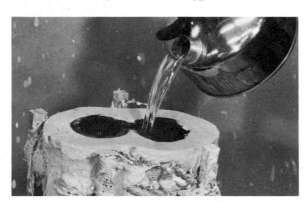

13. We are now ready to remove the wax. We pour hot water in to soften it, then pour the water out. Next, we reach in and remove the soft pieces by hand. As more of the wax needs softening, we circulate more hot water inside the mold. In cases where the wax is less accessible, it can be flushed out with a stream of very hot water or else steamed out (see page 142).

14. With the wax now gone, only the thin blue inner layer holds our mold together. We now neatly divide the mold in two by using small wooden wedges. Here we insert them in the seam. Starting at the bottom of one side, we tap them gently with a hammer, one after another in succession, until the blue layer cracks, and we can break the mold in half.

15. We take the mold apart and soap its interior, working up a heavy lather by vigorous scrubbing with a sponge. (See Separating Mediums for Plaster, page 163.) The soap, reacting with the gypsum plaster, produces a water–resistant surface that will prevent the plaster cast from sticking to the plaster mold. After we rinse off the soap with clear water, some water droplets should stand on the surface, as distinct beads or spheres. (This indicates the mold is ready to use, that its surface will not bond to the cast.) Should the droplets sink into the plaster quickly, we must repeat the vigorous soaping and rinsing until they do not.

16. After soaping, we carefully re-assemble the mold and use heavy rubber bands to hold the two halves in position. We then join the halves solidly at the seam with more strips of burlap, dipped in fresh plaster. When the plaster sets, our mold is ready for the cast, but must be thoroughly wet first. We fill the mold with water for a few minutes to force out the air in the spaces between the plaster crystals. (If this isn't done before the cast is poured, the mixing water of the fresh plaster will force this air onto the surface of the cast and cause troublesome defects there.)

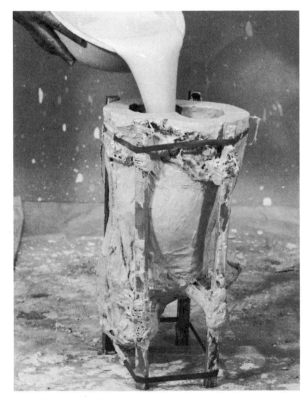

17. After draining out the water, we again invert the mold. We mix a batch of Hydrocal and now pour it in. At this point, our mold is filled only about a quarter full. Note the heavy rubber bands top and bottom. Also note the burlap seam reinforcement at the left.

18. We place our glass on the open end or mouth of the mold to serve as a temporary lid. We then slowly roll the mold in every direction to coat its entire interior with the liquid plaster. The glass lid conveniently prevents spilling. (Any plaster that doesn't adhere to the inside of the mold is poured back into the pan.) We then repeat the process of pouring in the plaster and gently rolling the mold once more; or until its inside surface is coated with about ¼″ of Hydrocal. Note how the splints serve as convenient handles for maneuvering the mold.

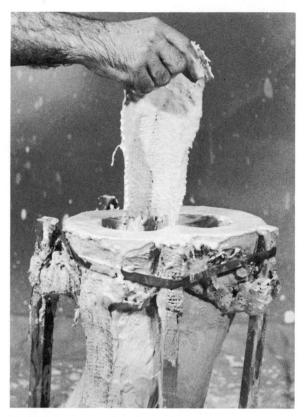

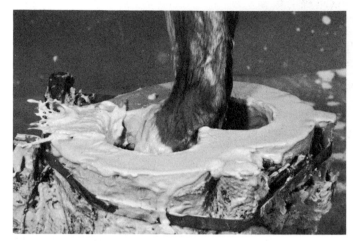

19. While our first batch of plaster firms up, we cut about two dozen strips of burlap. Then we mix a second batch of Hydrocal, dip in the burlap strips one at a time and wipe off their excess plaster as before. (These strips will reinforce the cast, now forming inside the mold.) Here we lower the first strip into the mold.

20. We hang one end of the burlap strip over the edge of the mold to hold it in place, while smoothing the rest of it against the inside of the cast. (The narrow parts at the bottom of the mold—such as the projecting arm—which we cannot reach, are filled solidly with Hydrocal.)

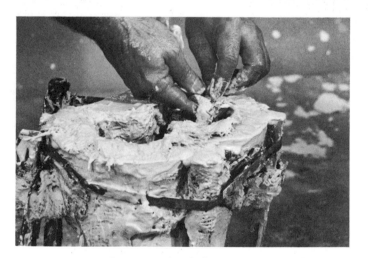

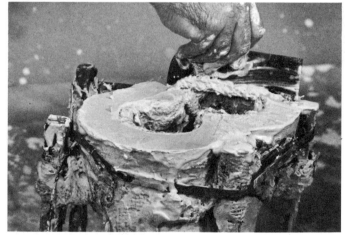

21. We have now lined the entire cast with a double thickness of burlap. While these strips are still soft, we neatly double the hanging ends in on themselves to reinforce the open end of the cast. (We also clean our hands frequently in the rinse bucket to keep them free of set plaster.)

22. Here the cabinet scraper sharply removes the excess Hydrocal before it hardens. This will make the base of our cast smooth and flat.

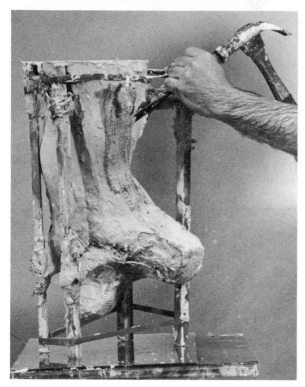

23. As the setting plaster begins to heat up, we must remove the burlap strips reinforcing our fishline seam. If these binding strips were to remain firmly in place, our setting Hydrocal—with its high expansion factor—would be restrained from reaching its fullest expansion and might crack internally. Here we use a hammer and chisel to remove these restraining strips. After these are off, the splints are also removed.

24. With the strips and splints gone, and the plaster fully set (it's ready when it gets hot), we can begin to get our cast out by breaking the waste mold. We do this systematically, using a wood chisel to wedge it off one piece at a time. We begin at the bottom edge of the mold and successively wedge each piece toward the open space vacated by the piece previously removed. We hold our chisel perpendicularly to the surface of the mold and tap it with the hammer until a piece of the mold drops away. (Prying it sideways with the chisel is not usually desirable. Such action may cause large undercut sections of the mold to lift up and break off small projections of the cast.)

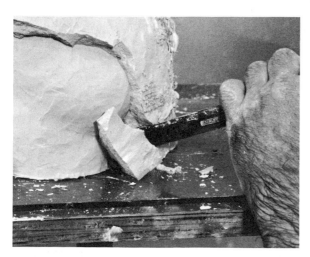

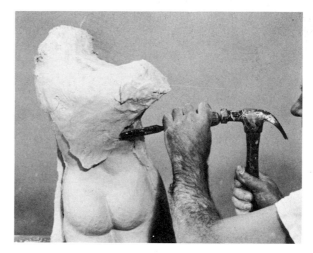

25. When a piece, broken from the mold, has an open space to move into, all the wedging force of the chisel is directed toward that space. (The piece will break off before the chisel ever reaches the surface of the cast.) If there is no open space, the wedging force—transmitted in two directions—can either crack the cast or cause the chisel to go too deeply and mar the cast. When done properly, as shown here, the mold will break predictably along the line of wedging force.

26. If no deep undercuts are involved, rather large pieces of the mold can be removed. This is because the waste-mold is made of soft plaster, while the cast consists of the harder Hydrocal. In the process of removing a waste-mold, however, even the hardest cast may have pieces broken off. This fortunately is not too serious because the pieces (whether wet or dry) can be put back again with white P.V.A. glue.

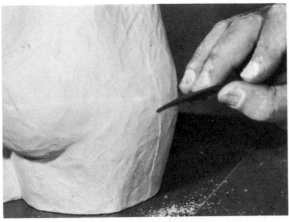

27. We now begin retouching the cast. We use a knife or steel plaster tool to remove the hair line left by the seam of the mold. Next, we wet down any air bubbles or nicks made by the chisel. Then we repair these defects with a soft—setting plaster. (See the Note below.)

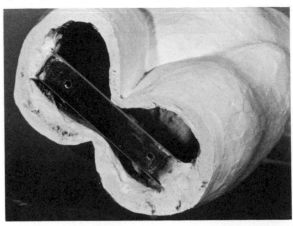

28. To prepare the piece for mounting, we bend the ends of a metal bar (1″ x ⅛″ x 12″) to fit into the bottom of the cast. We then drill two holes in this bar and thread or tap them for the mounting bolts. Finally, using burlap dipped in plaster, we fix the bar permanently in place.

29. Before drilling holes in the wood, we must first transfer their exact location to the top of the base. We do this by placing the cast on a thin sheet of paper and taping it there. Here we have turned over the cast to be able to rub the paper with a pencil. This marks the holes. Next, with the paper still attached, we position the cast on its base. Then we tape the paper to the base. When the cast is un-taped, the paper remains in position showing the clearly outlined bolt holes. By drilling through both paper and wooden base, perfect alignment is assured.

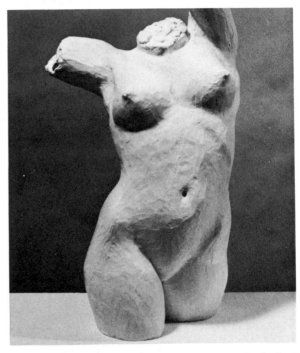

30. The completed plaster cast can now be bolted to the base, but is not actually attached until all its mixing or "free" water has evaporated. If attached too soon, its moisture might damage the wood base. (See Drying Plaster, page 77.)

Note: For patching purposes, we need a particularly soft-setting plaster. We can create one by modifying the standard plaster-mixing process; that is, by deliberately extending its soaking period. Instead of the usual 2 or 3 minutes, we let the plaster soak as long as 10 or 15 minutes. We wait until it begins to thicken by itself—indicating that crystals have started to form. Only then do we stir it. This breaks some of these newly-formed crystals and so prevents the plaster from getting too hard. The modified, weaker setting material that results is known as "killed plaster."

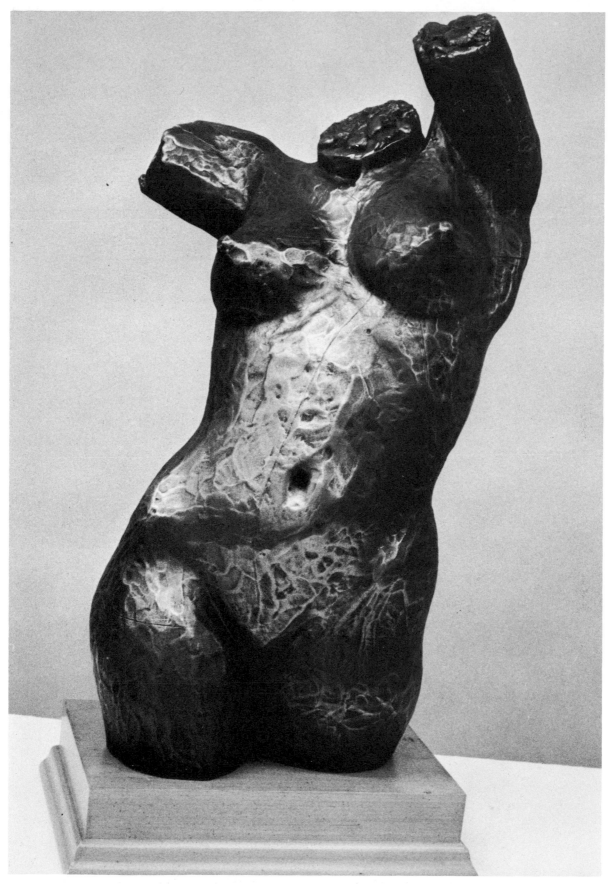

31. Once dry, the plaster may be colored and finished in various ways before being bolted into place. This completed piece was brushed with a mixture of graphite, linseed oil, and mineral spirits before mounting. (See Finishing Plaster, page 164.)

MAKING A METAL CAST FROM A WAX ORIGINAL

We will now use the lost wax process to make a mold in which to cast metal from a wax original. Earlier, when we pre-cast our wax rods and armatures, we melted the wax and poured it *into* a mold. For the lost wax process, we reverse this and melt the wax *out* of the mold. In both cases, we rely on the capability of wax to liquefy, but in the lost wax process everything depends on removing the wax without having to open the mold first. (All other types of molds must be opened first—either to remove the pattern or to prepare the mold's inner surface with a separating medium). To come apart, these other types of molds must be made in more than one piece, limiting them to less complicated patterns. But in lost wax casting, we can use a one-piece mold for any model or pattern, no matter how intricate. We can encase our original wax sculpture in a single monolithic mass of plaster. Then, when we melt the wax out with heat, the empty mold will retain a perfect impression of our original sculpture. Finally, after the mold has dried, we can pour it full of metal.

The lost wax process gets its name because at extremely high heat, the wax burns out of the mold, vaporizes, and is literally "lost." (It is often incorrectly assumed that the process itself—dating back to ancient times— was lost and rediscovered.) Although the details will differ, the technique is fundamentally the same whether bronze or lead is cast. Bronze, with its higher melting point, requires special foundry facilities. Lead, which is simpler and easier for the sculptor to handle at home or in his studio, will be used in our demonstration. What we learn from casting lead relates directly to the casting of bronze.

In its simplest terms, the lost wax process consists of encasing a wax model or pattern in plaster (or similar refractory material) then melting out the wax and pouring a liquefied metal into the negative impressions left by the wax. In actual practice, this process requires seven distinct steps:

(1) Gating the wax sculpture
(2) Making the plaster mold
(3) Burning out the wax
(4) Pouring in the metal
(5) Breaking and discarding the mold
(6) Chasing (or finishing) the metal cast
(7) Adding a patina to the metal

In professional sculpture foundries, specific sections or departments, staffed by specialized craftsmen, are responsible for each of these steps, which require their own tools, skills and techniques. Our demonstration of the lost wax process will be a simplified version of this. Before we begin, however, some clarification of each step will be helpful.

Gating the Wax Sculpture. A lost wax mold must provide the place for the metal to enter (the sprue); some passages to distribute the metal throughout the mold, and also other passages which simultaneously permit the escape of the air and gases generated by the molten metal itself. We can create these necessary passages by attaching wax rods to the wax model or pattern, *before* we make the plaster mold. (The same tools and materials, used for wax modeling are used here.) Later, when we melt these wax rods out of the mold—along with the rest of the wax—round tunnels will be created in the plaster, through which the metal can be channeled. Although the wax rods are named according to function (see the diagram below) the entire process of attaching such rods is known as "gating."

This diagram shows a complete system for casting a solid figure by the lost-wax process. The outer rectangle represents a cylindrical one-piece mold. The parts are named according to their functions.

The flow of metal follows this general pattern: It enters the cup or funnel-shaped *sprue*, is carried by *runners* to the *gate;* and enters the *cavity* of the pattern. (Although gating refers to the entire process, the word "gate" refers specifically to an opening into the pattern cavity of the mold through which the flow of metal enters.) As the cavity fills with the molten metal, air and gases escape by way of the *vents*. Bits of dust, which may also be present, are carried away by the *bottom vent*.

In the gating process, balls or *risers,* made thicker than the wax pattern itself, are placed above sections where metal shrinkage might occur. As the metal cast begins to solidify and shrink, the metal in these thicker risers is able to stay hot longer and continues to feed the cavity with fluid metal to compensate for any shrinkage there.

Although gating has one essential purpose—to create passages in the mold for the wax to flow out and the metal to flow in—more than one arrangement of gates is possible for any given piece. (No two craftsmen would necessarily handle gating in precisely the same way.) Logic and common sense are the key to getting a good flow of metal. As we shall see, runners, gates, vents, and risers are always placed where they can logically be expected to perform their specific functions.

Making the Plaster Mold. A lost wax mold must encase both the wax model and its gating system completely and monolithically. The mold made of plaster (or of clay with sand, silica, asbestos, etc. added to increase its heat resistance and strength) may be built up over the wax by hand. Or else the wax original may be set in a metal container and the mold material poured around it. In foundry terminology, such a container is called a *flask*. For low-melting alloys, such as lead, linotype metal, or pewter, ordinary plaster works best as the mold material, with either a tin can or large paper cup serving as the flask. In making our mold for casting lead, we can therefore use the same tools, materials, and techniques we have already used in making plaster molds.

Burning Out the Wax. Before the metal can be poured, we must first melt the wax out, then dry the mold thoroughly. A damp mold must *never* be used. It can be extremely dangerous. Hot metal—even a low-temperature metal such as lead—poured into such a mold will immediately convert moisture into steam which, with an explosive force, will expel the molten metal out of the mold. Bronze foundries burn the wax out of their molds by heating them in large, specially-constructed ovens. Since plaster is a good insulator and resists heat, this burning-out takes considerable time. In the process, however, all of the plaster's excess water is driven off, so that finally no trace remains either of the wax or the moisture.

The sculptor working at home without such facilities, can remove the wax by steaming his mold in a large metal container (see page 142). Since

this steaming leaves the plaster still wet, the mold must be thoroughly dried (see page 77) before any hot metal is poured.

Pouring in the Metal. Melting and pouring molten metal is at the very heart of the casting process. It can involve a knowledge of alloys, fluxes, and related metallurgy as well as familiarity with such specialized equipment as furnaces, crucibles, etc. Fortunately, the basic process of casting actual metal can be demonstrated with lead, without requiring either the extensive technical background or the elaborate equipment generally needed for other metals.

Breaking and Discarding the Mold. This involves destroying the plaster mold and removing all traces of it from the metal cast. In bronze foundries, the cast is scrubbed vigorously with wire brushes, then sandblasted, and finally soaked overnight in acid. For lead casting, we'll need only a hammer and chisel, a little water, and a coarse bristle brush.

Chasing the Metal Cast. This gives the cast its final shape and finished surface detail. Here, small chisels and punches are used to remove minor defects and also to create special surface textures. Other tools used in this connection are files, emery paper, and sometimes electric grinders.

Adding a Patina. The chasing process leaves the metal uneven in color. (The cut or filed areas are shiny in sharp contrast to the rest.) This can all be blended together, and the cast given a consistent appearance, by the addition of a patina or color finish. Patinas will occur naturally given a sufficient number of years and exposure to the elements, but heat and chemicals can create them immediately. Foundries use large gas torches to heat the bronze first, then the metal is brushed with acid. (Various acids produce various color effects. The interaction between heat and chemicals creates a lasting color finish.) For low-temperature metals, such as lead, a gas torch might melt the cast. Boiling the lead to heat it is more appropriate here.

MAKING A LOST WAX MOLD

In making plaster molds for casting low-temperature metals, we can either pour the plaster as a liquid or build it up as we did our tower. (Molds for bronze are made similarly but, since they're subject to exceedingly high temperatures, they require that such materials as sand, silica, or asbestos be added to the plaster for greater strength and heat resistance. Bronze molds are also given a special wire wrapping for still greater reinforcement.)

Whether the plaster mold is poured or built up, our starting point for lost wax casting is the wax original or pattern, with its system of gating already developed and attached. Before we begin the mold itself, we first weigh this entire wax assembly—on a household or other scale—and keep a record of its total weight.

In demonstrating the mold-making process here, we'll use a built-up mold and, as our wax original, the figure we modeled in Chapter 5. We find this figure, including its gating, weighs about 11 ounces. That fact will help us later in determining whether all the wax has been melted out and also tell us how much lead we'll need to fill the mold in the making of our metal cast.

To complete the mold itself, we'll need the following: plaster, burlap, and wax (and the equipment we used with these earlier): ¾" nails of plain, *uncoated* steel, a soft paint brush about 1" wide, pliers, a large pan, a 46-ounce tin can (such as those used for fruit juice); a larger tin can (such as those used for lard or clay), and an electric hot plate or kitchen stove.

We will begin by gating the wax sculpture and making the lost wax plaster mold:

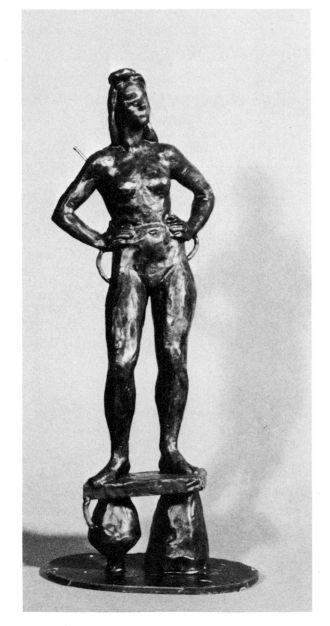

1. Here we see the simple gating already added to our wax figure. Under the model's left foot is the sprue; under her right foot, a ball-shaped riser. We have tilted the base of the sculpture itself to give the metal a direction of flow and vented the base on its lowest corner, near the riser. Under this arrangement, when the piece is turned upside down, the metal will flow into the left leg, while the air will escape from the right. Note that we have also vented the wrists. Everything else is essentially the same as it would be for a poured-plaster mold, except for the small nail set in the right shoulder and the wax disc at the bottom. (This disc, cut from a sheet of wax, extends ½" around the pattern to serve as a guide-ring, somewhat as the blue layer of the waste mold did earlier in this chapter. Note that both the sprue and vent from the riser are attached to this wax disc.)

2. (above left) More small nails are then inserted into the thicker sections of the wax, both back and front, and pressed in place just enough to hold them firmly. These nails will create holes in the walls of the plaster mold, thus serving as *blind vents*. (Their function is to prevent the cast from shrinking away from the surface of the mold.) When metal flows into these blind vents, it will solidify there first. The surface of the cast, locked against the mold by the vents will then solidify next. Blind vents are useful for casts with 1″ to 4″ cross–sections, but aren't necessary when the cross–sections are smaller

3. (above right) We mix a fresh batch of plaster and, while it's still liquid, coat the entire wax pattern —nails and all—with it. To do this, we hold the figure over the mixing pan and gently brush the plaster on. We then set the wax directly on the glass work surface (the guide-ring will provide sufficient stability to support it).

4. (left) As the plaster begins to thicken, we add more and quickly build up the mold. Note how we use the spatula for this. In adding the plaster, we're careful not to dislodge any of the small nails, nor to bury them too deeply beneath the surface of the plaster. (The nails, apart from their venting function, help determine how thick the plaster should be.)

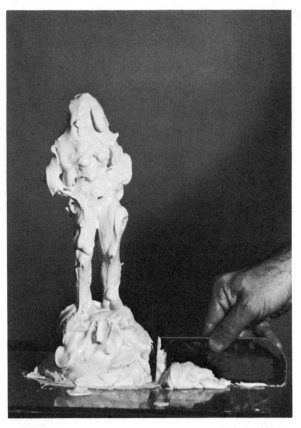

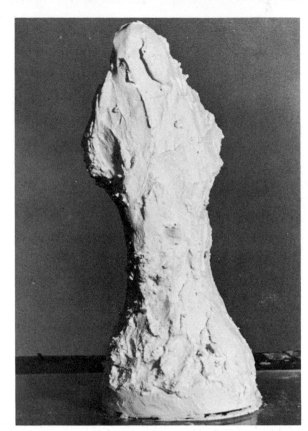

5. The cabinet scraper removes the excess plaster from the wax guide-ring at the base. Note how we hold the blade vertically to follow the guide-ring and thus shape a wall around the figure.

6. As the setting plaster heats up, the uncoated steel nails begin to rust with astonishing speed. Within half an hour, brown spots appear on the plaster where the nails are rusting near the surface. (These nails were deliberately chosen so they would rust. Should zinc or chrome-plated nails be used, the coating must be filed off the heads so they too can rust.)

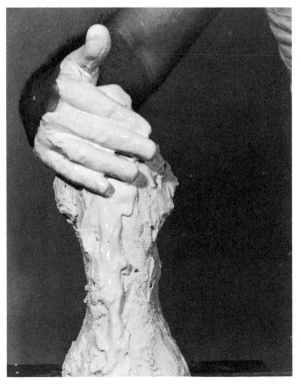

7. The brown spots make for fine visibility. Here we use a knife to scrape off any plaster that covers the nail heads. We then draw out the nails with pliers and press a small pellet of wax over each nail hole.

8. We mix a fresh batch of plaster and spread it thinly over the entire mold by hand. This thin outer coating seals in the wax pellets and prepares the mold for a reinforcing layer of burlap.

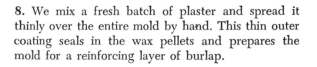

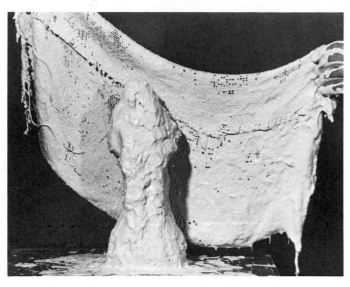

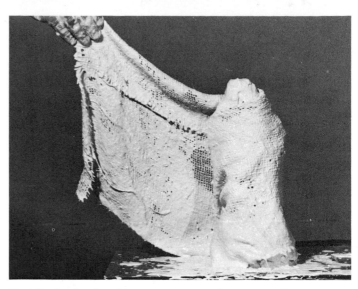

9. While the plaster is still fresh, we dip in a piece of the burlap. (It will serve as a binding to strengthen the mold.) Note that we have neatly folded its upper edge, then smoothed out its lower edge against the glass. Folding the burlap this way will make the mold easier to take apart later.

10. The burlap has been cut generously so it can be carefully wrapped twice around the mold. As we wind the burlap, we press it firmly in place.

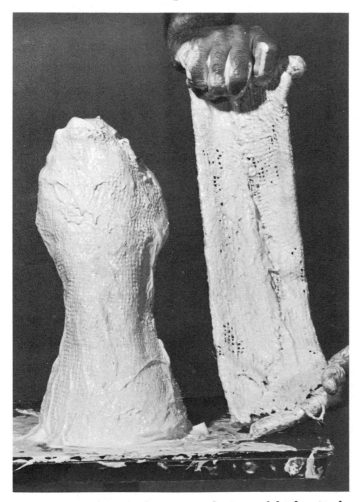

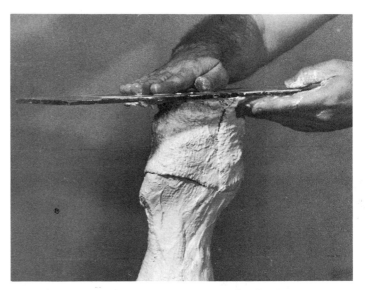

12. Since our mold will be turned upside down to pour the metal in, we must create a new flat surface on which it can rest. So we add enough plaster to fill the top of the burlap wrapping near the head of the figure, and now firmly press a sheet of glass over it to make this plaster level. We leave the glass in place until this plaster sets.

11. We now dip a second piece of burlap in the plaster and wrap it around the top of the mold. Note that its upper and lower edges are neatly folded here.

We'll digress now for the moment to show still another way of making a plaster mold for lost-wax casting. (This method is simpler and works best with smaller pieces of sculpture.) Here, we'll pour the liquid plaster around the figure, rather than build it up as we did before, with strips of saturated burlap. We'll also contain the plaster until it sets, with an enclosing dam or "flask." (Two figures will be used in this demonstration to illustrate two types of flasks.)

In addition to the plaster and wax used previously, we'll need a pane of glass as our work surface, a knife, electric wax-fusing tool, two or three large paper cups, a sheet of pasteboard (or the cardboard backs from a couple of legal-size writing pads) and a soft ½″ brush.

This is how paper flasks are made and the plaster then poured into them to form the molds:

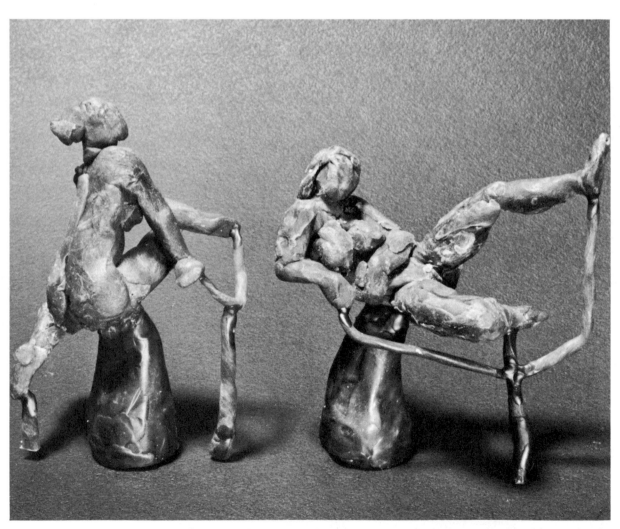

1. Using the principles already described, we have gated our small wax figures in the simplest possible way. Attached to the thickest section of each, is the sprue which here doubles as runner, gate, and riser. We have also attached vents to the hands and feet of both figures. (These will allow air to escape as the metal flows into the mold.) With the wax-fusing tool, we have firmly fastened the sprues and vents to our glass surface.

2. Shown here with the small wax figures are the materials we'll use in making our flasks. The sheet of cardboard, along with a second sheet, will be waterproofed to protect it against the liquid plaster, then shaped to conform to one of the wax figures. The paper cup, already waterproof, will have its bottom section removed so it can be shaped to enclose the second figure.

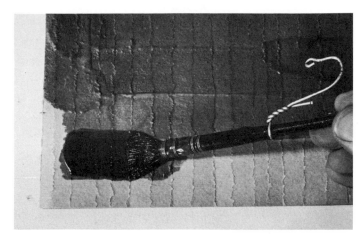

3. To make the cardboard bend easily, we score it with a series of parallel vertical lines. Next, we melt some wax and waterproof the cardboard sheets by brushing the hot liquid on, inside and out. Finally, we join the two sheets to make the enclosure, sealing the wax at the seams with our electric fusing tool. *Note*: The wire hook attached to the handle will keep the brush from touching the bottom of the hot wax container, thus preventing the bristles from being either burned or bent out of shape.

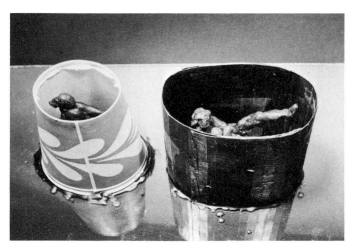

4. Both flasks are now in position. Each has been shaped to fit its own wax figure, leaving about ½″ of space between its walls and the piece of sculpture. Both flasks have also been solidly fastened to the pane of glass all the way around by holding a bit of wax against the wax-fusing tool and letting it flow into place.

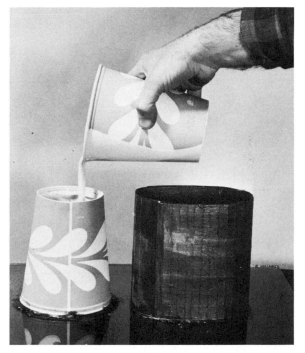

5. After mixing some fresh plaster, we pour each flask about one-third full. Then the pane of glass is immediately picked up with both hands and gently shaken and rolled. (This will remove any air bubbles that might cling to the wax. If the figures, their gating, or the flasks themselves are not firmly attached to the glass, this shaking activity might easily dislodge them.) While the plaster is still liquid, we fill the paper flasks all the way to the top.

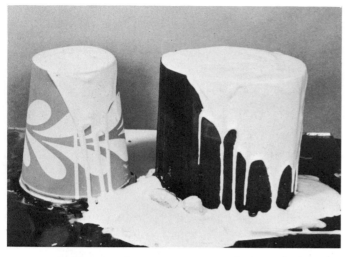 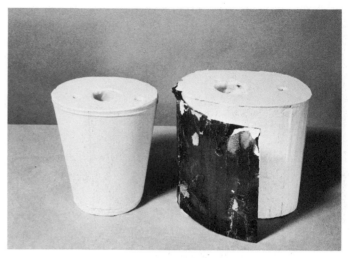

6. Even with precautions, accidents will happen. Our cardboard flask unexpectedly sprang a leak and a quantity of plaster poured out at that spot. We handled the leak simply, by placing a few small pieces of hard, set plaster at the point where the trouble started. This made the fresh plaster set quickly, creating a new seal which stopped the leak entirely. *Note*: The small amount of spillage seen at the top of both flasks is a natural overrun and presents no special problems.

7. After the plaster sets, we turn both molds over and peel away the cardboard and paper cup enclosures. This exposes the plaster to the air and helps it dry more quickly. (Although tin cans can substitute for the paper flasks, they're not as easily removed.) The sprues and vents which had remained fixed to the glass surface, have pulled out. Their locations are indicated by the holes seen in the bottom of the mold. To remove the remaining wax from the mold, we can either boil it or steam it out.

REMOVING THE WAX

Although foundries use special furnaces to burn out the wax, the sculptor working at home or in his studio can use the following methods:

Boiling Out the Wax. We fill a pot or container—large enough to hold the mold—with hot water at least an inch or two higher than the mold itself. We then place this pot on a stove or hot plate, bring the water to a boil and keep it boiling. The wax, now being melted out of the mold, will float freely to the surface of the water where it is skimmed off easily. We do this by alternately dipping a flat blade of either wood or steel into the floating wax, and then into a pan of cold water to chill it. After the wax builds up on the skimmer, we can cut it away with a knife and keep it for later re-melting and re-use.

When the wax has been completely boiled out (no more will float to the surface) we then remove the mold from the water. It should not be permitted to go on boiling beyond this point, because the plaster—being soluble in water—might lose some of its essential surface detail.

Steaming Out the Wax. This method of removing wax from the mold is more involved than boiling. It's done as follows:

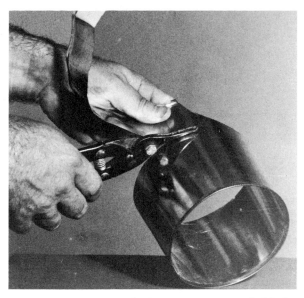

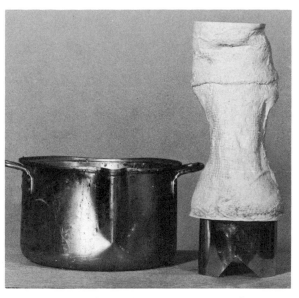

1. Here, we cut a rack from a tin can to hold the mold out of the boiling water. In both the top and bottom rim, we cut three or four deep notches. Those at the bottom permit the water to circulate; the others allow the wax to escape.

2. Here we see the mold sitting on its notched rack. The pan alongside will hold boiling water.

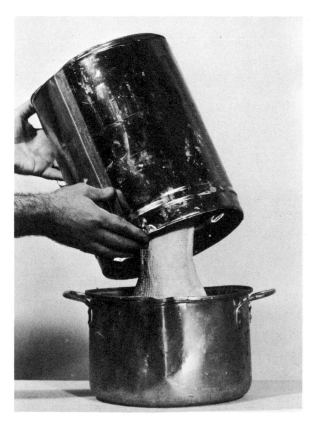

3. We now place the mold—with its sprue opening downward—on the rack inside the pan. (We put the rack in first, then the mold.) We then add water, bringing its level to within an inch of the mold. Here we set a lard can over the mold. This, acting as a cover, will keep the steam in the pan.

4. With the cover in place, the mold is being steamed. (This mold will be steamed more than two hours.) Because of evaporation, we must replenish the water from time to time. Therefore, we'll check the water level at intervals to add more boiling water as needed.

Notes on Steaming (1). To be certain all the wax melts out, it's better as a general rule, to steam a mold for too long, rather than for too short a time. If any wax remains, it will cause defects in the metal cast. One way to tell if it's all gone is simply by looking into the open sprue. If in doubt about this, however, wax floating on the water can be collected—after it has cooled—then weighed and checked against the weight recorded earlier. (This is possible because steaming does not vaporize the wax, as burning it out does in a foundry furnace.)

Notes on Steaming (2). If a large amount of wax is melted out in relation to the surface area of the boiling water, it will float to the surface and act as a kind of lid. If this wax layer is too thick, it can seal in the vapors of the boiling water, causing pressure to build up. The pressure, in turn, will shoot geysers of steam through the thick wax. If this pressure becomes intense enough, the lid will blow off the steamer and dangerously spew hot wax about. (The pressure is signalled by rumbling noises which gradually increase in frequency and intensity.) To prevent this pressure build-up, we melt out the wax in two stages. We turn off the heat before the mold is completely empty, let the water in the steamer cool, then remove some of the softened wax. Later, we reheat the water and complete the process.

Notes on Steaming (3). Although our demonstration called for a cooking pot, with a lard can cover, any improvised metal container can serve as well. For example, when steaming wax out of a larger mold, we can use a clean trash can or oil drum.

DRYING THE MOLD

Doing lost wax casting in the home or studio is simple and safe, provided certain precautions are observed, as noted earlier. Before any metal is poured, the mold must be completely dry. A damp mold is dangerous because molten metal will turn any moisture into steam, and steam can cause the molten metal to erupt explosively. These eruptions can lead to ruinous defects in the finished cast and, more seriously, to personal injury as well. Therefore, the most important step in the entire lost wax process is drying out the mold. The mold used in our demonstration was air-dried at normal room temperatures for a week, then heated three hours in the oven. For the first half-hour, the oven temperature was 500° F. As the plaster heated up this was gradually reduced to 250° F.

CASTING THE METAL

A number of metal alloys have melting points low enough to be handled on an ordinary kitchen stove. Tin, lead, linotype metal, babbit, and pewter all lend themselves to this simplified "top-of-the-stove" foundry work. Thus, anyone with a kitchen stove can cast his own metal sculpture and, in the

process, gain experience and a basic understanding of the lost wax process. For our metal-casting demonstration here, we'll use lead.

For this demonstration we will need: a large cast-iron pot and ladle, plumber's lead which comes in "strips" of five 5-pound units called *pigs*; a soft pine stick, a pair of protective gloves, a large water bucket, a vise, hammer, chisels, and other metal finishing tools; potassium sulfide (available from the drug store) and pastewax.

Note: The quantity of lead we'll require depends on how much our original wax sculpture weighed. As indicated earlier, our wax figure—including its gating—weighed nearly 11 ounces. Since lead weighs about 12½ times more than wax, we multiply this with the original weight of our wax—that is, 12½ x 11 ounces—and calculate about 8½ pounds of lead will be needed to fill our mold. In our calculations, we add another 1½ pounds as a margin of safety. Therefore, to make our cast, we know we must melt at least two 5-pound pigs of lead. We'll begin by melting and pouring the lead:

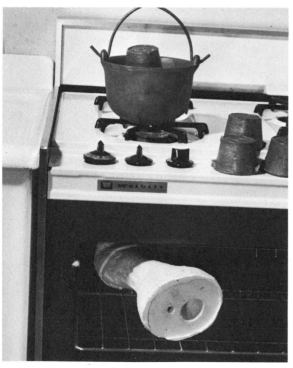

1. We break the lead "strip" into 5 separate units or *pigs*. Each one looks like an inverted flower pot. Here two 5-pound pigs melt in the iron pot, while three others are set to one side. (This pot with its 1½ quart capacity can hold as much as 40 pounds of melted lead.) We allow the thoroughly dry mold, hot from its heating in the oven, to cool somewhat by turning off the oven. While melting our lead, however, we leave the mold in the still-warm oven, since it should be just warm to the touch for metal casting. Note the openings in the mold: the smaller one on the left is the vent; the larger on the right, the sprue.

2. Here in the ladle is the now-molten lead. We use a pine stick to skim away the impurities so its surface becomes mirror-like. (Our stick also removes those impurities rising to the surface in the iron pot.) With this soft pine, we can test the temperature of the metal as well. When the wood chars slightly, we know the temperature of our lead is hot enough. *Note:* We should never pour metal any hotter than necessary for two good reasons. Excessive heat can create defects in the cast and also cause unhealthy vapors. (When melting lead, it's always a good idea to make sure the room has plenty of ventilation.)

3. We place the mold, sprue-up, on a heat-resistant work surface and ladle in the molten lead. (Gloves are worn to protect hands.) We work quickly with the ladle because if the lead begins to solidify before the mold is full, the finished cast will have layer-like lines or stratifications. Any remaining metal in either pot or ladle is left to harden. Later, it can be re-melted and used again.

4. As the sprue is filled, the metal in the mold cavity wells up; its excess flows out of the vent at left. This indicates we have poured in a sufficient quantity of metal.

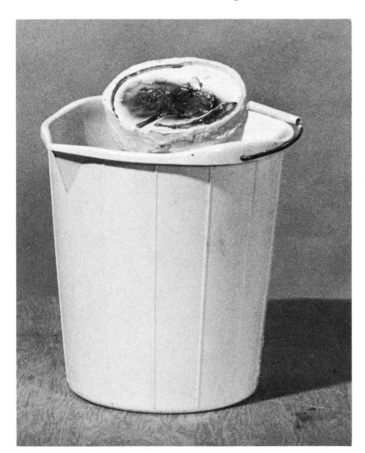

5. Next we half-fill the bucket with cold water and a few moments after the lead is poured—and when the sprue has solidified—we place the mold in the bucket to cool the metal and soak the plaster.

6. After about 15 minutes of soaking, the lead has partly cooled and the plaster becomes softer and weaker. Here a hammer and chisel are used to loosen the end of the burlap strip and to open the wet mold.

7. We now pull away and unwrap the neatly-folded burlap. Note that the last piece is removed first.

8. Here the second layer of burlap has been loosened. Parts of the metal cast, such as the top of the head; and edge of the base are now revealed.

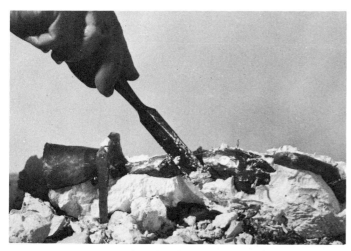

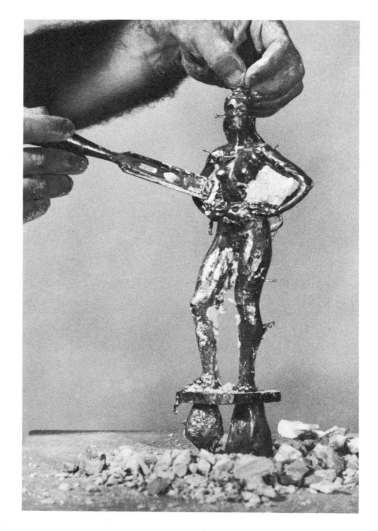

9. We use the chisel carefully to break away the remaining plaster of the mold.

10. Our cast emerges. Only one substantial piece of plaster remains under the left arm. Also to be removed are the nails, sprue, and riser, all cast now in lead.

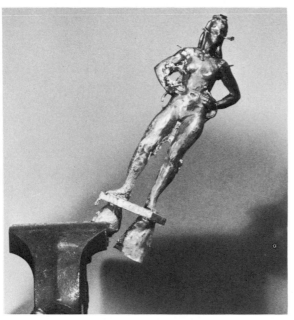

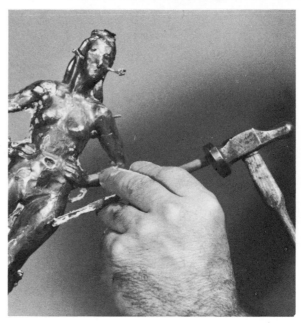

11. Here is our cast—with the plaster removed—conveniently held in a vise by the riser. It is ready now for the chasing process. Since lead is such a soft metal, we can easily work the piece with files, knives, and sandpaper. (Bronze and harder metals require more complicated tools.)

12. We chop off the blind vents—created by the nails—with a hammer and small chisel. Note the metal fin or webbing that formed between the legs. (Responsible for this were small cracks in the mold, probably caused by heat.) A knife or chisel will remove this defect easily.

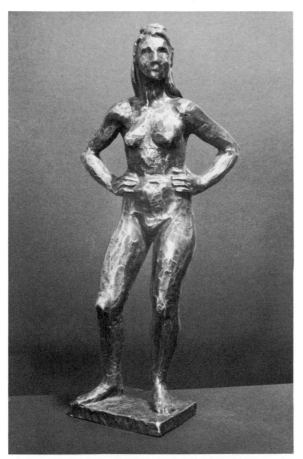

14. To add the patina, we fill our tin can with water, add a quarter-ounce chip of *potassium sulfide* (liver of sulphur) and bring this to a boil. Then we tie a string around the arm of the metal cast and lower the entire cast into the boiling solution, leaving it there for about 20 minutes. (The longer we leave it there, the blacker the patina will become.) The string itself will leave no mark. The cast can be lifted out at intervals to see if the metal has darkened sufficiently according to personal preference. For the potassium sulfide, an ounce of plasticine clay can be substituted, but this solution will require a much longer boiling period to color the cast. *Note*: A lead cast left outdoors will naturally take on a similar blackish color, if given years to weather.

13. We've completed chasing our cast. We have reproduced our original wax sculpture in metal, including all its surface details and texture.

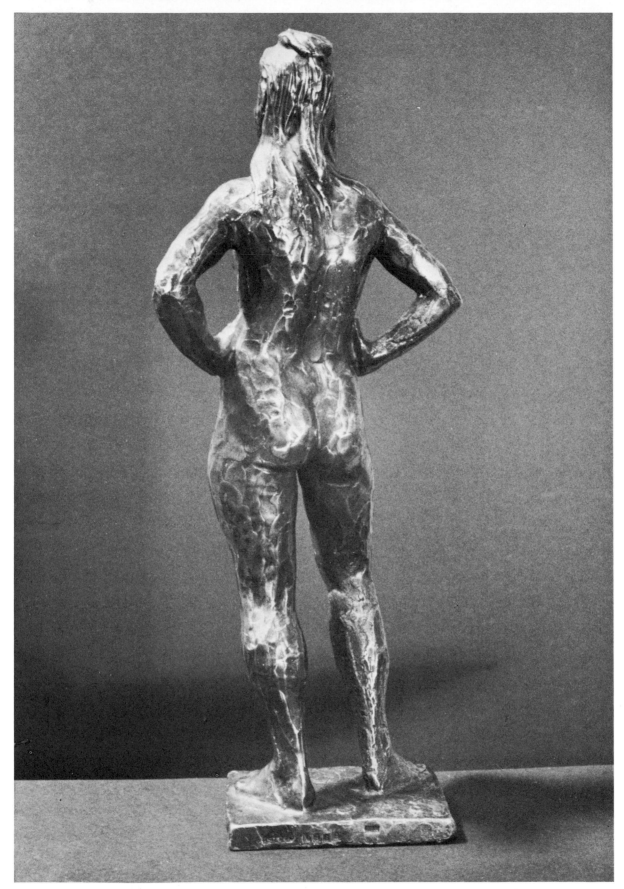

15. When the patina is done, we brush a coat of pastewax over the metal surface, allow it to dry, then use a soft cloth to polish it lightly. The pastewax creates surface highlights and also protects the patina. Here, shown in rear view, is our finished cast.

TERMINOLOGY OF MOLDS

Model or Pattern. Any object, ranging from a simple sheet of plastic or a wooden dowel, to a sculptor's original work, to be duplicated by the mold-making process.

Mold. A negative of the model or pattern; a cavity or container into which the positive may be poured. The mold is generally concave while the model is convex. (At specific points, however, the mold is convex where the model is concave.) Molds may be made of plaster, metal, plastic, flexible rubber, gelatin, etc. Some can be made for one-time use only; others are "permanent" molds to be used a number of times. (See Mold Types, page 151.)

Cast. The positive object produced by the negative mold. The verb "to cast" refers to the act of using a mold and usually means pouring a liquid material into a mold, where it can then solidify into a cast. Wax, plaster, plastic, or metal may be used as the liquid casting material.

Draft. A condition implying the absence of obstructions or mechanical interlockings between cast and mold. Draft refers to the shape of a positive and negative which permits them to be drawn apart easily; that is, the positive cast can be drawn out of the negative mold, without damage to either.

Undercuts. The specific areas whose shape causes mechanical interlocking between either model and mold, or between mold and cast. These mechanical obstructions prevent the separation of the positive from the negative. Most molds are named for the way in which they overcome the problem of undercuts. (See Mold Types below.)

Note: The diagrams below show both draft and undercuts.

The two molds of this sphere illustrate draft. The sphere at left has been divided at its largest diameter so the two halves are equal. This makes for a simple mold with draft and no undercuts. The one on the right, parted below the center, has both draft and undercuts. The smaller section below has draft, while the larger one above has undercuts. These undercut areas, shown in black, form an obstruction to removing the positive cast.

Parting Medium or Separator. A coating or thin film of material, such as soap or oil, which separates the mold from its model or cast. This coating keeps the cast or model from adhering to the mold, and so makes possible its eventual removal.

Parting Line. A line on the model or pattern where the two main sections of the mold meet and fit together.

Dam. A temporary vertical enclosure built—as with wooden rails—around a model. This contains within its confines the liquid material poured over the model, which solidifies and becomes the mold.

Registration Key or Point. A notch or negative hemisphere carved into the first half of a mold, which will create a positive counterpart in the second half. The two align both halves of the mold and together act as a "key" to hold them in place.

Sprue. An opening in a mold through which the liquid casting material is poured.

Mold Types.

A. PERMANENT MOLDS. These overcome their undercuts as follows:

1. *Simple molds* are made on patterns from which all undercuts have been eliminated. (The molds in Chapter 10 for rods, sheets, and armatures were all such simple molds.)

2. *Piece molds* are made as a series of parts—each of which has draft—permitting them to be conveniently disassembled.

3. *Flexible molds* are made of rubber or gelatin, which can be bent, flexed, or stretched over the undercuts.

B. ONE-TIME MOLDS. There are two types. Both overcome the problem of undercuts by requiring that the model be destroyed to remove it from the mold and that the mold later be destroyed to remove the finished cast.

1. *Waste molds* are made in two or more pieces so they can be opened to prepare the surface with a separating medium before the cast—usually plaster—is made. They get their name because the mold is destroyed or "wasted" once it has fulfilled its function.

2. *Lost wax molds* are made in one piece—of plaster and various refractory materials. They get their name because the wax model is melted out, vaporized, and "lost."

Appendix

Working With Models

When life models are not readily available, the sculptor can turn to an unusual collection of photographs of the human figure developed specifically for him.

MODELS FOR SCULPTORS

This photographic collection consists of a number of life poses directly related to three-dimensional space. In using them, the sculptor does not think in terms of one flat image, as he would with conventional photographs. Instead, he perceives the figure in the full-round, much as he does when actually working from life.

The inherent two-dimensionality of the photograph is overcome by showing *eight separate views* of each pose; then arranging these in space around a rotating column. When the sculptor looks at each view directly, he also can see obliquely at either side the two adjoining views. When the column is rotated (in either direction), the "model" is seen, not as eight separate figures, but as a continuously changing view of one unified central figure. Thus, the sculptor is required to take all views into consideration as he works.

This unique collection, called "Multiview Models for Painters and Sculptors" is available from Ibrod Associates, 64 Grand Street, New York, N.Y. 10013.

CONSTRUCTING A MODEL STAND

The ideal stand for life models is one which rotates. Its platform should be sturdy plywood with a minimum area of 30″ square or about 2′ by 3′. It should be large enough to permit a range of movement by the model and also provide sufficient space for a chair or other small prop. For reclining poses, a ready-made flush door, or else a plywood panel about 2′ by 6′, can be attached to the platform temporarily with screws, bolts, or clamps.

These are model stands to improvise or build:

(1) Mount the plywood platform or a large wooden box about 12″ to 18″ high, on ordinary furniture casters. (Although this is the simplest to assemble, it will shift around somewhat as it is turned, because of the swivel casters.)

(2) Mount the platform as a turntable on a "lazy Susan" bearing. (This is sold at hardware stores.) Since the pivot is relatively small, support the platform's outer edges with 6 to 8 furniture casters.

(3) Mount the platform as a turntable on a larger "fifth wheel" bearing. (This is available from sculpture supply houses, listed on page 171.)

(4) Buy a second-hand barber's chair from a barber's supply house. (These are often reasonably priced.) Remove the seat section and bolt the plywood platform to the base of the chair. The base will turn freely and can easily be raised and lowered. This makes for a turntable that's both versatile and solid.

Working With Wax

Microcrystalline wax can be purchased in either small or large quantities. The beginner will find that most art supply stores stock the wax, or a blend of it, prepared especially for modeling. The serious sculptor will want to get his supply directly from the oil companies which manufacture it. Prices are much lower and deliveries generally prompt. Regardless of where the wax is purchased, plasticity is the characteristic to seek out. This plasticity is easily determined by pinching a bit of the wax between the fingers.

BUYING WAX

Microcrystalline waxes come in blocks that are 1½″ thick, about 19″ long and 11¾″ wide. Each weighs approximately 11 pounds. Art supply stores sell them by the block; oil companies by the case. (A standard case contains five or six blocks.) Since it's costly and impractical for the manufacturer to break up the package, the minimum order must usually be for one or two *full* cases.

Because oil companies sell their waxes primarily for industrial purposes, they offer many grades, use complex technical classifications and specialized terminology in describing them. Thus a salesman for one of these large companies—no matter how well informed in his own field—may have some difficulty in recommending a wax most suitable for a sculptor's particular needs. To communicate with him, the sculptor would have to be able to read the complex data sheets published by the industry (which describe the various properties of waxes, and are based on test methods established by technical associations of the industry). Unless the sculptor can specify waxes in some of these specialized terms, there is likely to be a language barrier in satisfactorily establishing his wholesale source. The following, therefore, is intended to provide him with the necessary background information for accomplishing this.

Although various tests have pinpointed the exact properties of microcrystalline waxes, only two such properties are important to the sculptor. These, in combination, indicate whether or not the wax is likely to be good for his purposes. The key properties are:

The Melting Point or the temperature at which a given wax will change from a solid to a liquid. This provides some idea of the temperature at

which the wax will soften. The best choices have melting points well above room temperature.

The Needle Penetration or the depth to which a standard test needle will penetrate the wax under certain conditions. This indicates the hardness and consistency of the wax at a given temperature (usually 77° F.) and is measured in tenths of a millimeter. Penetration numbers on the low side indicate a harder wax; those on the high side, a softer consistency.

Waxes with good characteristics for modeling can be found within the following ranges:

A melting point from 140° to 180° F.

A needle penetration of 20 to 40 (at 77° F.)

By specifying microcrystalline waxes in this range, the sculptor can enable the industrial salesman to recommend grades suitable for him. The sculptor, before making his final judgment however, should request a sample and determine its plasticity with his own fingers. A selected list of waxes follows.

CHART OF MICROCRYSTALLINE WAXES

COMPANY	PRODUCT	COLOR	NEEDLE PENE-TRATION	MELTING POINT
Bareco Wax Division Petrolite Corporation 119 Coulter Avenue Ardmore, Pa. 19003	Ceraweld	brown	25	155°F.
	Victory	brown	30	155°F.
Eastern Mohair & Trading Co. 58-65 56th Street Maspeth, N.Y. 11378	Modeling Wax No. 175	brown	25	165°F.
Frank B. Ross Co., Inc. 6-10 Ash Street Jersey City, N.J. 07304	Sculpture Wax No. 1203/1	white	30	170°F.
	Sculpture Wax No. 64-0064	white	70	170°F.
Humble Oil & Refining Co. Houston, Texas 77000	No. 1500	yellow	27	149°F.
	No. 1750	yellow	22	175°F.
Mobil Oil Corporation P.O. Box 508 Philadelphia, Pa. 19105	No. 2300	brown	27	170°F.
	No. 2305	yellow	27	170°F.
Warwick Wax Division Western Petrochemical Corporation P.O. Box 558 Chanute, Kansas 66720	No. 150-A	brown	25	160°F.
	Warcosine	white	30	155°F.

Note: Two useful reference books on the subject are:
Industrial Waxes (2 volumes)
H. Bennett
Chemical Publishing Co., N. Y.
The Chemistry and Technology of Waxes
Albin H. Warth
Reinhold Publishing Corp., N. Y.

WARMING WAX

Wax placed in a metal container can be softened by the heat of an ordinary light bulb. (Bulbs of different wattages will produce differing degrees of heat; see page 47.) For effective warming, the container must be covered and some space left between the wax and the lid. Instead of an ordinary lid, however, a photographer's reflector light is used. This not only covers the can, but provides the necessary mounting for the light bulb. When the cover is lifted off to get at the softened wax, the hot light bulb is conveniently out of the way.

A standard reflector light can be purchased in any photographer's supply shop. The size chosen should be slightly larger in diameter than the can that holds the wax. If the reflector has a spring clamp, this will serve nicely as a handle. For even greater convenience, the handle can be modified to make the reflector easier to hang out of the way, when not in use.

To improve the handle, replace the spring clamp with a bar of aluminum —about 15″ long and 1″ wide. Bend this sharply to form a hook, as shown. Drill two holes in the aluminum bar, corresponding to those in the original spring clamp and attach the handle, using the original bolts. As a further convenience to prevent slipping, add a third bolt at the top, as shown, that can serve as a hanging pivot. Then to get this reflector lid out of the way, hang it from any horizontal surface—table, shelf, or model stand.

To stabilize the reflector light when it doubles as a lid, so it won't tip or slip off the wax can, place two aluminum or other light-metal ¼″ rods across the face of the reflector. (Have these a little longer than the diameter.) Space the rods so they won't interfere with changing the light bulb. Then, at those locations in the rim of the reflector, drill 4 holes, ¼″ in diameter. Put the rods through the holes, then fasten in place by bending the ends with a pair of pliers. *Note:* The rods won't slip out if their ends are threaded first and then nuts added to hold them in place.

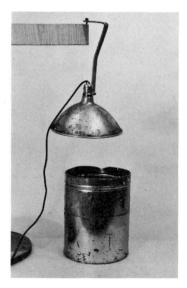

Wax-warming can and the photographer's light above, that serves both as its lid and heating element. Note the modified handle and hanging pivot.

WAX-FUSING TOOLS

Readily available for fusing wax are electric hand tools designed for other purposes. These include small soldering irons and the wood-burning tools used in arts and crafts. Despite their differing functions, they're similarly constructed. Both have an electric heating element attached to an insulated handle, with the heat directed toward a metal tip.

When buying such tools, the most important considerations are: (1) the size or wattage of the heating element; and (2) whether the tool can be disassembled to take apart the heating element, handle, and metal tip.

WATTAGE

Low heat is best. High heat causes the wax to burn and builds up a charred crust on the tool. This, apart from reducing the tool's effectiveness, creates ugly blotches on the work itself. For best results, a 23 to 30 watt element is recommended. In special cases, involving larger areas of wax and larger metal tips, an element of 35 to 50 watts can be used.

DISASSEMBLING

An electric tool that comes apart has several advantages. The heating element, which screws into a handle socket, can be replaced when it burns out. The metal tip, which screws out of the element, can be alternated with other ready-made tips; or modified, by altering its shape and size to suit the special needs of modeling wax. To modify the wax-fusing tool, first unscrew the tip, then flatten with a hammer—if long—to give it a more useful spatula-like shape. If short, notch the tip with a file. Then make an extension tip of copper, aluminum, or mild steel. Fit the new tip into the notch and fasten in place with a rivet. (See diagram.) *Note*: Both lengthening the tip and using the rivet, which is an indifferent conductor, are also ways of reducing the heat at the tip of the tool.

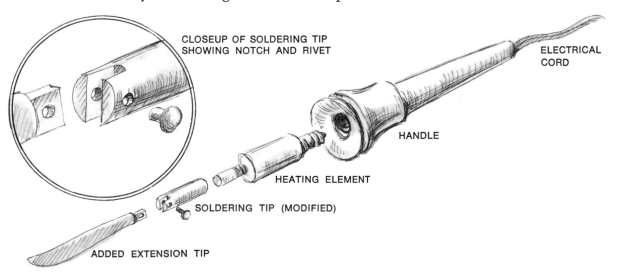

CLOSEUP OF SOLDERING TIP
SHOWING NOTCH AND RIVET

ELECTRICAL CORD

HANDLE

HEATING ELEMENT

SOLDERING TIP (MODIFIED)

ADDED EXTENSION TIP

When heated and in use, the wax-fusing tool should always be pointed tip down. This will prevent melted wax from getting into the heating element. If wax does get in, it can break the electrical contact between the heating element and the socket, or it can ruin the heating element entirely. If contact is interfered with, *unplug the tool.* Then carefully scrape the wax off the element's socket and threads. If the element is burned out, replace it altogether.

The wax-fusing tool can be kept in its proper tip-down position (when heated and in use), if provided with a special holder. To make this holder, pour a little plaster or lead into a small tin can. This will give the can weight and keep it from tipping. When the wax-fusing tool must be put aside briefly, set it in this holder, point down.

USING AN ALCOHOL TORCH

Small alcohol torches, fitted with blowpipes, are used for smoothing the surface of wax. Such torches can be found in most hardware stores. The one shown is a simple metal cylinder with a screw cap at either end. The upper half contains a heavy cotton wick; the lower half holds alcohol to be used as fuel. The small metal blowpipe to the side, with a tiny aperture at the top, slides into the position shown. A rubber tube connected to the blowpipe is used to conduct air to this aperture. To use the alcohol torch, first remove the lower cap. Invert the torch and fill the bottom cylinder with alcohol. Replace the cap. Remove the upper cap, slide the blowpipe into position, then light the wick. (*Caution:* Before striking the match, wipe up any spilled alcohol or let it evaporate completely.) Blow air through the rubber tube to focus a pinpoint of flame on your work. With practice, you can learn to control this flame with great accuracy. *Note:* Always use your flame sparingly so as not to obliterate any modeling or surface detail on the wax. Also, frequently chill the piece in the refrigerator to avoid a general build-up of heat within the wax itself.

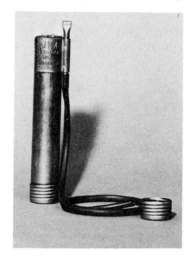

Alcohol torch with blowpipe and rubber tubing. Note that blowpipe is in working position near the wick. The upper screw cap is at right.

IMPROVISING AN ALCOHOL TORCH

Shown are two oil cans, available anywhere. One appears before conversion into an alcohol torch; the other after. To make this torch, saw off the long spout of the can, leaving a short stub. Solder the spout to two metal strips. Position these for blowing the flame, as shown, and solder in place. Improvise the wick by wrapping a bundle of ordinary cotton string around your hand, then twisting and stuffing this into the stub of the spout. Fill the can with alcohol. (*Caution*: Unless the spout is long enough to keep your face a safe distance from the flame, attach a length of rubber tubing to the wider end of the spout and use as above.)

Note: The soldered metal strips can be eliminated altogether and the unattached spout held by hand. Although both hands may be required to operate it, the fact that it's unattached makes for a different kind of flexibility in using this improvised torch.

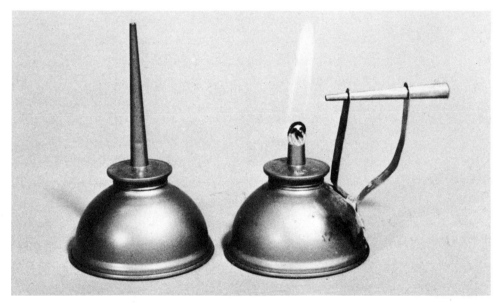

Oil cans, before and after. The can at right has been converted into a simple, but effective alcohol torch.

Working With Plaster

No matter how simple or how elaborate a sculptor's studio is, a supply of plaster is essential.

BUYING PLASTER

The beginner may purchase plaster in relatively small quantities (in 10- and 25-pound bags). Most plasters sold at hardware stores, however, being formulated with other ingredients for wall-patching purposes, are generally unsuitable for all aspects of sculpture. Small packages of plaster, therefore, are best bought in art supply stores.

Such plaster, sold in small quantities, usually comes from distributors who buy in bulk from the major gypsum manufacturers, then repackage the product under their own names. This is always more expensive, since repackaging adds to its cost. Also, plaster bought in small quantities may be insufficient for the work at hand. (It takes more plaster to do a piece of sculpture than one would normally suspect.)

The serious sculptor, when buying plaster, soon learns to think in terms of 100-pound units. This is the standard bag size, used by the major manufacturers to package all of their hard and most of their soft plasters. They do, however, sell common soft plaster in smaller (25 to 50 pound) sacks.

SOURCES

In the United States, two major producers of gypsum plaster offer wide distribution of their products. In certain regional areas, other large companies also provide good distribution. The major producers are:

United States Gypsum Company
101 South Wacker Drive
Chicago, Illinois 60606

Gypsum Division
Georgia Pacific Corporation
Commonwealth Building
Portland, Oregon 97204

The dealers for these and the other plaster producers can be found in the Yellow Pages of the telephone directory under such headings as:

Art Supply	Masonry Supply
Building Supply	Paint Stores
Dental Supply	Plumbing Supply
Hardware Stores	Plaster
Hobby Shops	Sculptor's Supply
Lumber Yards	

SELECTING PLASTER

There are two types of soft plaster: (1) common soft plaster, and (2) statuary or casting plaster. Common soft plasters, irrespective of manufacturer, are much alike. They perform well if stored properly, and used before they're too old. (Plaster will keep more than a year under warm, dry conditions.) The second type—statuary or casting plaster—includes a small percentage of additives, used to create a surface hardness. The usual additive is dextrine, which dissolves during the mixing process and later migrates with the "free" water to the surface of the setting plaster.

When the water evaporates, the dextrine remains on the surface of the plaster as a thin deposit of harder material. These hard-surfaced plasters are best for making casts, but can be used for modeling, provided the piece is completed before the plaster has fully dried. If it hasn't been completed by then, the surface crust will become a nuisance when carving or filing is required.

Hard plasters are manufactured to more exact standards, since they're designed for specific industrial applications. Their performance thus varies accordingly. The following list includes hard and soft plasters, as described by their manufacturers, with their uses for sculpture also indicated. USG denotes the United States Gypsum Company, while GPG represents the Georgia-Pacific's Gypsum Division.

Common Soft Plasters Without Additives (Suitable for Modeling, Casts, or Molds). These plasters are produced by many companies under a large number of brand names. They're widely available under such designations as:

> Molding Plaster
> Dental Plaster
> Plaster-of-Paris
> Pottery Plaster

Soft Plasters with Dextrine or Other Additives (Suitable for Casts).

USG: Art Plaster
Number 1 Casting Plaster

GPG: Statuary Casting Number 1
Regular Statuary Plaster

Hard Plasters (Suitable for Direct Modeling and Casts).

USG: Pattern Shop Hydrocal—moderately low-expansion gypsum cement with a long period of plasticity

Industrial White Hydrocal—high expansion material with a somewhat shorter working period

GPG: Densite K-25—low-expansion gypsum cement with good plasticity

Tooling Densite—low-expansion, high-strength material with special ingredients to insure a long working time

Note: Plaster with a high-expansion factor, having no additives, is somewhat easier to remove from mixing pans and equipment after it has set. Low-expansion plaster, having additives, is somewhat more difficult to remove and also has a shorter storage life.

Super-Hard Gypsum Products (Suitable for Casts Only).

USG: Hydro-Stone
Super Hydro-Stone

GPG: Denscal ST

Dyed Plasters (Suitable for Casts Only).

USG: Ultracal 30
Ultracal 60

GPG: Densite K-33

Note: These plasters have a green dye added, to make identification easier for shop purposes. If the color is objectionable for sculpture, the plaster can be finished in various ways.

As indicated earlier, products made for plastering lath or patching walls —and sold in hardware stores—are generally to be avoided. These, being chemically retarded to set in from 1 to 3 hours, not only solidify more slowly, but don't get as hard as regular gypsum plasters.

COMPARISON OF THE PHYSICAL PROPERTIES OF
SELECTED GYPSUM PLASTERS

MANU- FACTURER	PARTS WATER NEEDED PER 100 PARTS PLASTER (BY WEIGHT) TO MAKE A MIXABLE SLURRY	MANUFACTURER'S NAME FOR PRODUCT	SETTING RANGE: IN MINUTES	DRY COMPRESSIVE STRENGTH: IN POUNDS PER SQUARE INCH
GPG	75 – 77	K55 Pottery Plaster	25 – 35	1,700
USG	64 – 66	Industrial Molding	25 – 30	2,000
USG	54 – 56	Pattern Shop Hydrocal	20 – 25	3,200
USG	40 – 43	Industrial White Hydrocal	20 – 30	5,500
GPG	41 – 43	Denscal WH	20 – 30	5,700
GPG	39 – 41	Densite K25	25 – 35	6,000

USG	35 – 38	Ultracal 30	25 – 35	7,300
GPG	32 – 34	Densite K5	15 – 20	9,500
USG	28 – 32	Hydro-Stone	20 – 25	11,000
GPG	29 – 31	Denscal ST	25 – 35	11,000
USG	21 – 23	Super X Hydro-Stone	17 – 20	14,000

SEPARATING MEDIUMS FOR PLASTER

Since one batch of plaster normally tends to bond to another, making a plaster cast in a plaster mold might create problems. Fortunately, using a separating medium between the two can prevent such bonding.

For small work, the best parting compound is soap, particularly neutral oil soaps in heavy paste form, made especially for this purpose. These, such as English Crown Soap, are available from sculpture supply houses (see page 171). Another good separating medium is Murphy's Oil Soap. This household cleaning product is sold in grocery, variety, and hardware stores. Other useful substitutes are shaving soap in cake form, liquid hair shampoo, green surgical soap, and heavy liquid industrial floor soaps.

Soap, as a separating medium, has a number of advantages: It won't clog or blur any of the plaster mold's fine detail; it will react chemically with the mold to produce a waterproof substance (calcium stearate) on its surface. This substance prevents bonding with the cast, without actually creating an intervening layer of any discernible thickness.

To use soap for this purpose, apply it vigorously to the mold, with a circular motion of brush or sponge. (The action is much like that of a barber lathering up.) Thoroughly work the rich, thick lather over the entire surface. Then flush it away with running water. Repeat this lathering and rinsing at least twice more, or until water droplets stand on the surface of the mold as sphere-like beads. If the droplets soak into the mold and are absorbed by it, more vigorous soaping is required.

To prevent plaster from sticking to wooden patterns, rails, benches or other equipment; or when larger plaster molds are involved, the separating medium is more often oil or wax. Here the plaster or wood surface is sealed first with a thin coating of shellac before the separator is brushed on. This prevents the separating medium from becoming absorbed into the porous surface and so assures uniform separation. Some mediums, most frequently used for this, are:

Paste Wax Thinned with Benzine: Combine these in about equal quantities and mix well together. No heating is necessary.

Steric Acid Thinned with Kerosene: Steric acid is a wax. Shave ¼ pound of this into fine flakes and melt in a double-boiler. Remove from heat. Slowly stir in kerosene until the mixture is uniform.

Petroleum Jelly Thinned with Kerosene: In a double-boiler, warm two parts kerosene to one part petroleum jelly; stir thoroughly.

(*Caution*: The mixtures above are highly flammable and should be treated accordingly. Always use a double-boiler when heating them and do not leave them unattended.)

Note: Mineral oil, light lubricating oil or sweet oil may be used alone as a separating medium on shellac-sealed plaster molds, but should be applied with restraint to prevent any blurring or obscuring of surface detail.

FINISHING PLASTER

Plaster sculpture is given a surface coating or finish (1) to color it as a continuing part of the creative process; (2) to simulate another material such as bronze or marble; or (3) just to protect the plaster by sealing its porous surface against dust and dirt. This finish is often referred to as the *patina,* a term borrowed directly from finishing bronze sculpture.

There are two basic requirements for plaster finishes: (1) the plaster must be thoroughly dry, and (2) the surface coating must be applied thinly. The dryness can be checked by holding one's face against the piece. This will indicate if the plaster feels the least bit damp or cold. If it does, it needs more drying time. (To speed up drying, see page 77.) The thickness of the surface coating should be kept to a minimum so as not to fill in the texture, obliterate any fine detail, or generally soften the edges of the work. The finish, in other words, should be thought of as lying *in*, rather than *on* the surface. It should penetrate the surface, with any excess wiped or brushed away.

Many interesting finishing effects are possible for plaster. These include painting, staining, sealing, antiquing, waxing, and dusting. Their basic principles, and some examples of each, follow.

PAINTING PLASTER

The simplest and most obvious finish for plaster is a coat of opaque paint applied evenly to the sculpture in any color desired. This may be brushed or sprayed on for an all-over effect. *Note*: Another material which can be similarly brushed on is old-fashioned stove polish. This, which contains graphite, will produce a convincingly metallic surface.

STAINING PLASTER

The surface of unsealed plaster can be attractively stained by the application of a thin liquid color solution. The thinning is done with a suitable solvent; turpentine or mineral spirits for oil paints; alcohol for shellac; and water for inks and watercolors. Dry pigments mixed with water will also

make staining solutions; even clay slip can be used in this way.

Because the plaster surface differs in density, the effect of these solutions is never completely predictable. Considerable variations in color can occur throughout the work. The results sometimes are surprisingly beautiful. In other cases, the stained effect will be modified with other finishes applied over it.

Here are three ways of staining unsealed plaster:

(1) Dissolve a handful of clay in a large tub of water. Immerse the plaster for several minutes, then wipe dry. (This is an exception to the basic requirement that the plaster be thoroughly dry before applying the finish.)

(2) Dilute ordinary wood stain with benzine or mineral spirits. Dip a sponge in this solution and wipe with a vertical stroke over the cast to produce a wood-grain effect. This technique is especially effective if the sculpture has a wood-like texture.

(3) Greatly dilute transparent watercolors. Use successive washes of color to create a translucent effect. (Once these colors are applied, they won't readily wash off.) Let the piece dry thoroughly—overnight is usually sufficient. Then seal its surface with lacquer or varnish. This technique works best with small pieces. *Note*: Although the general rule for plaster finishes is to keep the coatings thin, a transparent lacquer of considerable thickness (applied as a series of thin coats) over a color-stained surface, can be quite attractive.

SEALING PLASTER

Depending on the effect desired, the surface of plaster sculpture can be sealed during different stages of the finishing process. That is to say, the color finish can be sealed either in or out. In the watercolor-staining above, lacquer was used as a last step to seal the color in. In other cases, if the piece is to have a smooth, even color, sealing the color out can be the first step. To achieve this effect, apply a coat or two of very thin shellac to the surface of the plaster. When this sealing coat dries, brush or spray on an all-over color, using enamel or lacquer paint. Especially convenient for this is paint that comes in spray cans.

Note: The shellac, when dry, should look flat and dull. This indicates it has properly penetrated the surface. If it looks shiny, this means it was applied too thickly. The excess can be removed, however—even if the shellac has dried completely—by vigorous brushing with an alcohol solvent.

ANTIQUING PLASTER

This calls for the color to be painted on, then wiped away at once, leaving behind only a trace to accent the deep places of the work and its surface

texture. Any piece which has already received a solid base-coat color, can be enlivened by this method. The antiquing color may be a white or light color applied over a darker-colored base coat; or it may be darker than the base coat to produce a shadow-like effect.

Here are two ways of antiquing plaster:

(1) Spray the sculpture with a metallic paint, such as copper, aluminum, bronze, or gold. Let dry. Then apply an oil paint, such as burnt umber, Van Dyke brown or Prussian blue, thinning it slightly first with turpentine or linseed oil. Wipe off most of the oil paint with a soft cloth.

(2) Paint the sculpture white, buff, or ivory by spraying the color on, or applying it with a brush. Let dry. Then brush burnt umber over the entire surface (thinning it first with mineral spirits, if ground in linseed oil, or extending it with a clear varnish or painting medium if the pigment is dry). Carefully wipe off most of the umber with a soft cloth.

Spattering Plaster

Here oil or other opaque paint is sprayed on in small droplets, rather than applied as a continuous coat of color. This is easily done by using an ordinary toothbrush, along with either a knife or a stick. Dip the toothbrush lightly in the color, then stroke the bristles with knife or stick, away from the work. As the stiff bristles bend and then are suddenly released, they will throw the paint onto the plaster in a series of small individual dots. When using a spray gun, a similar effect can be achieved by reducing the amount of air pressure. Here are two ways of spattering plaster:

(1) Begin with the simulated wood grain, described earlier in staining. Spatter this lightly with black paint. The speckling will suggest pores—or perhaps worm holes—in the wood.

(2) Alternately spatter a piece of plaster sculpture dark and then light. Start by painting on a light-colored base coat. Then spatter it first with a color that's darker; followed by a color that's lighter. This contrast will suggest the granular structure of stone.

Waxing Plaster

Wax, usually pastewax, can be used to finish plaster in various ways: as a stain, surface sealer, or antiquing medium. And it can, with buffing, produce a polished sheen. Pastewax can also be colored lightly by blending in dry pigments; or by melting it with dime-store wax crayons. For darker colors, ordinary shoe polish is a ready-made source for a variety of other effects.

To assure the penetration of wax into the plaster surface, first warm the sculpture in an oven, then melt the wax on the top of the stove. (*Caution*:

Pastewaxes should always be thinned with a little benzine. Since this mixture is highly flammable, combine them away from the stove and always use a double-boiler when heating them.)

Here are three ways of waxing plaster:

(1) Warm the sculpture in the oven. Color the wax by adding either pigments or crayons and heat the mixture on the stove until hot and thin. Apply the wax with a brush. Buff lightly for a waxy luster. (The color will be interestingly mottled, due to density variations in the surface of the plaster.)

(2) First simulate a bronze patina by combining a dry pigment with a little shellac and brushing this over the entire surface. (If the shellac is used sparingly, a soft powdery effect, much like an actual bronze patina, will result.) Green and turquoise pigment will look like copper nitrate, black pigment, like potassium sulfide; while burnt sienna will simulate ferric nitrate on bronze. Seal in the patina by brushing with clear pastewax. Then, with a cloth, polish gently until the finish is soft and lustrous.

(3) Seal the plaster surface with shellac. Then, as described earlier, spray with metallic color and antique with oil paint. Let dry. Apply pastewax to protect the antiquing. With a cloth, polish gently for a soft, lustrous finish.

DUSTING PLASTER

Dry pigments can produce still another range of finishing effects on plaster if the surface is either waxed or painted first. These pigments, although usually combined with a paint vehicle, are here used *as is*. They come in two basic forms: (1) metallic pigments, such as actual particles of aluminum or bronze, ground to a fine powder, and (2) earth pigments, including clays, lampblack, and the dry colors sold in art supply and paint stores.

Here are two ways of dusting plaster:

(1) Brush the raw plaster surface—unsealed and unfinished—with rottenstone pigment (a grayish material, ordinarily intended as an abrasive). Wipe this pigment away from the high spots, leaving only traces behind in the crevices of the work. It will remain there without any wax or fixative, creating a beautiful antique finish.

(2) With a metallic pigment, add highlights to a piece which has already been colored, sealed with wax and buffed. Place a pinch of this pigment—either antique bronze or gold—on a sheet of newspaper. Tamp a small amount of this onto a soft paintbrush, 2″ or 3″ wide. Then lightly dust the brush over the sculpture. This will leave just a hint of the metal adhering to the wax and create the illusion that the metal is showing *through* the wax surface.

Working With Metals

Because alloys of tin or lead melt at relatively low temperatures, they are most practical for home and studio use. Tin's melting point is 450° F while lead melts at 621° F.

BUYING METALS

Some of the alloys; most frequently used for sculpture, appear below. Suppliers for these may be found in the Yellow Pages under such listings as Metals, Lead, or Tin. Suppliers might also be located in terms of the uses indicated below for each alloy. For example, machine shops and garages sometimes cast babbit bearings; while die casters or jewelry manufacturers, might also suggest sources of supply.

TIN ALLOYS

METAL	CASTING TEMPERATURES	COMPOSITION	COMMON USES
Tin Babbit	750° to 825°F	91 tin 4.5 antimony 4.5 copper	Bearings; die castings
Tin Babbit	795°F	89 tin 7.5 antimony 3.5 copper	Bearings
Die Casting Tin	700°F	82 tin 13 antimony 5 copper	Die castings
White Metal	600° to 625°F	92 tin 8 antimony	Costume jewelry casting and die casting
Pewter	600° to 625°F	91 tin 7 antimony 2 copper	Candlesticks, plates, and ornamental castings

LEAD ALLOYS

METAL	CASTING TEMPERATURES	COMPOSITION	COMMON USES
50 – 50 Solder	500°F	50 lead 50 tin	Sheet metal and electrical soldering

Straight Lead	725°F	99 + lead	Plumbing and construction
Hard Lead	752° to 932°F	96 lead 4 antimony	Sheeting and pipe
Hard Lead	752° to 842°F	94 lead 6 antimony	Sheeting and pipe
Lead Babbit	617° to 750°F	85 lead 10 antimony 5 copper	Bearings

Type metal, which can be found at newspaper and printing plants, is another useful alloy. It consists of lead, antimony, and tin, and has a casting range of 525° F. to 600° F. Although somewhat brittle, it does make for sharp clear detail in the finished cast. *Note*: The casting range for metal generally runs 50° to 100° above its melting point.

Metals with extremely low melting points are also available now. These are much more expensive than any of the above-mentioned metals, but easier to handle because very low heat is required. They include:

Cerrobend ® with a melting point of 158° F.

Cerrobase ® with a melting point of 255° F.

Cerrotru ® with a melting point of 281° F.

For information on these, write to: Cerro Sales Corporation, 300 Park Avenue, New York, N.Y. 10022.

Information on Molds

This is supplementary material for Chapters 10 and 11 of this book.

STORING THE MOLDS

Plaster molds may be stored for unlimited periods, provided that certain precautions are taken. Two-piece molds must remain closed and placed on a flat surface. (Otherwise, they will warp and not fit together properly.) Also storage dries molds out, so they must be soaked thoroughly in water before use. This soaking time should be at least 15 to 30 minutes, or until air bubbles no longer form on the surface of the plaster.

SPECIAL CASTING TECHNIQUES

The slush casting technique is used when wax is to be cast hollow. This calls for pouring the mold full of liquid wax, then quickly pouring it out again. Each time the wax is poured in, then out again, an even coating is deposited inside the mold.

Slush casting is done as follows: Melt the wax to a liquid as described in Chapter 10, but do not pour it into the mold immediately. Open the mold instead and apply the first coat of wax with a soft sable-hair brush. This will prevent the formation of air bubbles which would interfere with the surface detail of the cast. Apply the hot liquid wax to both halves of your mold.

Next, look for any projecting areas inside the mold. (The concave parts of the cast will be reversed in the mold and become convex, projecting up from the surface.) These projecting areas need additional layers of wax as reinforcement, before any liquid wax is poured into the mold. Such a preliminary buildup is designed to protect these highpoints, which—since they project out—will receive more heat from the liquid wax during slush casting, and therefore be melted away to a greater extent. This would leave behind areas with only a paper-thin layer of wax and so create weak spots in the finished cast.

To reinforce these highpoints, first press wax pellets against the brushed-on layer. When this preliminary build-up is completed, pour the mold full of liquid wax, then quickly pour it out again. Sometimes a single pouring is sufficient; sometimes not. The temperature and viscosity of the specific wax will determine the number of layers needed for a strong and stable cast.

Miscellaneous Information

Various sculpture tools and other accessories can either be bought at art supply stores or sculpture supply houses. They can also be ordered from these sources by mail.

BUYING TOOLS FOR PLASTER AND WAX

Some companies, specializing in tools for plaster and wax, are:

Sculpture Services
9 East 19 Street
New York, N.Y. 10003

Perma-Flex Mold Company
1919 East Livingston Avenue
Columbus, Ohio 43209

Sculpture Associates Ltd.
114 East 25 Street
New York, N.Y. 10010

Sculpture House
38 East 30 Street
New York, N.Y. 10016

HAVING SCULPTURE CAST IN BRONZE

Sculptors who model in wax, or directly in plaster, can have their work cast in bronze. A number of foundries provide this service. They include:

Modern Art Foundry, Inc.
18–70 41 Street
Long Island City, N.Y. 11105

Avnet-Shaw Art Foundry
Commercial Street, Engineer's Hill
Plainview, N.Y. 11803

Excalibur Foundry
49 Bleecker Street
New York, N.Y. 10012

Tallix Foundry
P.O. Box 265
Cold Spring, N.Y. 10516

Since all are in the New York City area, those who live nearby can take their sculpture to the foundry for an estimate of casting costs. Those outside the area can write requesting a cost estimate. Their correspondence with the foundry should include: (1) *clear* photographs of at least two views of the piece of sculpture; (2) its size in inches, including height, width, and depth; (3) an indication of whether the wax is solid or hollow; and (4) whether the wax is the original work or a cast of the original. *Note*: If the piece is a plaster original, the foundry must first make a mold from which a hollow wax of the sculpture can be cast. This is because in the lost wax process, there must always be a wax for each bronze to be cast.

Packing Sculpture for Shipment. When shipping plaster sculpture, normal precautions should be taken to prevent breakage. When shipping wax sculpture—particularly small delicate pieces—they should have special supports. These can be made as follows:

Place the wax sculpture in a loose-fitting cardboard carton. Get two sheets of thin plastic (polyethylene), large enough to drape over the sculpture and still extend out beyond the edges of the carton itself. Lay one sheet of plastic on top of the sculpture. Mix a batch of plaster, then dip pieces of burlap in this, and place them flat on top of the plastic sheet. Continue doing this until two or three layers of burlap are formed. These layers should follow the side of the carton as well as the shape of the sculpture itself. They must fit closely enough to support the sculpture when the plaster hardens. However, at the same time, the plastic sheet needs to be drawn over the wax in such a way as to prevent the burlap-plaster support from forming undercuts. (These could lock in the wax sculpture.)

After the plaster hardens, turn the carton over, open its flaps, and repeat the process with the second sheet of polyethylene, more burlap, and fresh plaster. When this hardens, remove and set the plastic sheets aside. Rinse off the plaster supports to clear away any loose plaster particles that might adhere to the wax sculpture. Then, before returning the wax sculpture—along with its top and bottom supports—to the carton, wrap the entire assembly in one of the polyethylene sheets. This will protect the cardboard carton from the moisture of the plaster and also, by sealing in the moisture, keep the wax from sticking to the plaster. Finally, wrap and address the box for shipping.

Index

Photograph Credits